SO-BAU-866

Purchased in San Diego on 2/4/90 with WFC after Kevin Bubriski exhibit on Nepal

THE
PHOTOGRAPHIC
MEMORY

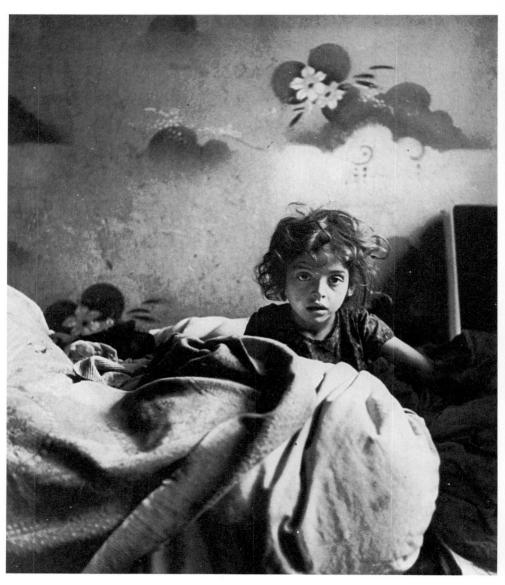

ROMAN VISHNIAC, USA 1938

THE PHOTOGRAPHIC MEMORY

PRESS PHOTOGRAPHY – TWELVE INSIGHTS

Edited by Emile Meijer and Joop Swart

Presented by

Quiller Press
London

WORLD PRESS PHOTO

Copyright © 1987 B.V. Uitgeverij Nijgh & Van Ditmar, Amsterdam, The Netherlands and World Press Photo Foundation, Amsterdam, The Netherlands.

First published in UK 1988 by Quiller Press Ltd, 50 Albemarle Street, London WIX 4BD

All rights reserved. No part of this book may be reproduced or transmitted, in any form or by any means, without permission from the Publishers

Translations (Swart, Meijer and Josti) by Carla van Splunteren, (Caujolle) by Technicis and (Barents) by Adrienne Dixon

Editorial co-ordination and production by BIS Book Industry Services / Carla van Splunteren and Nederhof Produktie, Nieuwe Spiegelstraat 36,
1017 DG Amsterdam, The Netherlands
Design Zeno, Amsterdam, The Netherlands

Cover illustrations front: Press photographers by Peter Solness, John Fairfax & Sons, Sydney, Australia; inset Peace March by Jeff Share, Sherman Oaks, California, USA; inset Winnie Mandela by David Turnley, Detroit Free Press/ Black Star, Detroit, USA

ISBN 1 870948 10 6

CONTENTS

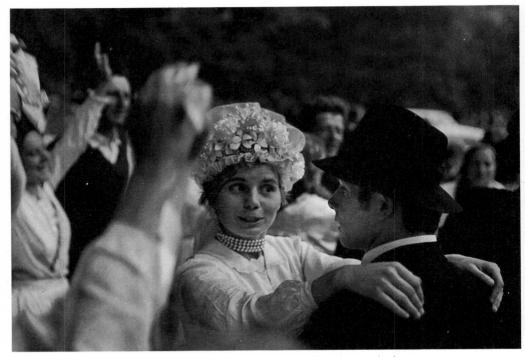

Photographing has an apt synonym in Hungarian: 'preserving'.
Felsötárkány, 1970
PETER KORNISS, HUNGARY

JOOP SWART

Introduction

'Photography is preserving. It is a hundred other things of course, but to most people it is simply preserving. They preserve themselves and each other.'
Cees Nooteboom in *Voorbije Passages* (Past Passages), 1981.

This book is the anniversary present to the World Press Photo Foundation from twelve authors, who have been very closely involved in press photography.

The striking title of this volume of their essays tempts me to delve into my own photographic memory, by way of introduction. After all, the course of my life was for an important part determined by press photography and my involvement in World Press Photo. You see, I am a child of the happy marriage between the written word and the photographed image, the illustrated press. It is the road on which I placed my first steps after World War II in what was then the Dutch East Indies.

Batavia 1946. A decrepit office building opposite the grey cathedral, army contact centre. Corporal Swart performing his first, above-ground, journalistic duty: writing the captions for military press pictures. Later on he went into the field as a reporter. Exhausting patrols, police actions. The lessons were soon learned. The writing press was reporting the colonial war from comfortable hotel rooms in Batavia. The photographers were toiling along through the mud, at the head of the line. 'If your pictures aren't good enough, you are not close enough.' The winged words of North America's fearless war photographer, Robert Capa, got the hallmark of reality.

Amsterdam 1951. A converted warehouse in Huidekoper Street. *De Week in Beeld* (*Picture Newsweek*), a distant forerunner of *Nieuwe Revu* (*New Review*). Forging ahead, out into the world with photographers like Sem Presser, Jan Stevens, Henk Nieuwenhuijs, Kees Scherer, Maria Austria, Henk Jonker and Aart Klein. It was never just the story, the picture was even more important. In the hard school of the General Editor, Toon Weehuizen, any commentary stood or fell with the visualisation: the *Look/Life* formula translated into what could be achieved and financed in the Netherlands.

Amsterdam 1955. The annual meeting of the Dutch Society of Photo Reporters, held in a smoke-filled backroom. Two freelancers, Kees Scherer and Bram Wisman, launched the idea of turning the annual national photo competition into an international event. They got a lot of support and a hesitant committee was eventually persuaded to approve the idea. They appointed Scherer and Wisman, plus Ben van Meerendonk, as organisers: the first step was set towards what was ultimately to be the independent World Press Photo Foundation.

Amsterdam 1964. A wide-eyed glass house of six floors along the Stadhouderskade. *Avenue* (a glossy monthly). At last a home for the long-cherished dream: the absolute meeting of text and image. Photographers from all over the world announced themselves. Visual imagination was in power and found international support. A silver award from the Art Directors' Club of New York, gold from Photokina.

The Hague 1966. A fine building with fitting surroundings. The Municipal Museum of The Hague. It was my first meeting with World Press Photo as a member of the jury. The winner of that year: the picture of a U.S. tank, dragging away the corpse of a Vietcong soldier, taken by UPI photographer Kyoichi Sawada. The Dutch press commented: 'Why do we always have to have war and violence?' Public opinion about the presence of the United States in Vietnam still had to undergo a change then.

Mainz 1982. The benches of the modernly-lit Mainz Council Hall are filled entirely with prominent members of the German photographic world. Professor Fritz Gruber, 'the godfather of press photography', presents World Press Photo with the prestigious Dr. Erich Salomon Award of the 'Deutsche Gesellschaft für Photographie' to mark WPP's 25th anniversary. Photographer Salomon, who died under Hitler's rule, set the tone for independent picture reporting with his 'candid photography'.

'World Press Photo has become – true to the best traditions', Fritz Gruber said, 'the inspiring meeting-place of picture reporting for the entire world.'

Budapest 1983. A gigantic world-fair complex is warming its concrete skin in the spring sunshine. Inside, Utazas '83, the ten-day cultural Spring Festival commences. In Hall 25, the Minister of the Interior, Dr. Zoltan Jonar, opened the World Press Photo Exhibition '82 and spoke of the revealing nature of press photography which thereby serves peace. After a quick tour, he arranged that he would come back for a look at his ease. Without protocol. The or-

ganisers told me that he would then be one of the minimally 300.000 visitors they expected to come to this exhibition. Glasnost avant la lettre!

Amsterdam 1986. In the golden glows of the Mirror Room of the Amstel Hotel, Raymond Demoulin, vice-president of the Eastman Kodak Company in Rochester, U.S.A., puts his signature underneath the contract that makes this photo giant, hand-in-hand with the K.L.M., the worldwide main sponsor of World Press Photo. It was – now also in the field of sponsoring – an affirmation and recognition of World Press Photo's leading position in international picture reporting.

New York 1987. In the U.S. temple of photography, the International Center of Photography, corner of Fifth Avenue and 94th Street, an exhibition called 'Eyewitness, 30 years of World Press Photos' requires all of the available space with its 250 pictures. Striking posters and invitations made New York aware of this unique occasion. *Newsday*, Long Island's N.Y. major newspaper, devoted its entire Saturday colour supplement – cover and thirty pages – to the event and announced that the exhibition could also be seen in Peking by the end of the year.

And thus it was that the idea of two Dutch press photographers led to worldwide recognition within a period of thirty years. The competition involved is an eagerly-met challenge by the top people in press photography throughout the world, the International Jury is considered the 'United Nations of Press Photography', the exhibition of award-winning pictures annually draws an audience of a million or more people.

While nothing is more dead than old news, yesterday's picture appears to be as alive, interesting and engaging as today's. Perhaps this phenomenon – so clearly illustrated by the pull of World Press Photo – can be explained by the fact that the press photo constantly returns the viewer to that fixed point in time. The picture recalls emotions, awakens memories. And this appeal to our memory can be so strong at times that you often know when, and exactly where, you were first confronted with the image in question.

Our memory is a storeroom, and a large part of the images it contains was placed there by press photography. And our views about important and complex events have often been recorded in our memory by a single news picture. A frozen moment of eternally hurrying time, never to be undone again, a second caught in a world without end. Because each morning, when the earth turns

anew to the sun and a new day is added to our existence, there are people who open three eyes instead of two: the press photographers of the world. Sometimes they are the messengers of good news, often bad news. We send them to the seventh heaven of human success and happiness, but they more frequently stand at the gates of hell amidst war, chaos and disaster. They are our eyes and – often to our shock and dismay – they make us *cognizant and everywhere*.

The genteel click of the camera, that accompanies our existence every moment of the day, is a unique sound which was not heard a generation ago. Before that there were only paintings of battles in the fields and at sea, which took place months if not years before they were recorded; marble and bronze statues of statesmen and the famous whose empty eyes stare at us, and the stylised portrayal in wood, metal or ivory of a naked man on the cross as a souvenir of the most gruesome murder in history.

Before photography there was nothing. Today, each heartbeat of time, each millisecond of eternity is recorded forever.

The World Press Photo Foundation, born in Amsterdam, seated in Amsterdam and governed by Dutchmen who enjoy the patronage of Prince Bernhard, annually tries to collect the best and the most important of press photographs from all the points of the compass. And what has evolved? Not only an important book, not only an imposing exhibition, but first and foremost an extremely valuable documentation of the time in which we live.

Within the terms of this book, we celebrate the photographic memory of the world.

Joop Swart

DON McCULLIN

Notes by a photographer

DON McCULLIN WAS BORN IN LONDON IN 1935. HE LEFT SCHOOL AT FIFTEEN AND JOINED THE RAF. IN 1964 HE WAS SENT TO CYPRUS ON HIS FIRST WAR ASSIGNMENT FOR *SUNDAY TIMES* AND THE PICTURES HE BROUGHT BACK WON HIM THE WORLD PRESS PHOTO PRIZE AND THE WARSAW GOLD MEDAL. SINCE THEN HE HAS WORKED ALL OVER THE WORLD AND ON MANY OTHER BATTLEGROUNDS, NOTABLY VIETNAM, BIAFRA AND THE LEBANON. HE HAS TWICE BEEN PHOTOGRAPHER OF THE YEAR, AND HAS WON TWO GOLD AWARDS AND ONE SILVER FROM THE DESIGNERS AND ART DIRECTORS ASSOCIATION. HIS PUBLISHED WORKS INCLUDE *THE DESTRUCTION BUSINESS; BEIRUT, A CITY IN CRISIS, HOMECOMING* AND *PERSPECTIVES*.

I try to remember my childhood.

I was brought up in Finsbury Park, London, which was a very poor working-class district. My mother, my father, my brother and I slept in the dark basement room in which my father spent his life dying of chronic asthma. My fear was his dying. My strength was in trying to play a part in his survival. When there was no coal I used to get it from a nearby yard where I crept at night with a sack. Often the room smoked with damp wood and coal that had lain under snow. This isn't a load of sentimental drivel, it's fact: that's why the reasons for my presence today as a photographer are of a sensitive nature that is difficult for other people to understand. Many people ask me, 'Why do you take these pictures?' It's because I know the feeling of the people I photograph. It's not a case of 'There but for the grace of God go I'; it's a case of 'I've been there.'

There are thousands of stories about the people of Finsbury Park. A travelling man, a conjurer and magician, lived there. He was known as Magic Balls. He used to wear a leotard and soft leather boxing boots, and was always smoking cigarettes, even down to the last eighth of an inch. He did the most extraordinary disappearing tricks with them, and sometimes tired of our demands for repeat performances. His wife Madge was very, very old, a wizened little thing with grey hair who looked like a tired sparrow. Magic, as we called him for short, was overweight, and the most bizarre joke to look at, but we children loved him.

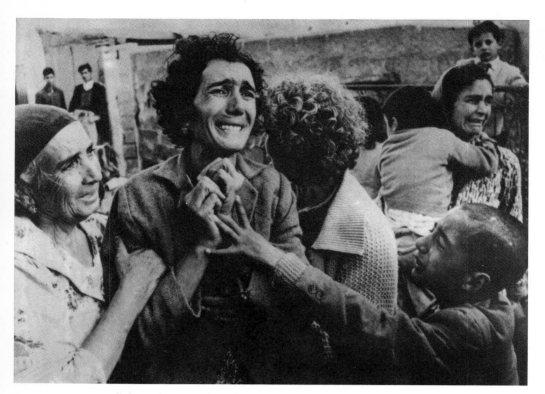

Pain and sorrow for a husband killed in action.
Cyprus 1964.
DON McCULLIN, ENGLAND

Don McCullin

In the street next to mine lived the grimiest woman you could ever imagine. She had a beret that she never took off her head, and I can only assume she had no hair. When you knocked on her door there would be a shuffling in the passageway, she would open the door into the smell, and her beret would appear, accompanied by two hideous green teeth. It was like the face of a rat greeting you.

This was my training ground, and such people have been my Bible as a photographer.

When my old man died two years later, I had to leave and go to work. I spent a year washing dishes in railway dining-cars, going from London and back. I think that was when I began to feel my life change direction. The prospects weren't too great – but travelling to different cities got me off the flypaper that you're permanently stuck on when you live in a ghetto area. I started questioning what I saw, and questioning myself. I started seeing.

My eyes seemed to be the greatest benefactor I had. I was confused and yet enlightened. Going over railway viaducts gave me elevation: I started seeing, and there was no way in the world that I was being given false information. I began taking note of the fact that I liked to watch the changing landscape, trees and valleys and rivers. I often had the desire to jump from the train into a river from a great hight: I tossed the odd tea-plate out, just to get the feeling of its flying through the air. It was romantic, just as when I was a boy I used to go along to the Saturday morning cinema, usually to see unbelievably poor films about Flash Gordon or the Lone Ranger, and when we came out and the bright light hit our eyes we used to thrash our hips away and back home as if we were on uncontrollable horses. But, now I was in the working world, I felt I'd reached the privileged position where I could take stock, not just of myself, but of society.

Yet I felt like a kind of mute – somebody whose whole thinking was trapped in his head and who didn't have the right to voice his feelings and opinions. It was quite a burden, and I still had tremendous adolescence in me even when I finally started my National Service. I was certainly a reluctant recruit, having my hair cut just as I was blossoming into the days of rock.

In the Air Force my travels extended to foreign countries, and when I came back it seemed as if my lifeline had been cut off. It hadn't. It was just beginning.

And now I've spent fourteen years getting on and off aeroplanes and photographing other people's conflicts.

Notes by a photographer 13

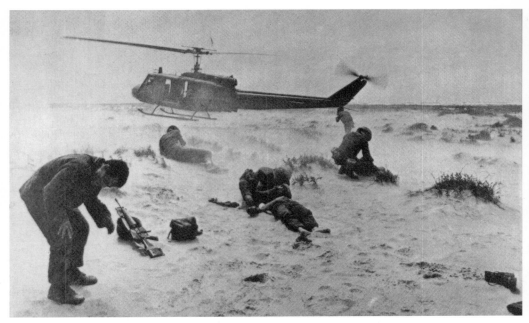

The desperate battle by the South Vietnamese at the end of the Vietnam war.
Vietnam 1972.
DON McCULLIN, ENGLAND

Don McCullin

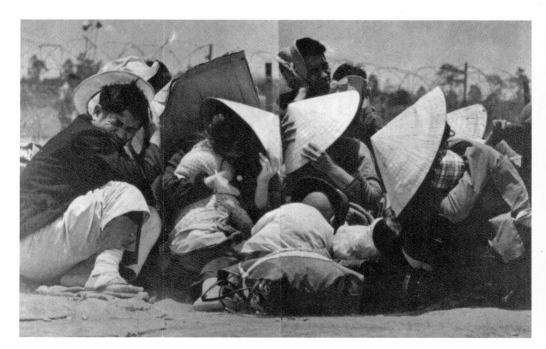

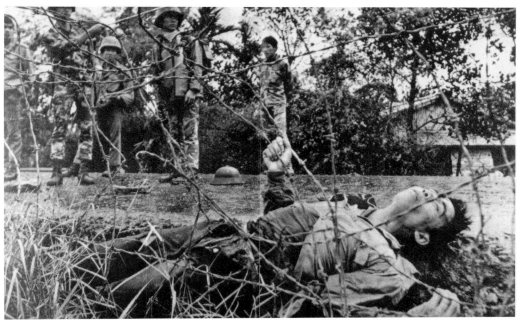

I've been dragged out of a truck and thrown into prison in Kampala for four days, lying at night listening to soldiers go in and start kicking the man in the next cell, break his legs and his jaw and take him out in the morning, dead. In Biafra I've stood in front of eight hundred living nine-year-old skeletons. I've been dragged round the back of a petrol station in Beirut by men with revolvers, and told myself, This is where I say goodbye. I don't believe you can see what's beyond the edge unless you put your head over it; I've many times been right up to the precipice, not even a foot or an inch away. That's the only place to be if you're going to see and show what suffering really means. How could I live unscarred after all that?

When I was younger I did it to become famous. But now there doesn't seem any point in going that close any more, because the law of averages will claim me and I don't want to die in someone else's war for a lousy photographic negative.

When I was young and went to war for the first time, I thought it was a terrific adventure. The sound of gunfire, that crackling in the air, used to make my hair stand up. I wasn't really sure why I was there – to take photographs or just to prove how exciting it was.

It took two or three years for that excitement to diminish, for those feelings to change. People started to talk about my pictures. They kept saying that I did not realize what effect my photos were having, how upsetting they were. So I realized that my photography was finally succeeding and I began to do my work even more precisely.

Of course I came in for a lot of criticism, some of it very hurtful. There *is* a certain mercenary element in what I've done that does disturb me, but the rights and wrongs of the situation are not as simple as some people make out. I have recorded what some human beings have done to others. It is better that we let these things happen and there is no witness, nothing to show us what is actually going on? People sometimes fail to understand how much the photographer himself is emotionally disturbed by what he photographs. They think that all war photographers are just ruthless and relentless. But some pictures of mine that they saw a couple of years ago have probably stopped hurting them – they are still hurting me.

All my photography is to do with people. I've been around the world covering their sorrows, wars and famines, and I know that we have disasters in our own country. I can hardly come back and ignore the thing I'm so well trained to see.

16 Don McCullin

One day in Bradford I was about to give up trying to photograph and go home, when I saw a man with two boys, pushing a very dirty old pram. I wouldn't have given it a second glance, because in the north of England you're always seeing men pushing barrows or handcarts, except that one of the boys was in it and he seemed too big to be in a pram. I jumped out of my car, put one of my cameras over my shoulder and ran up the road. The sun was filtering through a few hedges and the composition somehow didn't seem right. I thought the boy must be mentally retarded, so I was slightly on edge about whether I should take a photograph; but I've discovered that Bradford's the last remaining place in England where people aren't offended by having photographs taken of them. They're not fully aware of photography's power. They think something important's happening when they see a photographer, and they're quite tickled. It's the way England was when I was a child, when people had a certain respect for and were ready to demand something from each other. That's why I stayed in Bradford so often.

So I took the photograph and shouted out, 'Thank you — I hope you don't mind.'

He said, 'No, no.'

I looked at the boy, who had a shock of dark-brown hair and, on each ear lobe, a little cross painted with a blue felt-tip pen. Then I looked down into the pram. He had a pair of very thin jeans on and, where his right foot should have been, there was an empty space.

I said, 'I'm sorry.' I had to be careful; if people detect that you're losing your nerve they can turn on you. I had no right to be imposing myself, because I could see a disaster there.

That wasn't a creative photograph. My photography's an expression — of my guilt, my inability to make a protest in another way. It's an expression of something in front of me that doesn't look too good. I don't consider it an art form. An artist has all the time in the world to build up a picture. I have seconds to produce composition, drama, lighting, mood, statement. When I move into a room, before I even open my mouth it's as if I press a button in my head which records the data, sends out an invisible message which has to come back as quickly as it goes out and tell me right away, Photograph, and I have it, or, Everything's right, but maybe a little light just here might help, so out comes the flash-gun. You become a robot.

I was driving home down Tottenham High Road after prowling

round the East End of London. It was raining. I'd taken one photo-graph, but it wasn't much of a picture, and I was thinking. Oh, well, some days you get it and some days you don't. I passed a bus stop and saw there was something unusual about it. Very quickly I spotted that a man had collapsed. I stopped the car. I had the right lens attached to the camera, and I thought, Now, what am I going to do? This is very embarrassing. Do I photograph, or do I let it go?

It may sound crazy, but I don't just put the boot straight in. A photograph, an imaginary thing, isn't worth spoiling my character for. It's not important that I record every tragedy that goes on in the world. But I decided to try a couple of shots, and did something despicable. I wound the car window down and took the photo-graphs from inside. Then I hated myself for not having the courage and decency to get out and at least do something. I could see the disapproval of the man who was helping the fallen man, and thought, I might as well come clean. So I walked across the road and said, 'I've got my car there – perhaps I can take the old boy to hospital?'

'No. Clear off. There's an ambulance coming.' The man was hav-ing heart failure. I came away upset. I'm always shamefaced when I leave subjects, as if I've committed a crime.

Another day, in a closed street-market in London, I pho-tographed a man rummaging through some rotten vegetables. I was some way from him – I wanted to get the feeling of distance, as if I was any passer-by. He saw me and ran towards me with his fist clenched. He was a big, middle-aged man, and I thought, If he catches me, I'm going to be in trouble. I had my cameras hanging from my neck, and I tried to arrange them in such a way that I could defend myself.

A car drew up and someone said, 'Could you tell me the way to – please? '

I said, 'Don't ask me at this moment, mister, I've got problems coming my way.' As this huge man came towards me I wanted in-stinctively to run away, which I've done very seldom in my life; but I decided to confront him, and walked straight towards him at the same speed. I said, 'What's the problem?'

'You've got no bloody right to take photographs of me. What the bloody hell...' and he started swearing. When there were inches to spare between us he said, 'I don't like people like you', and proceed-ed to lecture me.

He had a whole nest of food in little bags in a pram which he was

Don McCullin

wheeling around. During the conversation he opened one and showed me a loaf of bread, which was three or four days old but which he'd bought for fifteen pence. And he said, 'Don't make any misunderstanding. This isn't for me, this food; I'm collecting it for somebody else.'

I listened to the points he was making and discovered I agreed with some of them. I was pleased that we were talking the subject out: it should happen more often. If we'd come to blows, I'd only have defended myself. I asked him if he'd accept my apologies, and he had the sweetness to ask me if I'd accept his. I said, 'I accept you as a man; you've no need to apologize to me. I'm the offending party.'

We parted wishing each other a merry Christmas. His last words as he trundled off were, 'I hope you're telling me the truth and you didn't photograph me. I'd hate to be seen like this.'

'I didn't, I give you my word.'

I don't believe I have the God-given right to snap pictures of people who don't want to be photographed. I know that there are areas where I can't just freewheel around with a camera, because it's stealing people's privacy, and I'd like to work with their co-operation.

I can't describe how I feel when I've had a good day photographing people, having met and talked to them and had their co-operation. It's as if somebody's given me an enormous present; I go home as if I've got a full belly.

When I photographed that man who was dying of asthma, I was looking at my old man in Finsbury Park. And when I see a boy who hasn't got any underpants, how can I deny myself the chance to photograph myself? I'm aware that I'm living in my head all the time, and it's all past history really – but, after forty years, it's still here with us. That's what I'm really trying to say.

In my life, poverty lasted a very short time; but there are people in England who are born poor and die poor. They don't and never will have any chance to get an education, to make decisions, to split when they get uncomfortable. They don't know the ways out. Poverty doesn't nourish the brain, and there are very many people who could offer our society enormous potential if only we gave them the opportunity and standards to stop worrying about warmth and employment and to live decently in the first place. I refuse to believe that it wouldn't be possible for all children in this country

Snowy.
Oakington, Cambridgeshire 1978.
DON McCULLIN, ENGLAND

Don McCullin

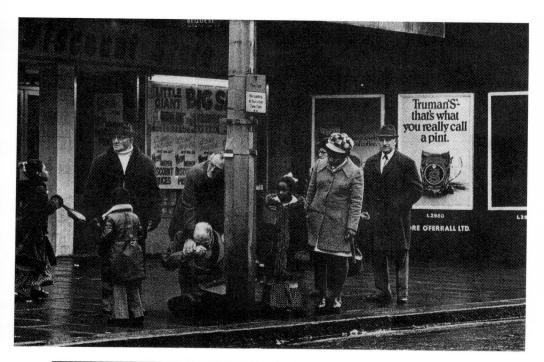

An incident at the Tottenham High
Road bus stop.
London 1976.
DON McCULLIN, ENGLAND

Doreen.
Bradford 1978.
DON McCULLIN, ENGLAND

Notes by a photographer

to go to bed in pyamas and in warm bedrooms with wallpaper on the walls. There's a whole conveyor belt with one disgusting social problem after another. I know these things are wrong. That's why I photograph them.

I've picked on people who have fantasies about themselves. I met a girl in Bradford who was nineteen. She was so incredible-looking that I found her strange. Because of her looks, and the demands that she thought people put upon her looks, she loved dressing up and becoming somebody else. She had a thing about her head, and she made weird things to put on it.

Usually I'm not interested in photographing beautiful women, because there's nothing for me to say about them. But, if I see a rag doll, I want to move in with my camera. I photographed another lady, Doreen. Forty years old, her fantasy was to look young and attractive in a stinking, squalid bedsit, in a page-boy blonde wig which she'd got back from the cleaners that day. Good people live in a sad world.

Another day, at the beginning of October, when the rain, like a monsoon, didn't let up from morning to dusk, I was sitting at home feeling as though I'd been imprisoned. Suddenly I thought to myself, Why should I stay indoors just because it's raining? I got my raincoat, and also decided against overdressing to beat the rain. As I climbed up and away from the village I could see torrents bubbling and rushing past me.

I had the whole countryside to myself, and the choice of where to trespass was mine. I chose a vast estate whose owner hadn't amalgamated his fields into bigger fields, so that it was full of coverts, copses and spinneys. As I left the last of the arable land and headed into the park, I could see a runny black dye mixing with the embers of the corn stubble which had been burnt the night before. I noticed an abundance of blackberries. All the men in the village were commuters, with little time to go blackberrying, so the bushes were full. I snatched the odd one, inspected it for maggots and sucked the juice.

I walked on and on. The rain had run off my coat and on to my legs, and my trousers were really soaking up the deluge. In a way that's what I wanted. I wanted to feel the rain; I'd just as soon have left my raincoat behind.

The only sad thing I saw was a dead rabbit, lying on its side with its paws outstretched, whose only companions were the night, the

Don McCullin

day, the wind and the rain. Looking at it, I thought how many soldiers I'd seen dead on battlefields; they were no different from that rabbit. I shook it out of my mind and walked on.

I saw an easy road, but I deliberately willed myself to go through a wood, knowing it would be difficult, slippery. Until I got to the edge of it and heard the drumming on the leaves I hadn't realized how heavily it was raining. As soon as I entered, it was as if I'd been transported back to a tropical rubber-plantation in Vietnam where we were patrolling, hoping to make contact with the Viet Cong. The atmosphere, the feeling was the same – the noise, the ground, the mud, the ridges formed by the rain. My heart started to race a little as I waited for the first round from the snipers, and I thought, What a waste of an exciting day to think about something that's so horrible and has gone.

As I walked through the wood I tried just to enjoy the noise of the water, which by now had got into my socks and boots. I'd deliberately left my hood down so that I could feel the rain on my hair and face. It kept running into my mouth and I had to spit it out. It was nice to do that, and nice to have it in my eyes. I don't know what I was trying to prove. I just wanted to appreciate the feeling that I was in command, that I could choose to walk out in the rain and do something totally different from other people, who don't have the choice because they have to work. I don't want to waste my privileges.

Coming out, I disturbed a whole lot of brown partridges, which took off bunched in formation, as if somebody had dispatched them with an order to keep together. They made a lovely flurrying noise. Once in a marsh I startled a beautiful heron, like some giant pterodactyl; its alarm in turn startled others, and I saw something I'd never seen before. Ahead of me, two dozen mallards rose in flight, gently but determinedly. (I counted them.) In Vietnam I saw B-52s bomb a whole kilometre of land in front of me; but this time, instead of bombs falling and the ground going up, there was a solid wall of beauty and joy.

After the partridges there were some young pheasants. One cock must have felt he could camouflage himself enough not to have to make a bolt for it; but he must have realized at the last minute that he'd be detected, because he took off and scared the hell out of me.

The drumming of the rain got quieter and quieter behind me. In the open cornfields there was just a slight metallic sound as it hit puddles. As I was walking I thought to myself, I haven't got a camera, but this is the way I think about everything, about the

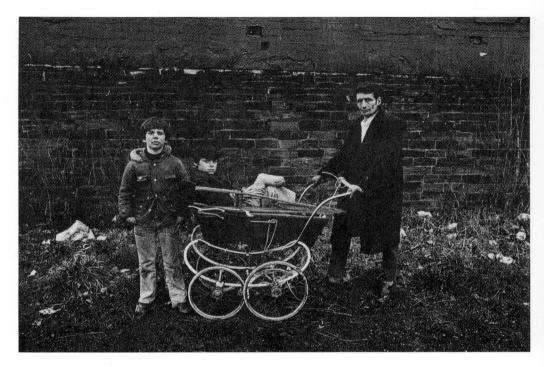

Father and sons.
Bradford 1977.
DON McCULLIN, ENGLAND

Don McCullin

aspects of things that draw me to photograph them. I stumbled around; I jumped a few irrigation ditches and crossed a ploughed field. The mud on my boots was getting heavier, so that I found walking very difficult. I got lost, but I found my bearings again and recognized a landmark that told me I wasn't very far from the village. I'd walked five miles; my clothes were saturated and my poor legs were aching. Yet I felt every footstep and every ache as more pleasure.

People who've got creative feelings in them do things that seem ludicrous to others. In a way I'm happiest wandering like a lost soul on moorlands, in open scapes with heavy rainclouds, because I'm doing what I want to do.

For the last twenty-five years of my life I haven't stopped travelling and yet when I'm not travelling my mind is travelling – I'm never settled. If I am in England I want to be in the Orient; if I am in the Orient I want to be in England – and I'm a very confused person really. But it's not so much confusion – it's probably nervous energy and a desire to continue shooting meaningful pictures that have some social conscience. It seems ludicrous to go to the other side of the world to find other people's social conscience when we have just as much of a social problem on our very doorsteps.

I will never – having promised myself – get on another aeroplane and go photograph another person's war. When I say another person's war, I mean another country's war. I will never risk my life to photograph the kind of miserable lives of refugees and wounded people in places such as Beirut. I've been wishing I could rustle up the courage to leave the battleground. I mean most people would be quite happy to run away from the battleground, they wouldn't need to rustle up the courage to leave – but I have a permanent kind of weakness in making that decision. I was always drawn back to it – and in a way I started almost making an identification as if there was an obscenity in my make-up and I didn't have the strength to tear myself away from photographing wars and deaths and the misery of suffering.

There's no way I can be one person any more. I'm totally confused about why I'm doing one thing instead of another. I'm always alone, always in another world, another bed.

I've been thrown up in the air so many times, landing on the other side of the world jet-lagged, sleepless and not speaking the language, and expected – the biggest joke of all – to be a photographer, a communicator. If that hasn't changed me, God knows

what could. I go to bed at night and swim round corpses in Vietnamese canals under shell- and small-arms fire. In England I create new confrontations, new fixed positions. I treat some assignments like battles. Sometimes when I'm walking over the Yorkshire moors, or in Hertfordshire, the wind rushes through the grass and I feel as if I'm on the An Loc road in Vietnam, hearing the moans of soldiers beside it. I imagine I can hear 106-mm howitzers in the distance. I'll never get that out of my mind.

I suppose it's a lingering from the past in my make-up that usually attracts me to poor people as subjects – gypsies and dossers, the people who have least of all. Probably all the wrong ways of representing England. Although I thought I'd beaten that, I still don't have self-determination. I know I can pay the bill, I can walk into most places and feel confident that I'm as good as anybody else; but I have the legacy of an inferiority complex. And I feel guilty about taking photographs of that kind, because I'm going to climb into my car and go back to my centrally heated house that's always got food on the table – even though I didn't grow up like that.

I feel guilty, too, because they've been taken with the eye of a photographer and not with the concern of a social worker. I have a dual purpose, and half of it is to get strong photographs. I want to produce photographs with what I know is my hallmark, and the only two ingredients I think are worthwhile are mood and drama.

I'm not an optimist. I'm a terrible pessimist. I suppose that's why my landscape skies are so dark and why my pictures are so dark – it's part of my pessimism. I do not offer much hope for a better society in the future. There are far too many complications at the moment with four million unemployed people with nothing but time and despair on their hands.

I'm not a prophet of doom even though my words sound very close to that. It is a contradiction – there are many contradictions in my make-up. I've never been lucky in happening upon an event because I'm there with my camera. I hate carrying cameras, they disfigure me. I carry a conscience.

Don McCullin

EMILE MEIJER

Photography and the art of painting: two techniques, one vision

'PHOTOGRAPHY AND THE ART OF PAINTING HAVE MORE IN COMMON THAN DO PAINTING AND PLASTIC ART', ACCORDING TO EMILE MEIJER (ROTTERDAM, 1921). HE ILLUSTRATES THIS PROPOSITION WITH A NUMBER OF EXAMPLES FROM THE HISTORY OF ART. BOTH TECHNIQUES PLAY WITH FORM AND SHAPE ON THE FLAT PLANE, BOTH EXPRESS THE VISION OF THE MAKER AND BOTH ARE SUBJECTED TO THE LAWS OF PERCEPTION AND REPRODUCTION. PHOTOJOURNALISM IS ART WHEN THE PHOTOGRAPH COMPLIES WITH BOTH THESE LAWS. THE AUTHOR SPENT MOST OF HIS PROFESSIONAL LIFE WORKING AS AN ART HISTORIAN IN MUSEUMS.

Everyone knows that photography had to be invented, but few of us realize that the same applies to the art of painting. The invention of painting took place in forgotten times, even before artistic hunters (or hunting artists) had made paintings in the Lascaux and Altamira caves, between ten and twenty thousand years before Christ.

It is commonly thought that humanity was born holding a drawing pencil. In comparison, the discovery of photography happened quite recently. Humanity wasn't born holding on to a camera.

It is hardly surprising, then, that photography is still discussed in terms of its discovery, while painting is considered to have existed forever. For this reason – and unfairly so – the attention is drawn more to new techniques and to the technical differences between photography and painting, rather than to the similarities between the two art forms.

The possibility of depicting visual reality was evidently something strived for in ancient times. The prehistoric cave paintings are an example of this. There is a story which also bears witness to this: when Christ bore his Cross to Golgotha, Veronica, a devout Jewess, wiped His face. To her astonishment, His image was fixed on the cloth. Truth or legend, the story in itself is evidence of the desire to capture moving, 'filmic' reality. A desire so great that the spread and exploitation of the magic box – the camera – has

taken on epidemic proportions. Millions have grabbed the chance with both hands to make a little piece of reality visually last. Of all those millions of hands, only one finger is needed to press the button each time.

The simplicity of this procedure is an easy thing, like playing a pianola. This old-fashioned mechanical instrument makes it possible for people to perform like virtuosos, without any training, talent or study. All they have to do is pump the pedals with some kind of regularity. The mechanism takes care of the rest. The parallel is obvious, but it is unfair. The mechanical reproduction of music is not art. It is the reproducing of art, the reproducing of that which others have made and executed.

The photographer, on the other hand, makes something that wasn't there before. God didn't create ready-made landscapes, ready to be framed into snapshots; potters don't throw pots for still lives, and pole vaulters don't determine themselves at which exact moment and from which angle they are going to be photographed. Just like other visual artists, photographers are searching for their own corner from which to re-create reality into pleasing images that evoke emotion and provide information.

There is a strange, insidious myth that photography is supposed to have freed painting of an onerous burden by taking over the painstaking task of reproducing reality. The propagators of this myth must have felt that the desire to make paintings that were 'just like real' was an ignorant, bourgeois desire.

Moreover, the myth also has it that as of the last quarter of the nineteenth century new developments in painting were made possible by this complaisance on the part of photography. Talk of ignorance! Anyone who thinks clearly for one single moment will realize that any new developments in painting are a part of massive changes in society as a whole – as is the case, consequently, with photography. Besides, after the invention of photography the maligned true-to-nature portrayal of reality came back into painting. Surrealists, magic realists and hyperrealists made use of this. What visitor to a modern art museum has not had the impression – at least once – of seeing another reflective visitor seated there, when this has, in reality, turned out to be a sculpture by George Segal (the use of the phrase 'in reality' is, in this context, pleasantly ambiguous). The deceptive imitation of nature is therefore not at all the exclusive domain of photography, let alone that photography should have released the art of painting of this obligation. So-called photographic precision dates from the dawn of Antiquity, and has

Emile Meijer

marked many periods in the history of painting. One familiar tale concerns the painting contest between Zeuxis and Parrhasios in Athens, around 400 B.C. Zeuxis painted a bunch of grapes. Birds appeared, wanting to peck at them. Parrhasios painted a curtain, complete with rod and rings. A member of the jury stepped forward and attempted to draw it aside in order to view the work.

Parrhasios won the contest because he had fooled people, and not 'just birds'. The very existence of this anecdote is sufficient evidence in itself to show that the deceptive imitation of nature was considered to be art.

Another illustration dates from around 1420 when a new wave of 'photographic' painting washed over Europe as oil paint came into fashion. The discovery of linseed oil as the ideal binder for pigments is attributed to Jan van Eyck. There is some degree of doubt as to whether he should be considered as the discoverer, but it is true that he was the first to put the new technique to use, reaching a high level of sophistication with it. One of its new possibilities as a vehicle was perfect material expression.

Jan van Eyck of Flanders was the founder of a peculiar form of realism that became a highly praised feature in seventeenth-century North of the Netherlands painting. But neither Jan van Eyck, nor other Dutchmen after him, could lay exclusive claim to this form of realism.

In 1963 a world-famous painting was transported by special convoy from Paris to New York for a one-woman show in the renowned Metropolitan Museum of Art. Her name was Mona Lisa, painted by Leonardo da Vinci a few years after 1500. The security measures employed for a head of state cannot be more stringent than those used to protect the wife of Francesco del Giocondo. The Metropolitan's curator, Theodore Rousseau, wrote the following as part of his catalogue entry: '...the painting gives us the impression of a lively and fascinating personaltity, and yet, just what the manner of this personality is, cannot easily be determined. Her manner is just as ambiguous as her smile, combining a touch of sensuality with one of intelligence and contemplation. The eyes... appear to be hiding some secret knowledge... The painting is mysterious...'

Rousseau's words are still cool and businesslike, when compared to what others have offered. Just about everybody able to read and write has elaborated on her smile, on her eternal femininity, her eyes, her hands. Practically no one has gone into the painting as work of art. Even Sigmund Freud offered his opinion on the painting. He was convinced that Leonardo had pained his mothers's

The photographer needs to be there where his theme is.
KEN SAKAMOTO, USA, HONOLULU STAR BULLETIN

Emile Meijer

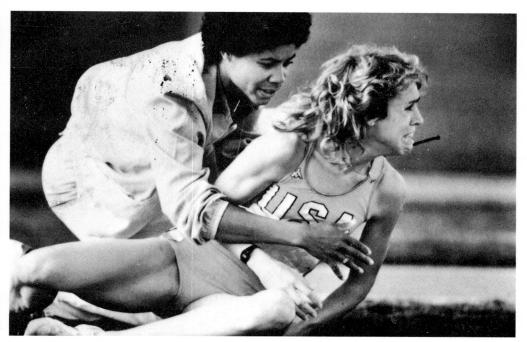

Photographers have to take reality as it comes (or falls).
Mary Decker's fall at the Olympic Games, summer 1984, Los Angeles.
DAVID BURNETT, USA, CONTACT PRESS IMAGES

smile. He never explained why only one smiling mother would have produced a Leonardo. Of interest, but hardly common knowledge, is what contemporaries saw in the painting. The painter and painter's biographer Giogrio Vasari wrote that Mona Lisa's face indicated just how much art was capable of approximating nature. Everything was, according to him, very precisely recorded: the shining of the eyes, the eyelashes, the eyebrows, nose, mouth, cheeks, and chin – it was so true to life it appeared to be flesh and blood. Had Vasari known the concept 'photographic', he would undoubtedly have mentioned photographic precision.

The American photographer Ralph Gibson talked of the Mona Lisa during a symposium on 'Art Photography' (Amsterdam 1979). He said: 'You know, once, standing in front of the Mona Lisa, I looked closely and analized the painting. Then I realized that nearly everything that can be done through painting can also be done by means of photography. And yet, there is no single photograph, to be sure, that has received so much mention. One day, maybe. After all, photography's still very young.'

Ralph Gibson and Giorgio Vasari would have been good partners in a discussion. It is evident that both grasped the essence of the painting, because their vision was not clouded by impassioned commentary in praise of the model. Ralph and Giorgio also could have talked about the camera obscura, as this instrument was known to Leonardo.

To sum up: the position that photography relieved the art of painting of its sour task of imitating reality, is untenable. Throughout history, the human desire for a reality perceived and re-created anthropocentrically has had an enriching influence on the human capacity for plastic expression.

It should also be perfectly clear that when Ralph Gibson said that what can be achieved through painting can likewise be done through photography, he did not mean: just press the button.

Both painters and photographers stand in particular relation to their subject, whether this be a live model, a still life, or nature. There is, however, an essential difference. Photographers are bound by the place, the time and the action. They cannot combine various actions occurring in different places and times without resorting to tricks that will remain visible in the result. Painters are totally free in this respect, and can allow for arranging a sundry collection of givens into an apparently natural whole. Painters have certainly taken advantage of this freedom, but not in the first place because the medium allowed for it. They proceeded according to

Emile Meijer

the ancient estethic principle that nature consists of a few scattered beauteous parts that can be combined into an ideal whole by the artist. An artist who does this 'idealizes'. Mona Lisa' portrait is, despite its striking realism, idealized. Ralph Gibson's work displays equally idealizing features, the difference being that Gibson had to find the ideal, principles notwithstanding, in existing reality, whereas Leonardo found it in his studio. Even the Dutch seventeenth-century landscapists – authentic realists in their day – idealized by assembling geographically separate elements into an apparently existing landscape.

How would photographers have worked in the Netherlands of the seventeenth century? Probably much like Rembrandt did when he went out to sketch the polderland around Amsterdam. His drawings and etchings are true to life, nevertheless forming a compositionally charming whole. A photographer could have done the same with a camera, although it would be impossible then to portray it as it was painted. Painters at work started by composing, and this is not camera-work. Rembrandt's painted landscapes show us no friendly spots along the Amstel River, no meadows with church spires in the distance, nor any anglers on a wooden bridge. They show river valleys in a hilly region, illuminated by fantastic lighting. Towns and castles lie on slopes. Rivers are spanned by bridges, bridges with multiple arches reminiscent of Italy, bridges with few arches reminiscent of the Netherlands. Single travellers are on their way nowhere, because the landscape they are crossing through doesn't exist. And yet, everything is painted as if it were really like that.

Studies and sketches were not after all, always used for the purpose of gleaning and gathering an ideal scene. Occasionally they served a purpose much akin to modern photojournalism.

The obvious examples of this – at least insofar as it concerns Dutch painting – are the Dutch seascape painters Willem van de Velde, the Elder (ca. 1611-1693), and his son, also Willem, designated as the Younger (1633-1707). They received assignments to depict the Dutch naval fleet in action. These projects were assigned by the state as well as by individuals and trading companies. The latter were interested because their ships were protected by the fleet, in the same way that nowadays oil tankers are escorted through the Persian Gulf. Clear transit was no less vital then than now.

Both the Van de Veldes' activities were highly respected. The Admiralty even placed a small vessel at their disposal so they could paddle around in the thick of the battle between the warring par-

ties. In one of father Van de Velde's pen-and-inks, showing the 1658 victory of the Dutch fleet over the Swedish fleet, one sees in fact the painter undauntedly sketching away while the oarsmen are working themselves into a sweat at the oars. This is how the reality of a war at sea has been generated, formulated in a picture filled with marvellous and minute detail. One's amazement at the picture as a work of art wins out over any distaste at the subject matter – that's the way it is when topical things are no longer topical. The connoisseur studies the drama with a look of rapture, mumbling: 'What a gifted draftsman that Van de Velde was!' One's enthusiasm grows the longer one looks – at arms and legs sailing through the air, a head here or there, the results of a direct hit on one of the warships' powder magazines. But when the enthusiasm has died down a little, one realizes something else: the most surprising thing of all is still the irrepressible human urge to record human deeds and misdeeds down to the last detail. Evidently the need of people to reproduce reality in one way or another is inseparably linked to the instinct to bring an aspect of themselves into the picture. Both painting and photography will serve this purpose.

The Van de Veldes knew how a ship was put together. Consequently they knew how to depict flawlessly the technical details of rigging, construction and armaments. Aside from this, they took care to put in rich and lively touches, like seamen and naval men. The whole was completed by a sensitive portrayal of the sea and its ever-changing moods. The illusion of reality was perfect.

It is not a strange idea, then, that realism is based on the precise portrayal of material reality – on how recognizable and nameable the particular scene. Realism along these lines is also to be found in the naturalistic novels of writers like Zola and Balzac. There are, however, other forms of realism, for instance those where material phenomena are brought to life by light and color. Impressionism, which was contemporaneous with naturalism in literature, is one such form of 'instantaneous' realism.

The material substance of a building does not change, at least as long as it is not eroded by acid rain. No one is idiotic enough to go and sit on the curb and wait for the house across the street to change its form. That which does alter from moment to moment is the lighting and, consequently, the colours. Claude Monet, the father of the impressionists, used the following as his point of departure: capturing the series of changes in light and colour in a dialogue with the indomitability of a stone monument like Rouen cathedral. He rented a room facing the church to keep his eye on

it. In the course of several months he made some twenty paintings as a 'sequence' in light and colour. What mattered was not the motif itself, Monet has said, but how he related to the motif. Different reflections of light on a concrete object, twenty times. Twenty different versions of one reality, or twenty different realities? However that may be, it cannot be argued that Monet gave his imagination free rein twenty times. His method proves the contrary. Somebody who rents working space in order to spend some period of time there observing light and colour is not a fantasy, but a man of science, a 'photoist'. What exactly did Monet mean by 'relating' to the motif? Presumably, that the motif, although apparently the same to everybody who looked at it, was unique the way it was viewed by him as a unique individual and portrayed by him as a unique painter.

It is said that Monet has talked of wanting to be born blind so that a certain moment in his life, should he gain his sight as if by magic, he could paint objects completely unhindered, without identifying them. Isn't that as if Monet wanted to be a camera?

During the last quarter of the nineteenth century, at the same time as Monet's cathedral, photographers were investigating the sequential aspects of the movement of humans and animals in action by means of photography. These motion studies by men like J. Muybridge and Thomas Eakins, are continually reported as being a part of the preparatory phase in the history of cinematography. But in our times of 'freeze frames', the stopping of film images as a kind of explicit plea to draw the viewer's attention to something specific, one can also consider the work of photographers like Muybridge and Eakins to include the oldest freeze frames, albeit of reality rather than of film images. Claude Monet (1840-1926) and Muybridge (1830-1904) were contemporaries who will never be found sharing a page of an art history textbook. And yet, both were obsessed with the desire to ferret out the secret of that single moment of stop-action, never before observed by the human eye, from moving reality. Nadar (1827-1910) and Cornelis Anthoniszoon (1499-1556) were not contemporaries, but they were both working on the same problem. They had to show their cities from a bird's-eye perspective. Nadar clambered into the basket of a hot air balloon and photographed Paris from above. Cornelis Antohoniszoon didn't climb aboard a balloon, but nevertheless he painted a wonderful view of Amsterdam seen from above (1538, Amsterdam Historical Museum).

Is Nadar's aerial photograph more real than Cornelis' view? The

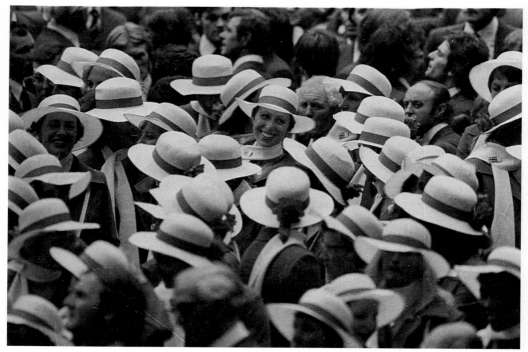

Composition: maximum expression, but also maximum harmony and balance.
Princess Anne at the Olympic Games in Montreal, 1976.
MONTY FRESCO, UK, DAILY MAIL

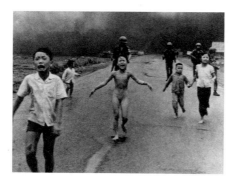

The 'natural' compositional
moment.
Bombing of Trang Bang, June
8, 1972.
HUYNH CONG UT, VIETNAM, AP

Emile Meijer

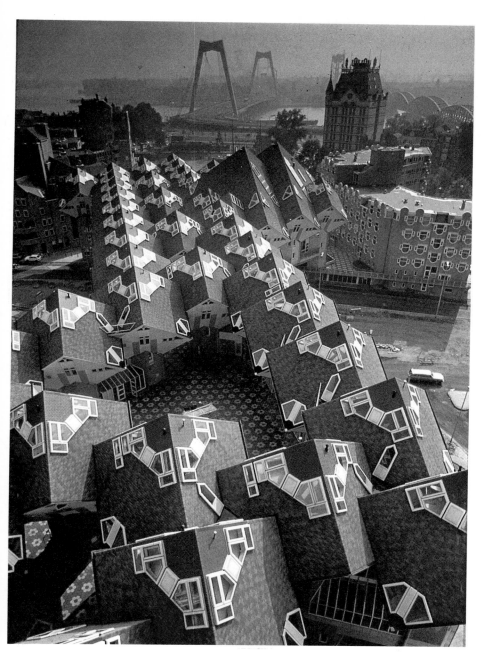

What matters is not the motif itself, but the personal – and therefore unique – way the photographer relates to the motif.
The new Rotterdam.
EMILE LUIDER, THE NETHERLANDS, RAPHO

Photography and the art of painting

answer given is that nobody ever disputed the accuracy of the painting. In fact, his precision was praised by many.

Nadar was up in the air, behind his camera. That is obvious. But where was Cornelis Anthoniszoon? In his studio. Using his knowledge of perspective, he constructed himself a base in the sky, hundreds of feet above Amsterdam. Although the viewer realizes that it was impossible for the painter to have been positioned in the place suggested by the painting, he still gets the feeling of floating above the city. It is evidently not a requirement for the artist to be physically present at the scene he depicts. The viewer gets the idea of being involved anyway. The photographer, however, is required on pure technical grounds, to be there with the motif. The painter's freedom to be absent at the moment suggested by the painting – while the viewer experiences this painting as an actuality – proves that the reverse, the necessary presence of the photographer at the scene, cannot be the primary, and certainly not the only reason for the topicality value of a photograph.

May 3, 1808: Madrid. The city's population, rebelling against the French occupational forces, is mercilessly punished. Looking through binoculars out of one of the windows of his villa on the banks of the Manzanares, Goya saw the first squads at work. At night with his servant, he made his way to the place of execution on Principe Pio hill. By fitful moonlight, he drew the corpses in great pools of blood, lying on their backs or stomachs, kneeling, kissing the earth or holding up their hands. His servant, Isidro, witnessed this and wrote about it. Six years later, Goya produced a painting that doesn't spare the viewer (1814, Prado, Madrid).

The painting is an exquisite example of Goya's art. How can esthetic appreciation concur with the inhuman event he painted? It does, only on account of the inseverable bond between form and content. The transferral of the distaste generated by the event is possible at this degree of intensity, only if the beauty stands out from the violence by way of emotional contrast (like Rembrandt's use of light and darkness). How else would these murders live on in the memory of the people, if nothing but a military report had remained, something running like: 'Today, May 3, 1801, rebels executed?'

Violence is also the theme of a 10 by 24-foot canvas by Picasso entitled *Guernica*. It is a fearful vision painted in blacks, whites and grays. Due to this alone, the painting already distinguishes itself from all other paintings, with the possible exception of the black-and-white pen paintings done by Willem van de Velde, the Elder.

Emile Meijer

It may be that Picasso identified, consciously or unconsciously, with war photography. *Guernica* presents fragmentary figures of people and animals. Among others, one notes a fallen partisan, a dying horse, a bull, a mother and her child, gestures of desperation, distorted faces, hands, feet, and a lamp in which a sun-symbol and a bull have been combined. At first glance it is chaotic, just like that market day in April of 1936 when Guernica, capital at that time of Biscayne, was flattened by German Condor Brigade bombs. It is an anti-Nazi manifesto, by way of the title as well as of the images. It is at the same time a personal statement of Picasso's which is typical of that period, around 1936, when he was choosing themes in which his fears were redirected into mythical prototypes like Crete's Minotaur. Picasso has evidently himself referred to his *Guernica* as an allegory. Nevertheless, the painting is so politically laden, that it is on exhibit at the Cason del Buen Retiro (Madrid) where it has hung a number of years encased by bullet proof glass.

The photographs Robert Capa made of the Spanish Civil War are not on exhibit behind bullet proof glass. They lack the weight and tangible presence of the great outcry on the wall, which is what Picasso's *Guernica* is. Still, Capa's photographs, in contrast to *Guernica*, show facts, not allegorical images. But to see Capa's photographs one must take them in hand, whereas *Guernica* will always be hanging there. A warning derives little effect if its presence is not continually felt. The best known of Capa's shots of the Spanish Civil War is probably the one showing a soldier the instant he is struck by a bullet. Doesn't a photographer's timing have something to do with this admiration of the viewer? It is a thought as cold as death itself.

'If your pictures aren't good enough, you weren't close enough,' was one of Robert Capa's and sayings. It captures his courage and involvement. Then, could not the seventeenth-century sea-war reporters, father Van de Velde and his son, just as easily have said: 'If your renditions aren't good enough, you weren't near enough'?

And Goya, going out at night to draw the bullet ridden victims, wasn't he following his artistic sense, too? Capa's statement shows that the question concerns a particular mentality, and not the medium being used. Painters and photographers share a few essential special terms. Both parties refer to: composition, perspective, tone, incidence of light, material expression, expressiveness, etc. Could it be, one wonders, that there is a more important element than this which both techniques share?

Anyone looking at a photograph or a painting sees a composi-

tion, an image put together from different elements in such a way that a maximum of expressiveness, but also of harmony and balance are achieved. How do photographers and painters work out a well-composed concept? They use diagrams, their manual. Such diagrams are supposed to guarantee expressiveness and harmony of the painting or photograph. A compositional diagram looks like a sort of mathematical pattern of horizontal and vertical lines, diagonals, circles and ovals. These lines indicate which directional moments and which accents will dominate the composition. Noncreative souls are reinforced in their belief that reason, the ratiorationalis, will lend them support down the difficult part of art. They will then undoubtedly be disappointed to learn that compositional diagrams, like the ones described above, are, in fact, constructions after the fact, drawn by industrious folk with a ruler and a compass on some reproduction of a well-known work of art. A compositional diagram of this nature shows how the diagonal of a broken tree-branch continues in the right leg of a peasant woman about to kick her dog, which cowers off, tail between its legs, down the other diagonal. 'The diagonal,' explains the museum guide, one arm up at an angle, 'is the line that indicates action.'

It goes without saying that the subject matter of a photograph or of a painting does not conform to a predetermined compositional diagram. A photographer cannot very well ask a scoring football player to be kind enough to move a bit more to the left. The photographer has to take reality as it comes. The painter does not. Still, Rembrandt's masterpiece *The Night Watch* (Amsterdam, Rijksmuseum), painted in 1642, gives the impression of being a scene he caught sight of by chance – although nobody would argue that he saw it that way while taking a stroll one evening, thereupon crying out: 'Hold it, gentlemen! this is going to be THE NIGHT WATCH!' The position of a painter like Rembrandt, who strove for naturalness, is therefore equivocal. On the one hand he is forced by the technique of the art form to take on the task slowly and deliberately, to study his models one by one, to put them on the canvas in eye-catching clusters. On the other hand, he wants to suggest that the painting came about at the moment the scene was caught sight of – the same way a photograph comes about.

One can also draw lines over a reproduction of *The Night Watch*, which will, in fact, demonstrate the harmonic arrangement of the figures and their attributes. The captain's head happens to be located at the intersection of the diagonals, that is, in the centre of the composition. Other accents also fit the diagram beautifully, where-

Emile Meijer

by it should be mentioned again that such a diagram is the product of a painting, and not the other way around.

Evidently a situation that is or looks haphazard can nonetheless form an orderly, overseeable whole that lends itself to being formulated through a mathematical pattern. Might it also be, then, that in the reality of daily life we are struck the most by views that present themselves to us with a certain composition? And then, that we can distinguish a pattern of perception in a painting like *The Night Watch* that we also apply in daily life? In short: do we perceive 'in composition'? It seems probable – for how could we be impressed by a photograph or a painting if the composition of it does not accord with our way of perceiving?

The composition of a work of art is based on two principles; the visibility principle and the principle of hierarchy. A simple example should clarify how this works. Take a sheet of paper and fill it with the drawing of a tree. Take another sheet of the same size and draw two trees. They both have to be visible, so don't place them one behind the other. The next question to be expected is: do both trees have to be the same size? And if not, which tree should be bigger? This is the basic hierarchical principle. The drawing can be further fleshed out with other possible elements, until a scene has come into being in which everything is reasonably visible in the spot allotted to it by the hierarchy of man and object. The visibility and hierarchy principles apply as much to a Holy Family as to a still life with strainer and ladle.

A prime illustration of the principle of hierarchy is again Rembrandt's *The Night Watch*. Rembrandt arranged the archers literally by way of rank and file, that is, by company rank: the captain in the lead, visible full-length, beside him the lieutenant, likewise full-length, and then down the line: other officers, N.C.O.'s and soldiery, further and further back, less and less visible. It is known from a certain document that the two main figures in the portrait had, in fact, each paid Rembrandt about a hundred guilders, one a little more, the other a little less, as their positioning indicates.

The rules of visibility and hierarchy are not, however, sufficient in themselves to make a painting or a photograph exciting. The meaning of the scene must be made clear by the postures, gestures and facial expressions of the persons portrayed and by the immediate environment in which the artist has placed them. Artistic expression is derived from the personal touches all painters and photographers intentionally give to their works, like brush strokes, tone, point of view, incidence of light colouring, sharp or soft edges.

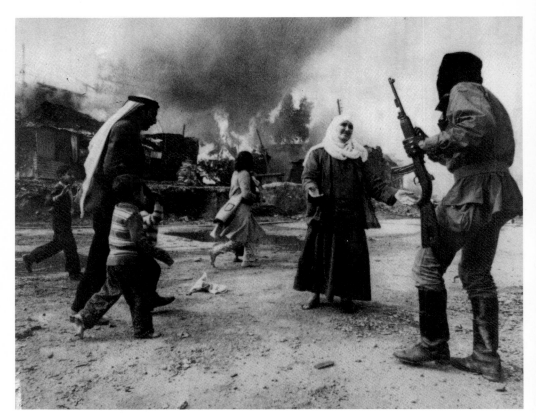

The irrepressible human urge to record human deeds and misdeeds down to the last
detail.
Beirut 1976.
FRANCOISE DEMULDER, FRANCE, GAMMA

Emile Meijer

A painting has its dimensions. This is not to be tampered with, at least not by a third party. It is hardly customary of museum curators to cut off a chunk of a painting because it is too large for the spot selected for it. This is different with a photograph.

The photographer as well as the picture editor can make a cutout, so that the most captivating composition remains and so that the picture can fit the column the editor has in mind. This procedure indicates, moreover, that composition is already an attribute of the photograph, as, of course, nothing can be altered in the hierarchy of the figures and objects presented. The position that a 'pre-composed' realitiy is being depicted – just as in painting – hereby gains in probability, just as the claim that compositional diagrams are reconstructions of the manner in which the photographer or painter recognized the order within nature.

The award-winning shot of crying North Vietnamese children fleeing a South Vietnamese aereal napalm attack on June 8, 1972 (World Press Photo of the Year, 1972) clearly exhibits a gripping composition. Nobody would dare argue that this composition was previously set up by the photographer (Anh Cong, A.P., Saigon). He just perceived the compositional moment as it happened. Just like the captain in *The Night Watch*, the little girl, Kim Phuc, running naked, is placed at the centre of the scene. There is a lot of space around her, enough to allow the gesture in her outstretched arms to come out. On the next plane, to the left, a child is glancing around. That is the traditional method, ever since the Baroque period, of relating the fore- and middle grounds. Four soldiers – with means of defence – are walking behind the children – who are without defence. Above the horizon smoke billows from the bombing of Trang Bang.

Today, it still is a photograph of June 8, 1972, a day in the Vietnam War. In the future it may be the photograph that receives mention because it has more to say than the actual story of the incident. The girl's nakedness turns her into a symbol outside of time, in the same way as classical sculpture freed its heroes from their time and milieu, by portraying them in the nude. The girl's outflung hands, extended to avoid contact with her burning skin, is a gesture of helplessness understood by all, everywhere. The black smoke in the background generally signifies catastrophe. Jerusalem burned in the same way, according to the prophecies of Jeremiah; that is the way Jeroen Bosch and Pieter Breughel painted their hellish scenes.

Thus, this photograph, 'Terror of War', could very well be a pho-

to which slowly etches its way into the photographic memory of mankind. It has all the prerequisites for such an enduring composition: visibility, hierarchy, expressiveness and symbolism.

JOHN G. MORRIS

The Arabic Oath or the three photographic Virtues

AMERICAN JOHN G. MORRIS (1916) LIVES IN PARIS AND IS THE EUROPEAN CORRESPON-
DENT FOR THE *NATIONAL GEOGRAPHIC*. BASING HIS JUDGEMENT ON THE MASS OF EX-
PERIENCE HE ACQUIRED WHILE A PICTURE EDITOR FOR VARIOUS FAMOUS
NEWSPAPERS AND MAGAZINES, HE OUTLINES THE CHARACTER TRAITS WHICH,
ACCORDING TO HIM, A GOOD PHOTOJOURNALIST SHOULD HAVE: TALENT, DEVOTION
AND INTEGRITY.

We used to talk a lot in Magnum, perhaps even too much, about
what makes a good photographer. Ernst Haas was talking about
this once in a London hotel room, to Robert Capa. Ernst was my
favourite philosopher of photography, a poet if you wish, and even
though he is gone I still hear his voice.

We had come to London after an 'emergency' Magnum meeting
in Paris – we were always having emergencies – and Ernst was
pacing around in Capa's little room, speaking with his usual anima-
tion: 'Capa,' he said, 'do you know the Arab oath?'

Capa said nothing and Ernst went on: 'Arabs swear by three
things: the eye, the heart and the brain (he touched his own, still
pacing, as he said this). That's all we need to look for in pho-
tographers: an eye, a heart, and a brain.'

I have no idea whether Ernst made up the business about the
Arab oath, but it sounded good and I have often thought of it dur-
ing the thousands of interviews I have had with young pho-
tographers, trying to assess their talent.

The eye. It sounds so obvious but it really isn't. The truly natural
photographer has an eye that is very sensitive to light values. He
has an Ansel Adams gray scale in his retina, and as the light
changes he catches different moods in his photographs. With one
eye he instinctively squints, forming the frames with which he com-
poses pictures. The skilled photographer structures his pictures like
a geometer. If he is super-skilled, like Cartier-Bresson, he will not
even have to crop them later.

I have never been sure to what extent vision can be trained. I'm
afraid it's something like training hearing. Some people are sensi-

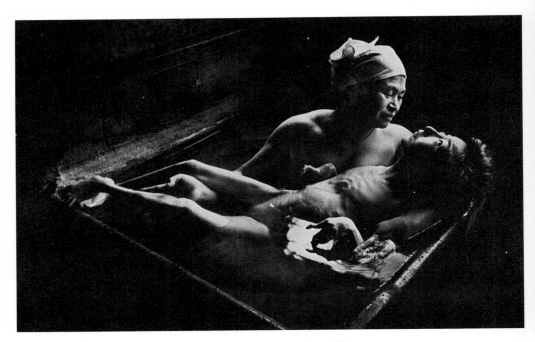

Tomoka Venmura being bathed by her mother. Minamata 1971.
W. EUGENE SMITH, USA

John G. Morris

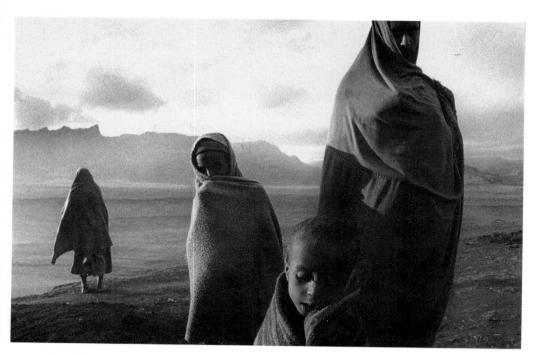

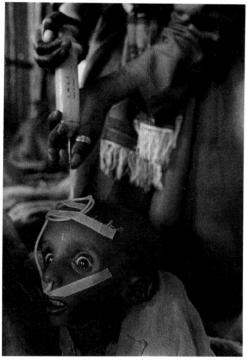

In the refugee camps Korem
and Bathi, Ethiopia, 1984.
SEBASTIAO RIBEIRO
SALGADO, BRASIL
MAGNUM PARIS

The Arabic Oath

tive not only to what symphony an orchestra is playing but also to whether the conductor is having a bad day. But how to teach this?

Contact sheets make it easy to test a photographer's eye. They show *how* he sees: whether his vision is precise and clear, whether he is sensitive to form and movement. They also show how well he exposes, but since that's becoming so easy it isn't the greatest test.

But contact sheets also show *what* the photographer sees. That's not merely an act of the eye. Here we get to the heart and the brain. The photographer's heart – let's say his emotional makeup – determines his responses to situations, and not just human ones. Edward Steichem became practically passionate over a pear, and Edward Weston could make sexy landscapes. The photographer's heart may also determine what he can *not* photograph. Dimitri Kessel of *Life*, covering the 1944 Greek civil war, was so upset by the carnage he witnessed that he simply could not shoot at times. John Sadovy, photographing the brutal summary execution of Hungarian secret police during the brief 1956 Budapest uprising, suddenly found that he could not see – tears were streaming down his viewfinder. Don McCullin, feeling helpless in the fratricide of Beirut, asked himself, 'Am I a photographer or a human being?' News photographers constantly face such dilemmas when they cover fires, accidents, would-be suicides.

I respect such feelings, for the photographers whom I most admire are those whom Cornell Capa calls Concerned Photographers, those who cling to the hope that their work, by bearing witness to this tormented world, may somehow bring about a better one. This kind of dedication comes straight from the heart – in view of the insanities of our times it scarcely bears rational examination.

Thus I have always taken almost religious inspiration from those of my colleagues, men and women, who have been willing to risk their fortunes and their lives to report the anguish of humanity: men like W. Eugene Smith, who gave war photography a special dimension, and who shared in the suffering of the Japanese victims of 'Minamata disease'; men like Larry Burrows, whose compassion reached out to both sides in the war in Vietnam, and who lost his life for it; men like Sebastiao Salgado, who spent many months with the famine victims of the Sahel; men like Peter Magubane, who lives daily throught the dangers of being a black South African journalist. I cite only a few of those whom I have known intimately; there are many more, and scores of them have paid the ultimate price.

It is curious how even contact sheets hint of the heart behind the

John G. Morris

eye of the photographer, how by revealing his interests they reveal the man. It was my painful duty to edit the contact sheets of Robert Capa's very last story – the one interrupted when he stepped on a land mine near Hanoi in 1954 and lost his life. He was accompanying a French army patrol, and there were pictures of that, of course, but it was clear that his main interest, his main concern, was of the effect of the war on the peasants – he intended to call that story 'Bitter Rice'.

Contact sheets also tell you a lot about the photographer's brain – the third element of the Ernst Haas trilogy and the final component of Talent. They tell how the photographer moves, physically and intellectually. The essence of good journalism is to be in the right place at the right time. The special challenge for the photographer journalist, as opposed to the writer journalist, is to be *precisely* in that place. Much of that ability comes through experience. I recall standing one evening under the rotunda of the U.S. Capitol, with other members of the Washington press corps. We were awaiting the solemn arrival of the coffin of Dwight Eisenhower, which was to be displayed in state under that dome – for an American one of the shrines of democracy. Bu first there would be the arrival of the accompanying dignitaries, headed by the then-President of the United States, Richard Nixon. With as much dignity as we could quietly summon, we elbowed each other for positions in the first row of the surrounding circle.

I was then the picture editor of *New York Times*, and I was astonished when my colleague, staff photographer Bill Sauro, suddenly stepped back about ten feet (three meters) from that first row, onto a marble step. What was he up to? It did not take long for me to find out. As the dignitaries filed in, they stood right in front of me, totally blocking the view. But Sauro, with his slight elevation, got the picture.

This is a fairly prosaic example of what in New York we call 'street smarts' – the cleverness that is so well demonstrated by the often maligned 'papparazzo' photographers.

But cleverness is not enough to make the great photojournalist. My hero is the man who gets to the *essential* of the event, who gets inside while the papparazzi wait outside. In that respect there has been no photographer in history like the great Erich Salomon. He was a pioneer, not only of the techniques of photojournalism, but of its proper content. A Jew, in World War II he took refuge from the Nazis in Amsterdam. Someone informed; he was last seen in May, 1944, en route to the death camp at Auschwitz.

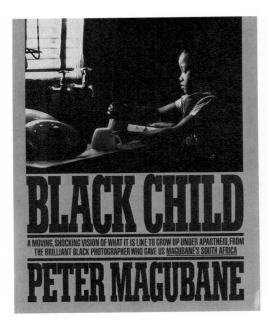

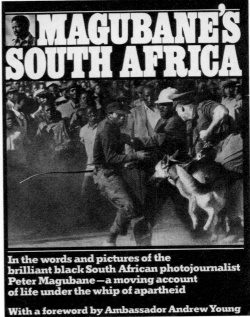

Cover of Peter Magubane's book *Black Child*.

Cover of Magubane's *South Africa*. A black photographer's document on the terror of apartheid.

John G. Morris

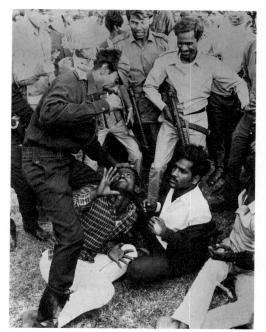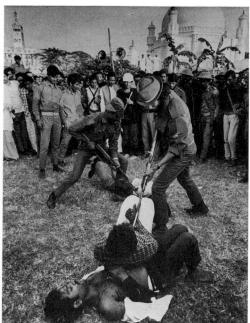

Most of us tend to see what we want to see; it is the special responsibility of the good photojournalist to see what there is to see.
Blood bath in Dacca, Bangladesh 1971.
HORST FAAS AND MICHEL LAURENT, USA, AP

The Arabic Oath

Salomon brings up the whole ethical question of privacy. Salomon sneaked pictures. He would hide his camera in a book to make pictures in courtrooms. He invaded the sanctity of parliamentary chambers. He dressed like a dipolomat – and walked into diplomatic functions. Perhaps today he would be arrested for such exploits.

But Salomon was after the *meaningful* picture. He was not just standing outside a nightclub to discover which celebrity was dating which. He was not sailing past a Greek island, as an Italian photographer did some years ago, to catch Jacqueline Onassis bathing in the nude. (Actually, since she had nothing dreadful to hide, she probably objected less to this than to the ever-presence in New York of paparrazzo Ron Galella, who hounded her every move so relentlessly that she finally took him to court.)

It can't be denied that such pictures sell. Should one then pass the blame to the editors and publishers of shameless magazines and newspapers, such as those sexy tabloids of Fleet Street? They would in turn pass the blame on to the vulgar public, which provides ten readers of such trash for every one reader of a 'serious' newspaper. Which is first, chicken or egg? In this case it's perhaps the rooster.

In defense of the press, it can be said that it is but a pawn of the powerful, in their game of selling 'image' to a gullible international public – whether it be the image of a politician, a product, or a pubescent movie star. But does not the press, by going along with this, help to create more and more of it? Let's look at the broad implications.

Every press photographer knows what a 'setup' is, and every public relations specialist now knows what a 'photo opportunity' is (I believe the term was coined by the Nixon White House). A setup is a photograph contrived to look like reality and a photo opportunity is an invitation to photographers to shoot an occasion that may or may not be real but in any event suits the interests of its sponsors.

Now whole battles, even wars, are offered (or closed off) to the press as though they were photo opportunities. Thus, the press was not 'invited along' when the U.S. invaded Grenada. Fortunately some photojournalists got there anyway. However, *no* press photographers got to the Mylai massacre in Vietnam. It remained to one U.S. Army photographer to record the scene – inadequately.

Perhaps the classic case of a 'photo opportunity', one that will forever be discussed in the annals of photojournalism, occurred at the end of the war which brought independence to Bangladesh, in 1971. Dacca, soon to be the capital, was under Indian control. Eth-

nic feelings were intense. Some Bihari prisoners were brought by Bengali soldiers to a race track at the edge of town. The purpose was to show them off to the press and to the angry populace, but the situation got out of hand. One soldier jabbed his bayonet at a Bihari, at first only showing off. But then another soldier bayoneted, for blood, and another. Among the photographers present were Marc Riboud of Magnum and Penny Tweedie, a London freelance. They thought the presence of photographers was inciting the action, and concluded that they should leave the scene. But the bayoneting was already out of control. Photographers Horst Faas and Michel Laurent of Associated Press stayed, photographing what became the ugly lynching of several prisoners. Their next problem was to get the pictures to the world. Dacca was under censorship, but they managed to get the pictures out of the country by courier. Transmitted from London, they shocked the world – and the Indian authorities into tightening discipline to prevent further violence.

At the time, Marc Riboud and Penny Tweedie thought they were right, to leave the scene when they did. But years later Prime Minister Indira Gandhi told Marc that the publication of the Associated Press pictures had effectively prevented further incidents. Faas and Laurent (who was later to be killed on almost the last day of the war in Vietnam) won the Pulitzer Prize for their pictures.

Most of us tend to see what we want to see. I submit that it is the special responsibility of the good photojournalist to see *what there is to see*. Thus Eddie Adams, one of the best, has often said that he never wanted, or expected, to see the police chief of Saigon suddenly shoot a Viet Cong suspect in the head – even though the picture made history and brought instant fame to Eddie. Like a good boy scout, he was prepared.

To me the supreme personal test of the integrity of the photojournalist is *whether he has told it like it was*. That's what I look for in his contact prints.

There are as many or more ethical problems of photojournalism for editors as there are for photographers. Theirs is the final responsibility for the printed page, and thus to the public. Too often the photographers are shut out of such discussions. Too often their work is disguised in anonymity.

Thanks to the educational work being done by such organizations as the National Press Photographers Association and World Press Photo, thanks to editors like Tom Hopkinson and Harold Evans and Howard Chapnick, thanks to books like this one, the

implicit questions of photojournalism are being addressed and the profession is striving for a new level of integrity.

Photojournalists provide the raw material of history, in this age of instant worldwide communication. Too often it is distorted or ignored. As Don McCullin has cried, 'Is anyone taking any notice?' But for better or worse, photographers have immense power to influence history, through their pictures, and through their behaviour in making pictures.

Let this power be not abused.

John G. Morris

CHRISTIAN CAUJOLLE
Photography and its uses

CHRISTIAN CAUJOLLE (1953) STUDIED AT THE SORBONNE AND THE ECOLE NORMALE SU-
PÉRIEURE IN PARIS. HE IS THE FOUNDER AND PICTURE EDITOR OF THE JOURNAL *LIBÉRA-
TION*. IT GOES WITHOUT SAYING THAT THROUGH HIS WORK HE HAS BECOME VERY
FAMILIAR WITH THE USES OF MODERN PHOTOJOURNALISM IN THE PRESS. HIS ESSAY
DISCUSSES THE FACT THAT IN THE EIGHTIES PHOTOGRAPHY IS BEING CONFRONTED
WITH THE VARIOUS WAYS IN WHICH IT IS APPLIED, WAYS WHICH SOMETIMES SEEM TO
BE OR ARE CONTRADICTORY. IT IS PRECISELY IN THESE VARIOUS APPLICATIONS,
HOWEVER, THAT THE AUTHOR RECOGNIZES THE MODERN FACE OF PHOTOJOURNALISM.

In the eighties, photography is not only the subject of esthetic dis-
cussions but is also confronted with its various uses. Here we are
faced with more and more different and contradictory productions,
styles and practices.

Before discussing in detail the forms in which photography is
printed and distributed, it is necessary to clarify a few ideas. In this
article we shall not discuss original photographic prints, as used in
exhibitions and collections. Users and spectators of such pictures
are faced with the same problems as people using printed photo-
graphs. Such pictures are only different in that they are closer to the
original which has been photographed, stressing specific materials
and subtle lights by a greater or lesser concentration of silver salts.
Apart from that, the different formats, the frames, the way the pic-
tures are hung and the arrangement of the exhibition space are in-
tended to show up the photographer's viewpoint just like press lay-
outs do.

It is important to stress that the term photography has become
supremely ambiguous. From the 'photomaton', the polaroid and
professional practices to the use of photography by certain painters,
the same word designates opposing, contradictory and continually
updated uses of the same basic technology. Writers on photography
are probably unable to agree on any other definition of photogra-
phy than that it is a reproduction process invented in the 19th centu-
ry, based on the photosensitive properties of silver salts. Starting
from that, practitioners use the process according to their own par-

ticular purpose and understanding of it, obtaining very different results thanks to its flexibility.

In the eighties we never see *basic* photography. Users only see special *uses* of photographic images and have to 'read' – and therefore interpret – very different pictures. We look in confusion at the picture, its use and its status (assailing us all at the same time) and, due to habit, repetition and cultural codes, are unable to discover what belongs to photography proper and what is the result of its use. Moreover, each photograph – that general and polysemic picture – invites several levels of interpretation and expression, whether it is a documentary, aesthetic, political or journalistic photo, without ever clearly distinguishing them. What makes it even more difficult to read a photograph is the fact that time, that basic photographic element, makes us perceive clichés. Nostalgia often gives value to a document which has little photographic interest and leads to very different interpretations from those possible and obvious at the time the picture was taken. We never interpret photography as such, only its specific uses, and we know that each specific utilization is a way of guiding and orienting the understanding of a picture, of stressing one aspect rather than another, according to the non-photographic context and aim of the user. We know that the same picture, used in a newspaper or on a book cover, as a poster or as a postcard, will not produce the same spontaneous effect on the spectator. For example, a picture will have a different impact when larger. There is a correlation between the space occupied by a picture and the space in which it is offered. A photo of a certain size (also depending on the size of the white field surrounding it) will appear intimate rather than documentary. And in gigantic enlargements, certain details, invisible or unimportant in small prints, suddenly take on an importance leading us to other interpretations. The technical process used (such as photo-engraving or offset), the thickness of the screen, and warm or cold printing colours also play a difficult to specify role. Any use of a photograph is an interpretation, more or less close to the original intention of the photographer, for a purpose chosen by the user. And here we are only speaking of changes introduced in the processing stage, combined with an environment of other pictures, texts, graphics and photographic lay-outs. We see a picture in its general context; the photo is often far from what we see.

To avoid any ambiguity of viewpoint, we should also recognize the absolute and necessary absence of objectivity in photography. Although a photograph represents something real, it is nevertheless

56 Christian Caujolle

an icon abstract. It is an intermediary in which we recognize elements already encountered and from which we try to reconstruct the reality existing at the moment when the picture was taken. The photographic process has become more than just the 'most faithful and fastest reproduction process' enrapturing our ancestors. The problem lies in the complexity of the relations between reality and the photographic image. Any photograph (which tells us first of all that it is a photo and not a drawing, painting or other reproduction process) has an obvious relation with reality. Though it is not reality it shows a close resemblance. This is so true, that a good many publications use this resemblance to assert 'it's true, it's on the photo' and justify their viewpoint by publishing photos which they want the reader to interpret naïvely and literally. Nevertheless, at most we can state that the reality captured on the photosensitive paper existed in front of the lens during the extremely short moment needed to take the picture. Optic distortions, blurred outlines and movements, the selected angle – these and other factors forbid photography any claim to objectivity. Photos are made by photographers, not by cameras; technique and mechanics are completely unimportant compared with the human decision to select this or that image or moment rather than another. Any photograph is somebody's viewpoint on the world or an event. By means of a special recording technology these pictures, which do not lie but which do not tell the truth either, assert their relation to a past reality.

To take this a step further, I should add that this is even the main interest of photography – its ability to reconstruct different viewpoints which are not mine and which will therefore surprise me and make me discover something else. A photograph only interests me if its picture supports my dreams and thought, if it stimulates both my need to understand the world and to escape from it. Photography, which cannot summarize the world's complexities but which can recall them, only exists for me if it shows me the world as I would never see it, if it brings me in contact with things my habits and observational distortions would stop me from approaching in daily life. This capacity of awakening curiosity and exalting a single point of view makes certain rare photographers just as important as other visual artists, writers or composers. We will come back to this when discussing special press problems, but it should be said at once that this is even more important than it seems in this era of television reporting and information, against whose rapidity photography has nothing to offer but its capacity to last and immobilize.

The writer Claude Simon, Salses 1985.
ROLAND ALLARD, FRANCE, AGENCE VU

Christian Caujolle

Television magnate Silvio Berlusconi, Milan 1986.
PASCAL DOLEMIEUX, FRANCE, AGENCE VU

Because of the growing importance of the uses of photography, as compared with the strictly creative aspect, the emphasis of discussions about 'good' or 'bad' photography has shifted. These two ideas derive from esthetics, with all the subjective and historical limitations this implies. Although the history of photography, rather than a list of names and schools, is a history of viewpoints and changes of viewpoint, one day it will have to be accepted that mediocre documents connected with important events and used properly have had and still have the same importance as certain graphical avant-garde researches disturbing our vision. In the final analysis it is the photos between these two extremes which we keep in memory, consciously or unconsciously, and which constitute modern views.

To avoid confusion and to avoid attributing consequences of the general situation to photography, the discussion must also deal with photography proper, its distribution, its uses and its influence on contemporary cultural expressions. We are not living in a time of battles between schools of thought and great political and ideological movements. This is a time when individuality makes itself felt and cultures interbreed. In the field of film, for example, everybody can see that cinema, advertising and television borrow from each other and, in a whirl of rapidly changing definitions and positionings, influence, quote, honour, rob and change each other. Because of their international (though certainly not yet universal) character films are the most obvious vehicle for the cultural developments characterizing our time.

The most interesting photographers are open and curious personalities – cultivated, and interested in other fields than their own. They know the history of photography better than their elders and it's no accident that clear echos of the thirties are heard again, both in format and in frames and viewpoints. This period, from 1920 to 1939, was the most inventive, the most eclectic period in the modern history of photography. Many things were tried, many tracks explored which are currently enriched by creative young photographers. Whether implicitly or not, contemporary photography uses other forms of expression and creation. And while photography and sculpture have a much richer historical relationship than photography and painting, the most fascinating young photographers are preoccupied with writing and the cinema. Jim Jarmush and Wim Wenders would not make the cinema they offer if photography had not reached its current degree of development, but Raymond Depardon (to mention only him) would not have

60 Christian Caujolle

been able to create his photographic work without the presence of these film-makers – or at least not in the same way.

Even wider spread are the literary outshoots of photography, from the story to the sequence and from the disconnected shots to news reports, which are continuously concerned with the relation between text and picture. The book, in its many forms, remains a cultural reference point for photography, which so often is inclined towards an inferiority complex.

There is therefore no 'good' or 'bad' photography to be found in the many uses to which the medium is put in the eighties. A 'good' photograph for a daily would be useless for advertising, and a 'bad' photograph according to the criteria of the Museum of Modern Art may well embellish a magazine cover. Photography, more and more judged by its uses, is faced with ever stricter rules for its formatting and interpretation. This is fundamentally different from the earlier situation, when users made photographers their instrument. Nowadays the photo is the instrument, not the photographer, because there is an abundance of photographs (often regarded without discernment), and users, playing with the laws of supply and demand and needing only to draw from the vast store of pictures, can afford a dominant position. This is also the case in advertising, where hyperspecialization is essential if a photographer is to survive. In fields like still life and child photography sophisticated technicians are needed who are not chosen for their photographic abilities but simply to execute orders.

Due to this situation, the seventies saw the rise of a type of photographer who protected his own viewpoint and expression by refusing to become an instrument. Such photographers often limit themselves to a single cultural expression, but have successfully defended the idea of *creator*. They assert (and show) a specific viewpoint on the world, recognizable pictures, a style, and imply that this attitude and their pictures have a graphical, esthetic and political meaning. Having acquired the right to express their viewpoint, these creators now want to meet professional standards in all fields. They are certainly aware that the 'great' photographers of the thirties worked for newspapers and in advertising and that many of the pictures of Kertèsz' Parisian period, nowadays shown in museums, were ordered by weeklies and for press campaigns. The basic axiom is very simple: if the viewpoint of a photographer is different and original, he can work in all fields in an interesting and surprising way. The result depends simply on whether the photographer protects his identity by incorporating or bypassing the limitations of his brief and achieves a creation.

These creators assert (and in so asserting define new approaches of photographic journalism) that the world and its events interest them as much as their own viewpoint and outlook. They do not pretend to be either objective or exhaustive; they want to give an account of the encounters, emotions, pleasures and tears they experience in the faces and landscapes of the world. They know that they interest the spectator by the specificness of their approach, and so may give him the desire to react or know more about the situation depicted. To be part of the photographic scene today, it is no longer sufficient to be involved with one's subject and dedicate oneself body, soul and lens to it; the pictures must also show distinctly what kind of relationship a photographer – one among the many and necessarily different relationships – has with his subject. This is the context in which we will try to point out the functions of the printed press and photographic journalism.

A brief return to the history of photography clearly shows its development. After the editorial and graphic inventions of the thirties, in which surprise played a constant factor, the great magazines of the fifties – those of what people have agreed to call 'the golden age of photography' – created a style and a function. This style has long determined the idea of news reporting. Such reports were laid out like a story, a tale in pictures given twenty pages by the editor, if necessary, to make sure it would be read correctly. Cartier-Bresson and Eugène Smith had the same profoundly humanist attitude, but different styles. Both could be found in *Life*, *Stern*, *Match*. They were intermediaries between the world and the reader, functioning as witnesses and vectors. This period, when travelling was still limited to the privileged few, gave birth to the 'great reporters' who visited far countries and brought back pictures permitting vicarious trips to those who read magazines. This was a time of exoticism and discovery, the beginnings of a style and an intense desire for a press which makes you dream of other places. This desire, far from gone, enlivens today's travel magazines in a highly sophisticated manner, systematically using colour and scientifically lighted double pages. In that same period, wars and events were covered by other photographers, also 'great reporters'. They, and the draughtsmen who sketched faces in court, were the only source of news pictures. Nowadays, exotic countries are a few flight hours away and the North Pole attracts summer adventurers who, without too many risks, can make their dream come true. Anyone can visit remote lands and return with a store of holiday pictures, correctly exposed thanks to the self focussing lens... Consequently,

Christian Caujolle

the magazine gets a different function. It states, without insisting, that photographs of professionals are not the same as those of amateurs and, if photographers continue to make people dream, it will not be of remote places (for what is there left to discover to-day?) but of the pictures people forgot to take, the angles they could not find. Indirectly they increase the value of photographers' work in the eyes of the public by stressing all too often their technical per-fection. Such pictures are also intended to call up good memories by embellishing them. Rather than exoticism, travel photography shows the difference between the viewpoint of the traveller and the photographer and serves as a frozen addition to television.

As far as bringing news is concerned, television has taken over from news reporting, which is slower. The photographer cannot offer movement and sound in his reports. In this era of fast food restaurants, the photographer is saddled with a handicap which magnetic photography can only overcome in terms of rapidity. New pictures, like news reporting, have other functions than mak-ing the facts known. When you open your morning paper, thanks to radio and television you already know everything it contains and sometimes more, as in the case of events which took place after the paper went to press. Consequently, you are no longer interested in the fact, but in the way the fact is handled by the paper and the magazine, their viewpoint and possible analysis of this fact. This means that pictures need to be taken from an original viewpoint, and need to astonish or summarize; that photographers need to pay attention to what happens on the fringes or behind the scenes; that they need to present a different position from that normally offered by television. And, O wonder, they need to provide the expecta-tion of a picture which is not forgotten after a first glance, which can be looked at on its own merits, which one can come back to, think, laugh, cry or dream about. Emotion and consistency are again on the foreground, redefining photojournalism. This creative photojournalism, which naturally expresses itself in various and contradictory forms, still needs to find its proper place. Market de-velopments of printed matter do not always make this easy. To counter the role of television and the evolution of mores and life styles, press men have created new products, more and more seen in terms of marketing, target groups and market gaps. Magazines specialize in travelling, fashion, leisure, sports; there are magazines for women, students, the family, psychologists, hunters, chess play-ers or piano tuners; hobby magazines for the hours when you do not work. Programmed products of supposed comfort, relaxation

S.O.S. – Racism.
H. DE WURSTEMBERGER, FRANCE, AGENCE VU

President Mitterand is welcomed in Lomé, Togo, 1987.
FRANCOIS HUGUIER, FRANCE, AGENCE VU

Christian Caujolle

Hotel in Vitry, 1986.
GERARD UFERAS, FRANCE, AGENCE VU

Photography and its uses

and leisure, run by people more interested in scoops and in convincing the consumer of the correctness of their motivations than in reporting. Consequently it is very difficult to introduce new photojournalistic practices in the general press, because managers often tend to disassociate financial arguments from the real dimensions of pleasure and dreams in printed consumer magazines. But viewponts evolve, and demand as well. The most audacious editors – those who have taken up the challenge of working with the most modern photographic practices – are succeeding. To give only one example, which I have personally experienced and which has upset certain conventions in press photography, Libération has its own general formula, its own viewpoints and its own use of different types of photos with their own status.

But it is the new ways of looking at photography – a taste for different pictures ont the part of a young public which is daily subjected to thousands of coded pictures and photographic conventions – which enables magazines to really publish the work of photographers and give them the right to say 'I'.

We know that a photograph is not a piece of information in itself, that any photographic document – even the most abstract – must be accompanied by a caption conveying the information which it supports. We also know that surrounding titles, lines, characters and symbols, dimensions and graphic treatment are guidelines making us perceive a picture one way rather than another. In this context – which is only of the possible uses of a photograph – the effect and thus the perception is radically changed when no text is put with the picture or when the photographer is told to do the writing. Thus, contrary to its ordinary illustrating practices, the press can print pictures which enrich imagery and the collective imagination. Thus are written – in most cases not really consciously – new pages in the history of viewpoints. It is therefore a pity that quite a few editors, to make an immediate profit and convince themselves with financial arguments, though certainly in contempt of their public, systematically get pictures made without the least creativity. In our time, when the 'people', real or false, occupy at least a third of the available magazine space, nothing is quite so sad as to note that the covers of the weeklies are all the same. A well-known face is always photographed in the same light. And that's why Stéphanie of Monaco resembles Platini and why John Paul ii, photographically speaking, thinks he is Reagan. Just as nothing resembles a photo of a dead body in the trenches of 1914 so much as a mutilated body in Guatemala in 1987, so nothing resembles a face,

Christian Caujolle

whether famous or not, so much as another face lighted the same way. This systematic lighting method and fixed style for making covers are used to make stars from the heroines of trivial news items... In this case, the photographer has nothing to say – neither of the sitter nor of his approach. The picture has become merely a window, a sales argument. And its repetition makes us weary.

This change in making cover photos should not only be blamed on magazines. It is also the result of certain developments in photographic agencies, which have become large industrial machines distributing their products in more than fifty countries and which, to get their pictures published, must supply material fitting the most common characteristics of the entire world. In these circumstances, the best picture is the most neutral picture which can be used for the most purposes. It is no longer a matter of photography, but of markets, economies, demand and profits.

Among the conventional functions of magazines we could also look at the picture series spread over two pages, generally the product of different photographers trying to build up and demonstrate something, without regard for the fact that a photo demonstrates nothing, that it is no proof and that the law – wiser than the papers in this – doesn't recognize it as formal proof. A photograph can simply witness the encounter of the photographer, witness what has touched or upset him to the point of pressing the button. It simply hopes that its emotional content will be understood and, if possible, shared. It is therefore useless to try to make dumb pictures talk by giving them large titles, embellished frames and loud or spectacular captions which take their place without convincing the public.

Only by getting printed can photography fulfill its role of showing pictures and viewpoints. Newspapers and magazines distribute them, in a contradictory situation brought about by the delusion of general information and the fear of esthetics and elitism. Nevertheless it has been demonstrated that publications are successful and interesting when form and aim are consistent. In the eighties, when so many titles with sophisticated artwork and undeniable cultural pretensions are published, we get the impression of living in an extremely contradictory situation, in which a press directly descending from the fifties co-exists with strictly commercial products and new forms of expression, and a real struggle is taking place between claims to providing uniform planetary information and a desire for the quality of the craftsman. The role of income and a systematic approach against research and enthusiasm are not new. But

photography is currently being redefined within the context of this old ideological quarrel.

When publishing in the press, the photographer should be aware that his pictures are faced with editorial limitations outside his control. Together with the people he works with, he has to find the best way of integrating his pictures in a given publication. He should also be aware of the fact that developments in subjects and equipment have led to a new, broader definition of photojournalism. Perhaps a trifle provocatively, it can be asserted that today's photojournalists are those people who, by their pictures in the press, participate in the various ways of transmitting information on the printed page. And that, for example, Guy Bourdin, who is listed as a fashion photographer, is a photojournalist, because for the last twenty years he has used the pages of Vogue to tell us about women, luxury, fashion, beauty, eroticism, interbreeding, fantasies and their development. He tells us how he perceives these things; and these fields, often neglected in 'general information' are important characteristics of our society. Guy Bourdin is one of the few people who has seen their workings through his own special viewpoint. Therefore, we should not neglect genres, styles or specialties. Our time requires that differences rub shoulders, strengthen and confront each other, and that the same photographer alternates photojournalism in the most traditional meaning of the word with personal graphical research into portraiture, fashion and advertising, provided he never ceases to defend the originality of his viewpoint.

Beside the press there is the book, which does not well financially. Only large and definitive monographs, reference works which the professional and the lover of photographs want to keep on their bookshelf, and cheap photo pockets have a public. There can be other editorial successes – works which are specialized, written for a special public, and little concerned with photography itself. Whether the subject is eroticism (discretely renamed 'charm' and often mawkish and conventional) tennis, football or the voyages of the pope, it's the subject which is important, the topical success from a bestselling magazine as repeated in a book. Nevertheless, books are certainly one of the places where the photographer has most control over the finer points of his expression, where he can develop aspects of his work which are not acceptable to magazines obsessed with speed and the necessity of a quick profit. Moreover, books are an opportunity to really round off an oeuvre in finished form. If so-called photographic books do not sell well and reach no public it is because in most cases they are made as narcissistic ob-

Christian Caujolle

Manifestation F.E.N., Paris, 1986.
XAVIER LAMBOURS, FRANCE, AGENCE VU

Photography and its uses

jects and not as books. The true books of the fifties, mixing text and pictures for making a point or telling a story, have been succeeded by albums. With the 'gift book', that beautiful and expensive book, asserting the egotism of the participating photographer, luxury objects have come on the market which do not communicate. Apart from a few research or avant-garde works (limited printings with a precise destination), the photographic book should consider itself a special use of the photographic picture. Bookshops are all too often loaded with books which are supposedly meant for a broad public but manage to reach only a few lovers of photography. True, books should be a vector of photography. but above all they should establish a precise and culturally-oriented relation between the photographer and his readers. This role cannot be filled by travel albums full of beautifully printed colour photos without a precise story, especially since such books mostly repeat (often with a number of bad pictures) general subjects published in travel magazines... Like any other product a book needs to have an identity, a function, if it is to find a readership. In its text, its lay-out, its development, its aim, it should be a book and not an album or portfolio.

Other vectors of photography are being developed for different uses, spreading high-quality photos in small or large quantities. For example, photographic postcards (as widely collected as mailed) make for astonishing photo collections. The poster and even the photographic badge demonstrate possible uses – uses combining the pleasure of the image with freedom of form.

It is essential to escape systematic approaches and false income, because photography is more than ever diversified. The many different styles and viewpoints correspond to the complexities of our world. This whirlpool of forms and approaches must go together with an intelligent use and carefully worked-out forms of publication which, while respecting the aim of the photographer, integrate his work in more general topics. There are no more accursed artists or creators. There are only difficulties to be found and (for financial reasons) to be shown in the right way. Any use of a photograph is a compromise between the photographer's creation and the function which the user assigns to the picture. Consequently, from the viewpoint of the photographer no use can be perfectly 'right'. And yet, photography can only be effective and continue to direct the development and history of viewpoints while witnessing such changes, if it is printed and distributed.

The main thing will continue to be the authentic and consistent viewpoint of those who look through these strange rectangles and

Christian Caujolle

squares they call viewfinders to cut the world and recreate it on paper in highly similar fictional forms. If they are true creators, their pictures touch us. We can only hope that they will continue to be used for the most varying purposes, from the postcard to the magazine and from the image bank to the daily, without ever confusing photography and its uses, and always distinguishing between visual and editorial effects. Newspapers and magazines are not photographic journals and albums are definitely not books. Far from aesthetic fights, photographers and editors, while remaining on the look-out for creative and inventive viewpoints, should remain alert about ways of transmitting photographs, the only thing at stake in photography today.

WILBUR E. GARRETT

Teacher without a classroom

WILBUR E. GARRETT (KANSAS CITY, MO., USA, 1930), SERVED FOR TWO YEARS IN THE
AMERICAN MARINE CORPS AT THE TIME OF THE KOREAN CONFLICT. HE OBTAINED A B.A.
IN JOURNALISM FROM THE UNIVERSITY OF MISSOURI AND WAS AWARDED MANY PRIZES,
BOTH FOR HIS WRITING AND HIS PHOTOGRAPHS. SINCE 1980 HE IS THE EDITOR IN CHIEF
OF *THE NATIONAL GEOGRAPHIC MAGAZINE* (CIRCULATION – ELEVEN MILLION).

BILL GARRETT'S ESSAY IS BASED ON HIS PERSONAL AND PROFESSIONAL EXPERIENCES
AS A JOURNALIST AND AS THE EDITOR OF THE *NATIONAL GEOGRAPHIC*. HE CALLS THE
PHOTOJOURNALIST A 'TEACHER WITHOUT A CLASSROOM'. WHILE IN HIS CONTRIBUTION
CHRISTIAN CAUJOLLE PREDICTS THE END FOR THE TYPE OF PHOTOGRAPHS WHICH
MAKES PEOPLE DREAM OF FAR-AWAY PLACES, GARRETT CLAIMS THE OPPOSITE. AFTER
ALL, TWO-THIRDS OF THIS PLANET LIES BELOW THE OCEANS: MORE THAN ENOUGH UN-
EXPLORED TERRITORY FOR THE PHOTOJOURNALIST CUM EXPLORER WHOM CAUJOLLE
HAS PRONOUNCED DEAD.

Imagine for a moment a futuristic scenario. The science of genetic
manipulation has been put to the service of breeding the ideal pho-
tojournalist. Which ingredients would this genetic recipe call for?
Certainly it would call for the eye of the artist and also the churning
curiosity and sense of historical accuracy of the scholar. The geneti-
cist would have to select carefully, since the aggressive drive to
communicate is not always found in scholars. A few well-selected
missionary genes would contribute courage, dedication, and a
masochistic compulsion to change hearts and minds – risk and dis-
comfort be damned. But beware. Too much missionary zeal would
spoil the mix. The success of the progeny would rest on the skill and
subtlety with which this gene pool is blended. There's no need spe-
cifically to add technician genes, since the above mix should pro-
vide the limited mechanical skills needed to operate the cameras of
the future. To temper the blend and make the progeny a useful
citizen, the blend should include a fine strain of teacher genes.

Fortunately, this ludicrous exercise will never be needed and, I
hope, never be possible. Photojournalism ranks as a chic, romantic

profession, continually attracting more talented young people than the profession can use. And, like fingerprints, in the real world no two are alike, and they seldom conform to anyone's idealized preconception. All that the above scenario does is expose my own prejudices.

Why did I top off this mix with teacher genes? Because basically photojournalists are teachers without classrooms. At the *National Geographic Magazine* we approach every story as a teaching challenge. The missionary part? Admit it or not, most of us proselytize for causes we believe will make this a better world whether we're covering a local political race or spotlighting the threat of acid rain. Intelligent, well-researched, and balanced information is what is paid for and expected by both editors and readers. Blatant preaching or editorializing rankles readers, as it should, when presented as objective reporting. But it would be naive to think it isn't present and welcome to some degree in every story. At no time am I confusing professional photojournalism with the sensationalist photography that exploits both subject and reader.

Why will we be needing hypothetical or real talent in the future? Experts have been telling us for years that photojournalism is dead. Well, it simply isn't true. We should respond to such pronouncements with good humour and go about our business as Mark Twain did when told there had been a report of his death: 'The report of my death was an exaggeration'. It's true that many publications featuring photojournalism have died, or committed suicide, but it has not been for lack of a market or the need for good visual communications.

In his introduction to *Eyewitness*, World Press Photo's 1986 annual, Christian Caujolle perpetuates the doomsday tradition: 'The now-mythical era when the large illustrated weeklies published the stories of travelling photographers in superb double-page instalments lies behind us. There no longer is much land to discover and the exotic no longer gives rise to amazement at a time of unimpeded global information. In a sense, long-distance tourism and certain tour operators have, with the aid of television, taken the place of the old tradition of the photojournalist travelling the world to make us share it.'

What follows this pessimistic introduction are 100 pages of prize-winning pictures taken by photojournalists who have travelled the world, sharing their experiences through their cameras. The day before I read this, I had spent an hour captivated by a set of pictures brought to me by Jim Brandenberg. It was a dazzlingly beautiful,

The magic of the 'mythical' era is still very much alive.
Cover of the *National Geographic*, December 1986.

The 15th-century version of the television news.
Cover of the *National Geographic*, November 1986.

Wilbur E. Garrett

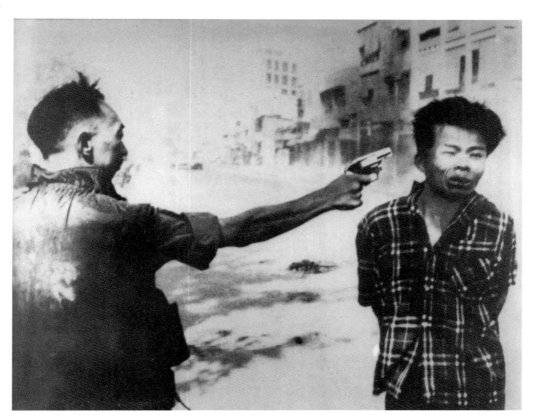

The most important shot of the Vietnam War.
Saigon 1968
EDDIE ADAMS, USA, AP

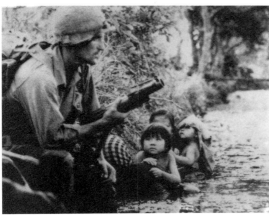

Bringing the horrors and futility of the war to the people back home day after day both on TV and in still images.
Vietnam 1966, Bao Trai battle.
HORST FAAS, USA, AP

Teacher without a classroom

scientifically valuable record of a family of snow-white Arctic wolves living in the high Arctic – an exotic subject from a faraway land. We will publish it in superb double-page layouts, and the readers will love it. Our December 1986 issue features 22 pages of pictures brought to us from the black abyss 12,000 feet down in the Atlantic Ocean by Bob Ballard. He found and photographed the wreck of the *Titanic* in one of the truly unexplored regions: the two-thirds of this planet that lies below the oceans. No, the magic of that 'mythical era' has not come to an end yet.

But it's not because the bean counters of this world haven't done a lot of damage. Too often they have gained control of a publication and driven it to its death like a horse that's been run too fast for too long. Often a magazine offers such quality that it attracts too many advertisements for its own good. When bottomline publishers permit this to happen, articles are lost among the ads and the slide begins. Readers and advertisers become bored and leave. In panic, editorial costs are cut to make ends meet and the slide accelerates. Demographers are hired to find out what's wrong. The best people leave or are fired. Creativity is replaced with demographic solutions. Usually one creative person stays on until the end to write a best-selling obituary book on what went wrong.

One of the best, *The Fanciest Dive*, describes the demise of Time Inc.'s illfated *Cable* magazine that was so badly conceived and produced that it was stillborn. As publications die of natural causes or commit suicide, new publications, and even new mediums, will come along to fill the gaps. Nature abhors a vacuum. Photojournalism, or visual communication in some form, has always been needed, and always will be.

The oldest artifacts of man's compulsion to communicate predate written records, to the magnificent cave paintings left by Cro-Magnon people 17,000 years ago. It could well be said that the first 'photojournalists' were those skilled artists. You cannot experience the magnificent murals at Lascaux, France, without sensing the powerful urge of these early people to communicate and leave a record perhaps for future generations, perhaps for their gods. Whichever it was, they were accurate, skillful, and painted with wit and humour.

One drawing shows a bull skidding to a stop in front of a rectangular shape that probably symbolizes a trap set to capture animals for food. Another scene, a series of six drawings of the same red deer crossing a stream, anticipates the Muybridge multiple-image motion studies. Repeated lines along the back of a running animal

Wilbur E. Garrett

evoke a sense of movement as surely as a stroboscopic sequence does.

The ancient Chinese developed a powerfully creative and long-lasting culture using a written language based on stringing together abstract drawings. You could even say their calligraphy was an early version of the picture story. Man's personal urge to communicate is also reflected on the cover of the November 1986 issue of *National Geographic*, which shows a woodcut made in 1493 to illustrate an epic poem composed by a Florentine scholar to honour Columbus' discovery of the New World. The poem was read in the streets of Florence by the town crier, a 15th-century version of the TV evening news.

American Indians, who had no written language, left a record of their victory over General Custer through primitive colour drawings of the carnage on the battlefield. The sketches of one Sioux Indian were drawn on the pages of a cavalry muster roll he had taken from the body of a sergeant. The Sioux was killed a few weeks later in a subsequent battle, and the book was recovered and preserved. It may have been the best eyewitness account of the battle ever 'published', though it was an edition of only one copy.

The still photograph is simply one, and certainly not the last, in a sequence of tools developed by man to communicate better. Like all the others over the eons, it will be improved upon with new technology, and just as man still paints and uses calligraphy, we will continue to use this magnificent medium in the foreseeable future. The printed page is still the most practical and efficient teaching tool available to mankind. Unfortunately, it it not as permanent as cave walls since so often the quality of our paper is poor.

If anything, the newer electronic mediums whether televison or one of its many progenies seem only to have increased the potential and appetite for the convenience of in-depth reporting offered by the printed page, whether in a daily, weekly, or monthly periodical, or a book. With continually evolving styles and formats, more magazines and books are published today than ever before.

We reach a growing audience at the *National Geographic Magazine* with a style that somewhat schizophrenically has one foot in journalism and the other in academia. And rightly so, since the magazine is the journal of the National Geographic Society, which was organized 100 years ago as a scientific and educational organization. Though we publish 11 million magazines a month with a readership of some 40 million, we have the look, feel, and a bit of the style of a book. Perhaps this explains the reluctance of people to throw

away the magazine. Weighty collections of *Geographics* fill shelves in homes and libraries around the world because we are considered an educational and useful reference work.

No one would ever question that our most valuable asset over the years has been our photography. But noble as our intention to educate may be, the power of the photograph creates fear as well as respect. It used to be fashionable to say: 'I take the magazine for the children.' Ironically, as we have taken a more realistic look at the ugly as well as the beautiful and have presented the failures as well as the successes of our times in better balance, we increasingly receive letters from parents who cancel their subscription because they don't want their children to see the world our writers and photographers find.

Extrapolating from the number of specific comments from our readers, it is not unlikely that we lost as many as 10,000 member/subscribers because of one article on early man in 1985. Some religious fundamentalists refuse to have anything in their home that they view as supporting the theory of evolution. Obviously these people are exceptions rather than the rule, or our circulation would be shrinking, not growing.

Far more of a threat than such devout readers are authorities who recognize and fear the power of the photograph. No longer can the photojournalist move with impunity into many situations without someone trying to control his work. We confront the problem daily. This power of the image became painfully apparent to the whole world during the Vietnam War. Fifteen years after its end, journalists – or 'the media', as critics seem to prefer – are still blamed for the United States losing the war.

And the critics may well be right. Bringing the horrors and futility of the war to the people back home day after day both on TV and in still images sapped their will to support it. If you opposed the war, the photojournalist was a hero. If not, he became a force to be controlled. The effect of permitting free and open photographic coverage of the fighting by our government was not lost on the rest of the world. The North Vietnamese virtually never permitted it. The result: only the American side was seen, in indelible images, to be killing and committing atrocities.

Who could be unaffected by Huynh Cong Ut's photograph of the little girl, her clothes burned away by napalm, running down the road in terror? Or by pictures of the dead in black plastic body bags, being tossed around like sacks of vegetables? No photograph in history had so much impact on a political problem as Eddie

78 Wilbur E. Garrett

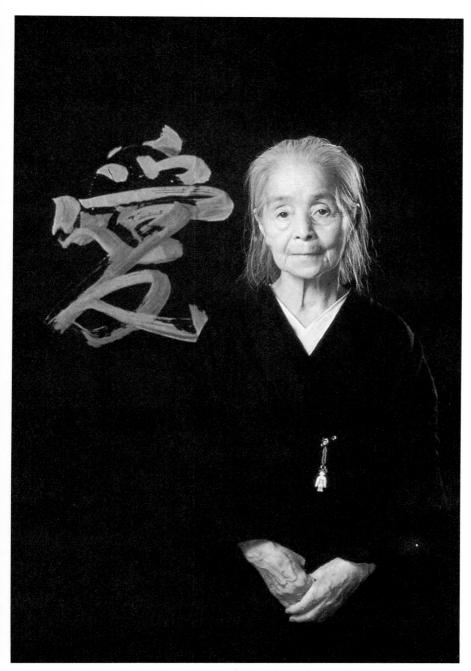

Calligraphy and photojournalism: creative picture language.
Calligrapher Aikawa-Cho, Japan 1985
EDDIE ADAMS, USA, A DAY IN THE LIFE

Teacher without a classroom

Adams's picture of the Viet Cong peasant soldier being shot in the head by a South Vietnamese police chief. No matter that the Viet Cong soldier may have done something to generate such uncontrolled anger; that act wasn't photographed and shown to millions of people. This one image has become the classic example of the photograph becoming a powerful tool for propaganda for better or for worse.

If you are responsible for disseminating a certain image, whether it's for a product, a cause, or a government, you can no longer ignore the power of the photograph. The cloak of immunity once enjoyed by the journalist is gone. The person with a camera may be just as much a target in today's wars as the one with a gun. And with good reason. The camera can be more dangerous, or more useful, than the gun.

In 1972 journalist John Everingham and I were picked up while walking along a trail in Laos by a communist guerrilla patrol. I'm convinced we were released eventually not just because our captors were able to verify that we were indeed journalists but also because the communist side felt that journalists were a plus for their cause. Not only were we released, but our cameras were returned too, and we were permitted to photograph guerrillas building a school in the village in which they had their headquarters. However, requests to accompany them on combat patrol were rejected.

Recently I was able to locate Samnuck Lanmao, the young officer who was in charge of that unit 15 years ago and who, had he chosen to do so, could have simply disposed of us. We've since exchanged letters, gifts, and family snapshots, and we'll probably meet again some day. He's now an official in charge of irrigation in the present government of Laos. Fortunately for John and me, we were thought, by either Samnuck or his superiors, to be worth saving.

On the other hand, more and more our presence as journalists is not wanted, even though we attempt to be completely fair and accurate. Perhaps it is *because* we atttempt to be fair and accurate. Like most other journalists, *National Geographic* staff have been refused visas to South Africa. Until recently Albania issued no visas to travellers from outside the communist bloc. Every project in the Soviet Union – even those approved – is scrupulously controlled. We were even denied permission to photograph the Queen's fabulous library while doing a story on Windsor Castle in England.

Censorship extends to the product. Several times a year the *National Geographic Magazine* is confiscated in Czechoslovakia with no

Wilbur E. Garrett

reason ever given and no magazine ever returned. Whoever does the censoring may well feel we have not been honest or fair from his point of view.

Just as ignorance of the law is no defence in court, we cannot piously defend our honesty with the old canard that the camera never lies. Liars use cameras as well as anyone else. Even without staging a picture, there are countless ways to lie with a camera, from the choice of lenses to the choice of when to push the shutter button, from the choice of angle to the final cropping, or in the choice of whether to use colour or black-and-white film. There is a current concern among a few people that electronic retouching has suddenly made it possible to fake pictures.

Nonsense. People who want to do so have been altering pictures since photography was invented, sometimes to lie and sometimes simply to enhance the power or artistic quality of the print. Skillful manipulation in the darkroom can change a photograph completely. Many of photography's most skillful and ethical masters have been geniuses at improving pictures in the darkroom. Ansel Adams and W. Eugene Smith were two of the best. And many subjects, famous and otherwise, are masters at manipulating photographs without ever stepping behind the camera.

By removing colour from a situation through the use of black-and-white film or filters are we more, or less, honest? When we eliminate something from a scene by using selective focus to blur it beyond recognition are we manipulating the truth? Even made with the best of intentions, pictures can lie simply because the photographer or the editor is uninformed. In most advertising photography some degree of dishonesty is assumed and usually required.

Crusaders with the highest motives may unwittingly be the most dishonest. And accuracy does not always guarantee honesty. But in 32 years at the *Geographic* I've found very few photojournalists, staff or otherwise, who in their manipulative efforts to make the best pictures deliberately altered the essential truth of a documentary photograph.

Perhaps I 'protest too much' or 'speak too long' on the subject of integrity because I was stung with an accusation of dishonesty when we altered pictures on two separate occasions to fit them to the rather rigid confines of our cover. The first was a scenic view of the pyramids at Giza; the second a portrait of a Polish coal-miner. The retouching was done using digital engraving equipment. Had it been done with scissors or an airbrush it would never have become an issue. In neither case was photographic honesty impaired, unless

it was in placing the logo and the contents type over the pictures as we do every month. But new technology, whether it's the invention of gunpowder or a tool for electronic retouching, always frightens some people. I'm told that there are still laws on the books banning automobiles from some cities because they might cause horses to bolt.

Actually new technology, from faster and better films to better presses, has enhanced the quality, the impact, and even the integrity of photojournalism by vastly improving the quality of the printed image. The very low price for the high print quality of the *National Geographic* is not, as some people think, just because we are a tax-free educational organization but also because of the incredible efficiency we have developed in conjunction with our printers in putting ink on paper II million times a month. Since we are the journal of an educational organization with no stockholders to pay, the profits all go back into the educational and scientific projects of the Society to produce better products.

Our large circulation provides us with the luxury of spending a great deal of money occasionally in pursuit of a story, while editorial costs remain a small percentage of overall costs. This permits us to give writers and photographers a freer hand in going where they must and staying as long as necessary to do the best possible job. It also has allowed us to break new ground in the use of holography as a tool in mass communications. More importantly, it permits us to publish the finest photographic reproduction in the mass media, which in turn attracts more readers. It's quite the opposite of the 'vicious circle'.

If we at the *National Geographic* should be stupid enough to fail, either individually or collectively, other people or publications will come along to replace us. Photojournalists must not fall prey to pessimism. We are not, like the dinosaur, a disappeared species. We are healthy and, with no genetic manipulation needed, are evolving to an ever higher level of professionalism. We are pushing visual communcations to become an ever more powerful teaching tool.

Wilbur E. Garrett

PETER KORNISS

The photojournalist as a conservator of disappearing cultures

PETER KORNISS (1937) IS A HUNGARIAN PHOTOJOURNALIST WITH A PROFOUND HUMAN
INTEREST IN DISAPPEARING CULTURES. HE DISCOVERED THAT THE POPULATION OF
TRANSSYLVANIA (FORMERLY A PART OF HUNGARY BUT ANNEXED BY RUMANIA) HAD
KEPT ITS TRADITIONS AND CULTURE INTACT THROUGH THE YEARS. THESE HUNGARI-
ANS, HE FELT, SAW THEIR CULTURE AS ESSENTIAL AND NECESSARY, AS AN INTEGRAL
PART OF THEMSELVES – JUST AS THE SOUL IS AN INTEGRAL PART OF THE BODY – OR,
TO PUT IT IN ANOTHER WAY, THEY THEMSELVES, IN THE WAY THEY LIVED AND DIED,
WERE CULTURE.

I am in a difficult position. I cannot pretend that everything I will write about is merely a matter of theory for me. I am a photojournalist by profession, and I have been occupying myself with the subject of which I shall speak for nearly two decades.

It would be easy enough to say that 20 years ago I decided to do certain things in a certain way. But it would be far from the truth. By itself, making a decision solves precious little. Serious, long-term work – that is always what lies behind a process, that is the road along which the photojournalist experiences different stages of intent and recognition. And in the meantime he must continually rethink the lessons that the work of others have held for him. I too had to take this road, and in order to point out its milestones, I will now walk along it once again.

It all began for me when I stumbled on the past. Twenty years ago I took some pictures in a secluded Transsylvanian village of my native land, where traditional Hungarian peasant life was still basically untouched. It was a fantastic experience. So just imagine my surprise when I discovered, back home in Budapest, that people thought that the pictures represented members of a folk dance ensemble. They couldn't imagine that this culture had remained intact anywhere.

Let me explain their ignorance. Transsylvania, where two mil-

lion Hungarians live, only became annexed to Rumania after the First World War. However, due to the geography, the language and the fact that agriculture was still in a backward stage, the area was very isolated and many aspects of old village life remained intact into the sixties. But at the time we knew hardly anything of this in Hungary. We couldn't travel much, and the mass media were more or less silent on the question of the Hungarians living in the neighbouring states. Meanwhile, in Hungary dynamic agriculture had reshaped the face of the village, preserving only certain trades, folk customs, and to some extent music and dance. In Hungary, the world of the peasant had receded into the past.

There is no photojournalist who wouldn't have been greatly excited by this experience. I felt that my mission had found *me*; I could not ignore the challenge.

Photographing has an apt synonym in Hungarian: 'preserving'. It expresses the essence of photography, for by its very nature photography preserves that which is passing, disappearing. Time and photography ara indivisibly linked. The moment the shutter is released is the moment of farewell. Already, the picture shows what was, the photograph preserves its imprint.

Just think of the implications of knowing today that something represents yesterday, that the lens is a witness to the last hours of a disappearing world. That is what the villages of Transsylvania made me realize.

The task seemed simple enough: to take pictures of whatever could still be found of a disappearing culture. I have always admired those photographers whose honesty and commitment put them at the service of major social issues. Their example gave me ample food for thought, and so I turned to them for guidance and inspiration. However, there was one important difference that I had to take into consideration, namely that documentary photographers usually catch things in their lens that they wish to get rid of, whose disappearance they wish to hasten, while I took pictures of things disappear which I did not want to disappear and decline; on the contrary, I saw their disappearance as the loss of an important part of our cultural heritage.

Edward S. Curtis was an outstanding person who played an important part in the history of photography, and had I known him then, I would have started on my road with more awareness. But I could not have known him, for his legacy lay buried in libraries and forgotten collections. His photos reappeared only in the early seventies. Yet I know of no other photographer who invested so

Peter Korniss

much time, energy and devotion in a single task as Edward S. Curtis. For 30 years he took pictures of the vanishing world of the North American Indian, and he left us over 40.000 photographs.

What he said about his starting point is something to think about: 'While primarily a photographer, I do not see or think photographically; hence the story of the Indian life will not be told in microscopic detail, but rather be presented as a broad and luminous picture.' Obviously, Curtis had a plan in which he made the objectivity of his pictorical universe subservient to his personal image of the world of the Indian.

As for the problem of 'microscopic detail', I too ran up against it very soon. I took a photograph of a mourning woman in a cemetery, who in her pain threw herself upon her husband's tombstone. Her body covered an important part of the inscription on it. My ethnographer friends objected to the fact that most of the carving on the stone was hardly visible, while others argued that such an honest manifestation of pain is more important than any folk motif. Needless to say, I sided with the latter. A vanishing culture, a vanishing reality, should not be represented by the painstaking reproduction of detail – unless, of course, we use the camera expressly as the auxiliary tool of ethnography. To record or preserve is not synonymous with stocktaking. Our task, first and foremost, is to capture the important phenomena, the typical occurrences and profound interrelationships. But what someone finds important, typical or profound is a matter of personal judgment. We all see the world through our own eyes, and what we see is tempered by our way of thinking and feeling.

Curtis was no exception in this respect. His work gives us ample opportunity to understand his nature and way of thinking. In a vanishing world, he cared only for value, only for what he judged worthy of preservation in the Indian way of live and in their traditions. He knew that destruction was inevitable, and this realization pervaded his entire oeuvre. One of his most famous pictures, *A Vanishing Race* (even its title is symbolic) characterizes Curtis's work perfectly. In it, the indistinct, misty figures of riders headed towards the darkening horizon. It is an illustrative picture: the melancholic atmosphere of gloom rises, swells, and comes forward, towards us. The process of disappearance did not so much shock Curtis as work on his sympathy. At times it seems to have veiled his vision.

He was clearly a romantic at heart. Yet I would not say that the romantic atmosphere of his pictures came only from within. Did not the culture he portrayed carry elements in itself? In Indian

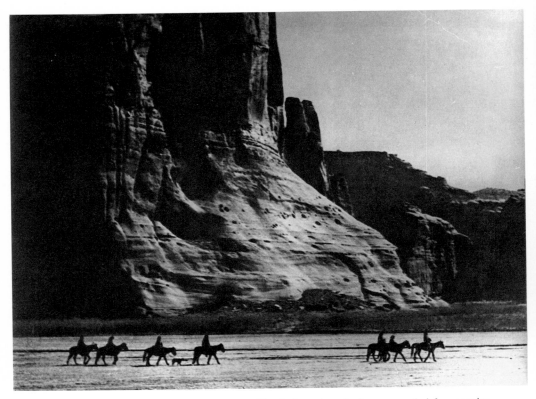

The way of life and cultures of the North American Indians recorded for eternity
thanks to one obsessed photographer.
Canon de Chelly – Navaho.
EDWARD S. CURTIS, USA

Peter Korniss

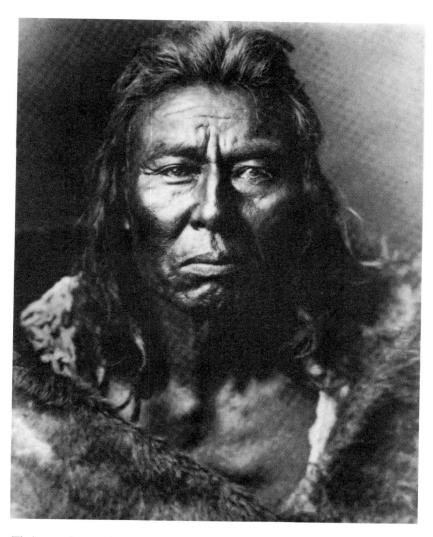

Their eyes betray the awareness of defeat, of a future without hope.
Arikara Man.
EDWARD S. CURTIS, USA

thought and conduct and in the visible aspects of Indian life, such as the places where they lived, was there not something romantic as we understand the word today? In any case, temperament and sensitivity made Curtis an apt vehicle for the subject of his choice.

It was not the representation of tragedy that Curtis set as his goal. Even a quick look at just a few of his portraits will reveal that he was thoroughly familiar with this world and its problems. The North American Indians, who have a strong aversion to the camera, were never so open and revealing for the benefit of any other photographer. Yet even when they donned their ceremonial robes, perhaps only for Curtis's sake, their eyes still betrayed the awareness of defeat and hopelessness. They are sad warriors; their glances reveal their surrender to time. Far from joining them in their surrender, Curtis wanted at the very least to preserve something of the past. A past, which he could treat only with a sense of nostalgia. During the first few years of my work in Transsylvania, I was not yet familiar with Curtis's pictures and what they could teach me. But I found that at first there was no escaping from the trap of nostalgia.

Human nature is merciful in what it lets through the sieve of memory: we remember the good and the beautiful rather than the bad. Collective memory is a benevolent creator, too, and does an even better job of selecting. We need our past, and so are more understanding towards it; we more or less take from it what is important to us, and recall what is close to our hearts. Involuntarily, the past has a way of turning its best face towards us, so it's no wonder that we tend to be nostalgic. This nostalgia is shared by the photographer, especially if he is confronted with a marvellous spectacle from the past, one he has never seen before, such as the natives of a village celebrating a marriage in their colourful folk costumes.

I had spent a lot of time taking pictures of folk dance ensembles before. I was familiar with the old folk customs, but only with those performed on the stage. I loved the songs, the dances, the mood of former village life that art had conjured up for me. But in its real setting, in its original form, as a part of life itself, it had a very special effect on me.

So this is the road I took; in the first years of my career, I photographed folk customs. It must be obvious that these not only had to do with holidays, but with all the major turning points of life: birth, marriage, death. They embraced all of life.

It would be futile to hide the fact that at first I was most impressed by the spectacle they presented. The sequence of the ritu-

Peter Korniss

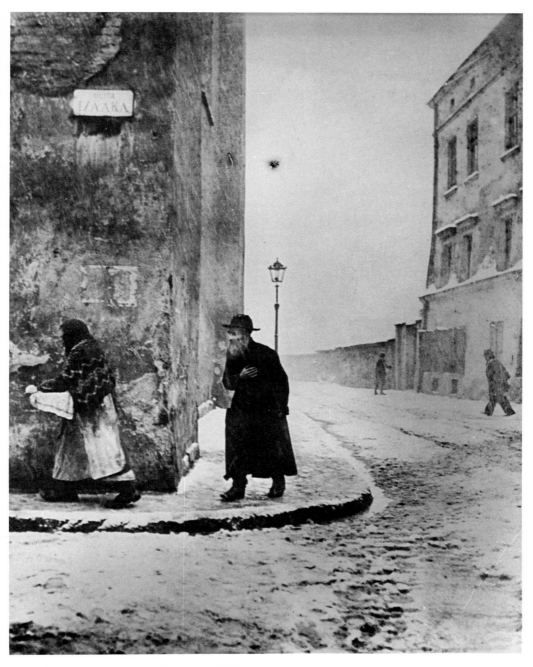

It was my task not to let this world disappear.
Isaacstreet in the ghetto of Krakau, 1938.
ROMAN VISHNIAC, USA

The photojournalist as a conservator

als, made ceremonious and memorable by time and the community, the participants of nativity plays walking in single file, the carefully arranged crowd of wedding guests, it all literally begged to be photographed. I still feel today that many things came my way without effort, for tradition is a great artist of form. It was a pleasure to release the shutter.

But soon I was struck by another 'spectacle': the open and very visible expression of emotions. People hid their feelings much less than in our modern, big city world – every shade of feeling from infectious joy to staggering pain. Especially in the course of ceremony and ritual, their artistic choreography did not only provide an outlet for private and communal self-expression, but also had a reverse effect, calling forth its very spontaneity. Form never hid or subdued its essence, the human content, but spotlighted it. I found this content more and more intriguing. It attracted me, and I had to follow its call.

I have seen repeatedly that the forms taken by the outward manifestation of emotion cannot be separated from culture as a whole. They can be understood only within a cultural framework. An interesting example of this is the above-mentioned picture of the woman pressing herself against her husband's tombstone. Some of my English friends thought that this photograph was unrealistic and theatrical, while to me it seemed natural and characteristic. After all, I had come upon similar displays of mourning and pain in other parts of Transsylvania as well.

My work was greatly facilitated by the openness and hospitality of the people. The first meeting was usually followed by an invitation. They opened their doors to me, and introduced me to their neighbours. After a while this even proved to be a source of embarrassment, for it was hard to find time to spend at least one night with every family I had met. Naturally I did not wish to hurt anyone's feelings. In the seventies the problem was solved by a law: from that moment on, a foreigner in Rumania could only stay at a private home if he was a close relative of one of the inhabitants.

My relationship with the people was intimate to the end. The fact that we shared the same language surely contributed to this. There was a natural, profound understanding between us, that of Hungarians living as a minority group in Transsylvania and those living in Hungary. But I must add that the hospitality was warm for everyone regardless of the language spoken, as long as the person in question was able to win the villagers' trust and sympathy.

This openness of the village communities was not restricted to

Peter Korniss

the East-European villages. I sense the same trusting openness in a classical photographic essay whose location and title is *A Spanish Village*. A whole village seems to have opened up for W. Eugene Smith, who said the following about the birth of one of his famous pictures: 'In photographing the dead man and the mourners, I did not want to invade the privacy of the moment, yet I could see from the outside that it was a very moving and even beautiful moment. Finally, I approached the son who had come to the door and asked him if I could enter for a few moments and photograph. He said that he would be honoured.' This warm reception was not addressed to the photographer but to the guest, a guest who also happened to be a photographer.

What lead Smith to that Spanish village back in 1950? He wanted to cover a story about Spain for *Life Magazine*. He prepared himself for his task with his usual thoroughness. He read widely, took notes, and travelled 7,000 miles before he began to take his pictures in the small village of his choice. But why there? Because 'away from the publicized historical attractions, away from the unrepresentative disproportion of the main cities, away from the tourist landmarks, Spain is to be found. Spain is of its villages...' He was looking for the essence of Spain, and he found it in a tiny village that was closer to the past than the present.

I've seen almost 100 of his photographs (*Life* had published only 17) and it is clear to me from these that Smith veritably 'mapped out' the life of the village. He examined the villagers' realationship to the soil, to the animals, to work, power, holidays, religion – and to each other. His aim was nothing less than to show the most intimate interconnections of the world he was photographing. He was in search of typical situations and grabbed the moment that summarized and highlighted, the moment when something happened that shed light on everything else. Making the moment last: that is the unique possibility open to photography. Perhaps we photojournalists are best placed to appreciate this. For we know that we can condense relationships into a moment. Others can see that moment as coïncidental, but it gives general validity to what we wish to say.

I think this is why Smith's village seemed so familiar to me even though I had never been to Spain. I recognized the resemblance to East-European culture. The external elements were different, but the perennial struggle with the soil, the faith and traditions handed down from one generation to the next, had the same kind of definitive effect on the most basic aspects of their lives.

Struggle, everyday struggle – I could not escape it myself. After

Language, song and ritual express the identity of community.
Easter Monday in Szék, Rumania 1971.
PETER KORNISS, HUNGARY

Return to the source of energy from the past.
Immigrant worker András Skarbit at home, Hungary 1985.
PETER KORNISS, HUNGARY

Peter Korniss

The dramatic also has its place in documentary photography.
Szék, Rumania 1973.
PETER KORNISS, HUNGARY

The photojournalist as a conservator

all, I did not reach for my camera only when on holiday. The visits of the first few years turned into regular, longer visits. The warm hospitality of those who took me into their homes provided me with an inside view of their daily lives.

The pictures multiplied: children walking miles in the snow and mud to get to school, women spending the day weaving in dimly lit rooms, old people whose backs were bent from a life of labour. These pictures became more and more important to me until slowly, imperceptibly, nostalgia gave way to a more objective view of things.

This objectivity turned my attention to regions inhabited by non-Hungarians. I began to work in Rumanian, Slovak and Serb villages, both on weekdays and holidays. And as the pictures grew in number, they reminded me again of the old truth: the shared peasant fate, without regard to nationality.

Naturally, all this was not due to Smith's influence alone. His work merely strengthened my belief that even the most intricate relationships can be condensed into a picture, and underlined the realization that, as well as preserve the distinguishing folkloric features, I must also emphasize the common fate of my subjects.

I own a treasured photo album. It, too, is about people sharing a common fate. It's title is *A Vanished World*. I would prefer to call it *A World Condemned to Death*. In this album, Roman Vishniac reports on the lives of the Jewish communities of Eastern Europe in the thirties. When he took his photographs, Vishniac already knew that Nazism had condemned this world to annihilation, and this turned him into a man obsessed. Later he wrote: 'Why did I do it? A hidden camera to record the way of life of a people who had no desire to be captured on film may seem strange to you. Was it insane to cross into and out of the countries where my life was in danger every day? Whatever the question, my answer is the same: it had to be done.'

It is an unsettling book, perhaps because we know that those portrayed fell victim to inhumanity, almost to the last man. It is also an unsettling book because in it everything speaks of defencelessness. For me, the most shocking picture is the one of the little girl whose room is decorated with painted flowers. Vishniac wrote that the child had no shoes, she had to spend the winter at home, in her bed. A moving story. But even if we knew none of this, it would be enough to look at the little girl's wide-open eyes. I don't think I've ever seen so much sadness, fear and anxiety in the eyes of a child. They spoke of centuries of bitterness.

Peter Korniss

Vishniac knew that he was looking back in time, that it is the past he saw and the past he helped others to see. About the birth of the picture taken on the corner of Isaac Street in the Jewish quarter of Cracov he wrote: 'At that moment I had the feeling that the centuries had moved backward; that I was in 1500 and every man going by belonged to this time.'

This timelessness radiates from all his photographs of everyday life. It came from the wise rabbis, the children going through the Talmud, and the pictures taken of religious gatherings. The religion that made these communities survive through the centuries is ancient beyond our imagination.

In the face of fascism Vishniac could do only what a photographer must. 'I knew it was my task to make certain that this vanished world did not totally disappear,' he wrote. So he preserved it in his book.

And now I think it is time I explained why the task of preservation is so important to a Hungarian photojournalist. Small nations are always more sensitive than others about protecting their national identity. They nurse their traditions and watch over their culture, for it actually is their existence, their survival that is at stake. In 1788, the German poet Herder wrote the following about the Hungarians: 'They are living here now, among the Slavs, Germans, Rumanians and other peoples, as the smallest population group, and centuries from now, perhaps their language, too, will be lost to memory.' It is understandable that such fears only fuelled the general apprehension. In any case, it is a historical fact that for centuries Hungary was dependent on foreign powers; it was only able to protect its existence as a nation by preserving its language and culture. Thus, the values from our past have always been of special importance to us.

The man who collects folk music also saves the past for the present. In the face of Herder's prophecy, Béla Bartók preserved our musical vernacular for us. For 20 years he spent a great deal of energy in tracing and noting down our ancient peasant music. Furthermore, he did most of his collecting in Transsylvania, where he could still find original folk music in its uncorrupted form. I too began to photograph what was left of the old peasant world there, though at a much later point in time. I have to admit that Bartók's example was an inspiration.

From a professional point of view Transsylvania was an unparalleled source of riches, not only because in some places its geographical and national isolation and its backward agricultural con-

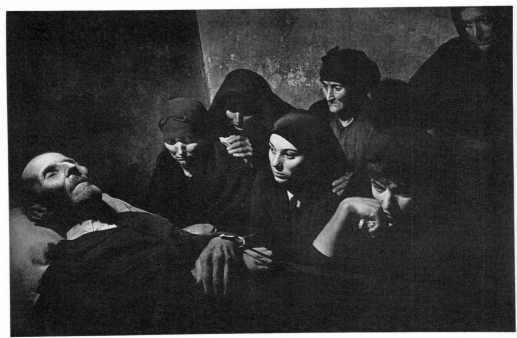

It was not the photographer who was the guest, the guest happened to be a photographer.
Spanish village, 1951.
W. EUGENE SMITH, USA

Peter Korniss

ditions had preserved the past with fewer changes, but also because in a minority situation a people's inclination for self-preservation is much more pronounced. They know that language, song, ritual, ceremony, and even handiwork are the carriers of their identity. For those living as a minority, it is not a theoretical but a practical and well-tried truth that culture is a right – the right to self-preservation, the right to survival. This thought also strengthened my belief that photography must contribute to the task of preservation.

But what is it that photography can do for the cause? What is it that *only* photography can do? Scientific knowledge and literature can be published in books, castles and palaces can be restored, dilapidated houses can be reconstructed in outdoor village museums, the props of daily life – the furniture, clothes and utensils – can be displayed in museums and the human voice, songs and music can be reproduced on tape. I realize that all these examples reflect apects of man. But man himself can be made visible only through photography, the vehicle that can present him most faithfully. And in the final analysis *he* is most important – he and the human condition.

The conclusion is simple. The photographic essay wishing to present a culture, a vanishing culture, must first and foremost present man, and through him his culture. For it is he who lives it and endows it with substance.

This human element is what makes the photographer's task most difficult. Every experienced photojournalist knows that it is the most incalculable factor in photography, even though it is also the most inspiring. Not the carving on the tombstone but the woman lying on it, her gesture and posture, those are the eternal movements of an ancient folk dance.

How we approach our human subject is a matter of individual preference. There are as many possible solutions as there are photojournalists, situations, and cultures. Vishniac said: 'The first condition is, not to let people know that you are taking a picture. You must take the picture as it is. Only then do you get a little piece of life.'

Vishniac made a virtue (and what is more, a theory) of necessity; after all, as his writings reveal, his methods were dictated by circumstance. The people in his pictures, not to mention the authorities, were against his taking them. That is why he needed the hidden camera, and that is how the method Vishniac called 'the invisible approach' was born. But his attitude is more important than his

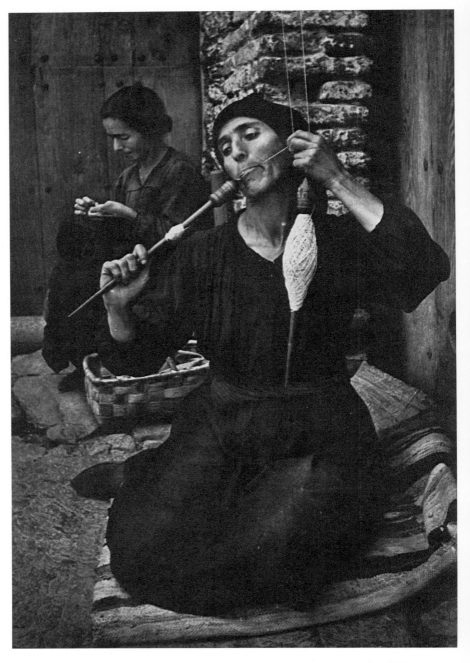

I felt familiar with Smith's Spanish village. His photos have a universal validity.
Spanish Village, 1951.
W. EUGENE SMITH, USA

Peter Korniss

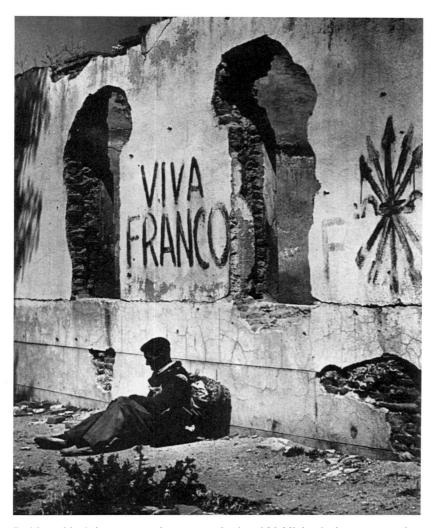

Smith grabbed the moment that summarized and highlighted, the moment when something happened that shed light on everything else.
Spanish Village, 1951.
W. EUGENE SMITH, USA

The photojournalist as a conservator

method. He was not an outsider. He found and recognized his own fate in the fate of others. And this approach can never be called invisible!

Legends abound about W. Eugene Smith's conduct. But nothing says as much about his ability to get through to people as his own pictures. He must have had a difficult time in that Spanish village, where the language and the culture were alien to him. Yet I feel as if the people had formed an alliance with him, an alliance in the service of a good cause. Trust is not placed in the photographer, but in the man. If he does not regard the people in his pictures as mere subjects or themes, if he does not intrude and is not tactless or agressive, if the lives of others honestly interest him, they will feel this and accept him. And after a time the presence of the camera will be as natural to them as the spade, hoe, and other tools in their own hands.

I have slightly altered Robert Capa's famous words for my own benefit: 'If your pictures aren't good enough, you aren't close enough to the *person*.'

I must admit that it was not difficult to be close to these people. And with the passage of years I noticed that the rich communal and personal relationships radiated something of their warmth towards me, too. This realization shaped the last phase of my work. The countless moments of empathy and rethinking brought the lesson from within.

Let me explain. I could not regard the recurring motifs of interconnection as something accidental in the scenes played out before my eyes. The groups of children, walking hand in hand, the lines of women holding on to each other, the girls strolling arm, the young men with their arms on each other's shoulders – this was the choreography of their culture. It expressed their belonging in a physical manner. For culture is not a haphazard conglomeration of phenomena, but a coherent system.

I had known before that the essence of the holidays and ceremonies lay in people being together. I could feel its strength and beauty. But at last I understood that there was more at stake: the community, which preserved tradition and pervaded the entirety of their lives. It educated, guided, helped, penalized and supported. It created a system of values. It also strengthened the bonds of belonging that made the hardships of life a little easier to bear. For the community saved the individual from the feeling that he must face his fate alone.

I felt that this, too, had to be said, especially because by the mid-

Peter Korniss

seventies, a new feeling was in the air in Hungary. A long-forgotten interest had flared up in our past, history, and culture. And with this we also realized something we had missed before, though perhaps not consciously: the importance of interpersonal and communal relationships.

The photographs of the villages of Transsylvania belonged to this period of increasing interest. They brought news of the Hungarians of Rumania, who still preserved their traditional culture. And they also brought news, at least I very much hope that they did, of the human values that must be preserved along with tradition.

A futile dream? If so, I am still dreaming. For like it or not, though press photography is concerned with the present, it is made for the future as well. In the future, the tiny photograph mosaics will help us reconstruct the past – the past which always has been a lesson for the future.

I am confident that every photojournalist is familiar with this feeling, even if he keeps it a secret. W. Eugene Smith expressed it most beautifully: 'Each time I pressed the shutter release it was a shouted condemnation, hurled with the hope that the picture might survive through the years, with the hope that it might echo through the minds of men in the future – causing them caution and remembrance and realization.' I believe that this is the best definition of our joint responsibility.

OLGA SUSLOVA

Photojournalism in the Soviet Press

OLGA SUSLOVA STUDIED AT THE INSTITUTE FOR FOREIGN LANGUAGES IN MOSCOW. FOR
TWENTY YEARS, SHE WAS AN EDITOR OF *SOVIET WOMAN*'S ENGLISH EDITION AND SINCE
1977 SHE IS THE EDITOR IN CHIEF OF THE ENGLISH EDITION OF *SOVIET PHOTO*. SHE IS
ALSO ACTIVE IN THE TRADES UNION AS THE VICE-PRESIDENT OF THE PHOTOGRAPHY
DEPARTMENT OF THE UNION OF JOURNALISTS. IN HER CONTRIBUTION SHE SKETCHES
THE CHARACTER OF SOVIET PHOTOJOURNALISM AND COMPARES IT WITH THAT OF THE
WEST.

Press photography is a type of visual information – the 'elder sister'
of cinematography and television. At a time when these new media
flourish and have phenomenal prospects, they still have to reckon
with the fact that their elder sister has no intention of retiring, well-
earned though retirement may be. She will continue to wield
authority in the family of information media and technical arts well
into the foreseeable future.

Theoreticians give a number of reasons for the viability of pho-
tography, including that, unlike the cinema and television, it is
capable of implementing the call of Goethe's *Faust*: 'Stay, sleeping
moment, you're divine!' But more exact and truer to the German
translation of the underlying idea of Faust's brilliant 'stay', is 'con-
tinue', 'pause', 'wait a while'... Seen in this light, would not this cir-
cumstance help us to cast doubt on the prevailing notion of the ax-
iomatic static nature of the picture as distinct from the dynamism
of cinema and television images? Instead of comparing photo-
graphs with wax figures such as we find at Madame Tussaud's, it
would be better to keep in mind that thanks to their static nature,
pictures are capable of registering moments filled with the vital
juices of our fast-moving time.

The present worldwide interest in retrospective photography
would hardly have reached such an unprecedented scale if we had
approached photography as being only a means of establishing a
fact, of giving an idea of some individual, concrete aspect of life.
Perhaps it is because photography is capable not only of recording
the facts of reality, but also of interpreting phenomena of social and

public life, of disclosing something typical in these phenomena and determining the nature of their relation with other phenomena of reality, that the pulsating life of long-gone years has been prolonged to our day.

In this connection it will not be amiss to note the character of photographic work in the first years of Soviet photojournalism, of which, regrettably, little is known in the West. Yet it was the Soviet photojournalists of the 1920s and 30s who, thanks to their grasp of the essence of social phenomena, were able to bring them to the present-day viewer in all their depth. We cite but one name from among the many talented reporters of those years: Arkadi Shaikhet. He excelled not only in interpreting and registering a certain event – no matter how significant – or portraying some hero of the time – no matter how famous – but also in grasping the quintessence of a social phenomenon, typified by this event as a generalized symbol, for which the given event could serve as a symbol and a confirmation. Shaikhet's classic *Lenin's Lamp* not merely records the fact of the appearance of electricity in the houses of the peasants. It is an emotionally coloured, deeply moving event, behind which we see the tenor of life at the time when the country took the road of electrification, when every step on that road was incredibly difficult, and each victory was celebrated with a nation-wide holiday.

Each of Shaikhet's compositionally perfect, masterfully made reportages contains a protracted, prolonged moment of the social life of those years, coloured by the author's attitude towards it: the peasants' trust in Soviet power; peasants in the reception room of President M. Kalinin; state concern for the children who were orphaned in the First World War and the civil war; the bathing of an orphan on entering the children's home; the emancipation of the former outlying colonial regions of Russia; the enthusiasm of the joint construction of the Turkestan-Siberian Railway by people of different nationalities...

Was the creativity of Arkadi Shaikhet and his fellow press photographers as new a word in Soviet photojournalism of the 1920s and 30s as, say, that of Alexander Rodchenko, a photo artist who may rightly be considered the founder of a new aesthetics of photography, born out of protest to the canons of the imitative pictorial (photographic) art? The question may appear rhetorical. Innovation, understandably, may be displayed not only in the search for forms. Incidentally, it is to Alexander Rodchenko that Soviet photography owes its many creative discoveries in the sphere of social content, which acquired new aesthetic meaning in an innovative form.

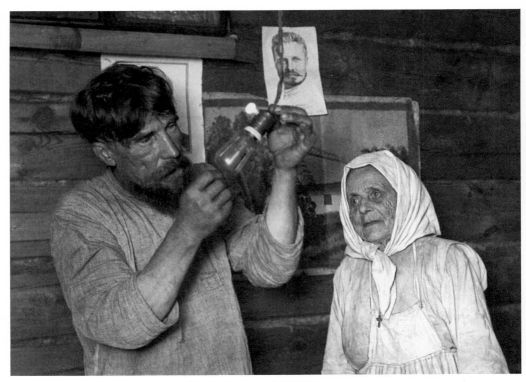

Lenin's lamp.
ARKADI SHAIKET, USSR, 1926

The first train of the Turkoman-
Siberia railway.
MAX ALPERT, USSR, 1929

Olga Suslova

The young pioneer.
ALEXANDER RODCHENKO, USSR, 1930

Photojournalism in the Soviet Press

Among journalists there was quite a lot of opposition to some of the purely formal strivings of Rodchenko and his followers. But today, after the passage of time, they definitely occupied their own place within journalism, for the most important thing for all the quarreling creative groups of those years was to adhere to a single firm and invincible world outlook that united the photographers of the young Land of the Soviets. On this platform there was a place for Rodchenko, whose personality is as significant in the photography of those years as that of Sergei Eisenstein in the cinema, Vladimir Mayakovsky in poetry, Dmitry Shostakovich in music, Vsevolod Meyerhold in the theatre, and a host of other avant-garde artists. Max Alpert's first multi-picture photographic works, Victor Temin's unique photo information of events, and Arkadi Shaikhet's firm alloy of publicist reporting and photographic art also belong on this platform. Masters with a vivid creative individuality, they shaped a new social Soviet photography born of the revolution.

In what way did this photography differ from the photojournalism of the West? Without any pretence of an all-round explanation of the question, which is worthy of serious theoretical research, I shall try to express my opinion in general terms.

As we all know, to strive for a genuine, 'unprocessed' reality in historical periods of social upheaval and change is a formidable task. In those times, it is the photographic document which can quench the thirst for the unvarnished truth. Moreover, the conventional nature of photography itself essentially creates a distance between the image and reality, a distance of which we are aware but to which we seem to attach little importance.

In the years when Soviet photojournalism was born, a host of talented progressive photographers, masters of social photography such as Louis Hein, Dorothy Lange and others, were doing good work in the West. They have gone down in the annals of world photography thanks to their selfless activity aimed at improving the lives of American workers and farmers who were suffering from hunger, unemployment, and ruin. The moral character of their activity was clearly manifested in their classic photographs, but the photographic creed of these masters also is very important to us. That is why we remember today Dorothy Lange's words: that the photo eye should be all-pervading, very close to our true essence, and that it should possess a total social adequacy. We also recall the words of Louis Hein: 'There were two things I wanted to do in my life: I wanted to show what should be remedied and to show what should be assessed according to its merit.'

Olga Suslova

Did the Soviet photography of the first years of the revolution possess 'total social adequacy'? Undoubtedly it did, though its character and aims differ from those set themselves by American photographers. The sharp social nature of the publicist photography of the first years of the October Revolution was unique not only in content, but also in its relations with the mass of the people. Only two illustrated publications were put out in the country at the time, but even without the aid of the press, photography addressed the new viewers – most of whom were semi-literate workers, peasants and Red Army men – from exhibition stands and show-cases in city streets and squares, at railway stations and river ports, at plants, factories and Red Army clubs.

What the young Soviet state needed above all was educational, agitational and propagandist photography, beginning with informative items, photo information about current events and facts. But it was in those years that the People's Commissar of Education, A. Lunacharsky, reminded us that 'after all the apparatus in our brain is immensely superior to the camera, for it is capable of synthesizing, thinking and feeling. A picture is not merely a chemical disc, but a tremendous act of socio-psychological creativity.'

Apparently it is this circumstance that makes it possible for us today to perceive the objective news items of those distant years as a subjective report that is marked by the author's vivid individuality. His contemporaries may have felt they received enough information from the photographs. In any case, they made no attempt to expand the framework of the picture in order to learn more than the nominal about the event. With our present view of those pictures we see many more signs of the time and we get the impression that the author of the photo can supply the answers to many of our questions. He seems to prompt us, to suggest an idea. This is a case of today's viewer becoming to a certain extent a co-author of the picture, adding to it his share of subjectivity which the photo chronicler may have lacked. Perhaps our present-day concept of its documentary pictorial character explains the fact that these photographs today are occasionally perceived as genuine photographic art?

However, let us return to the question of 'total social adequacy'. For Soviet photography this applies, in that its major, life-asserting, optimistic character fully corresponded to the life and mood of millions of Soviet people, and continues to do so. The very fact of creating the world's first workers' and peasants' state, the affirmation of social justice, the constant concern for the growth of the eco-

The death of a soldier.
ANATOLI GARANIN, USSR, 1941

Olga Suslova

Astronaut Yuri Gagarin.
VALERI GENDE-ROTE, USSR

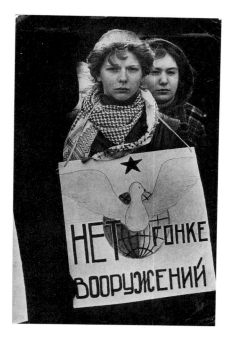

The young want peace.
ALEXANDER ZEMLANICHENKO, USSR

nomic might of the proletarian state, the positive assessment of advanced experience in the productive and cultural life of society, the endeavour to enhance the spiritual growth of Soviet people, the affirmation of the new morals of socialist society – all this has, in a broad sense, been the key subject of Soviet photojournalism and remains so to this day. From the first years of the revolution it occupies the position of an advising, constructive critic, a consultant and propagandist of advanced social experience, which does not exclude an analytical comprehension and a critical analysis of the negative phenomena of the social life of society through photojournalism. Therein lies its frank tendentiousness, its ideological platform, and, finally, its 'total social adequacy'.

Under the circumstances it is easy to imagine how alien and unacceptable for Soviet photojournalism – and for journalism as a whole – the postulates of the bourgeois press were, as expressed by Lord Northcliffe in expounding the laws of selling newspapers: 'If a dog bites a man, that's not news. But if a man bites a dog, then it's news... War is a bestseller, i.e. the best motive force of trade... Second to war are sex and crime...'

The interest in acts of violence, crime and catastrophy encouraged by the demonstration of naturalistic detail inherent to Western photography, and the thirst for scandalous sensationalism nurtured by the daily depiction of such events and facts in the illustrated press of the West, as well as in the cinema and on television, as a rule, neutralize aesthetic feeling. They are habitforming and breed indifference. But that is not the worst result. In the first place the savouring of violence and brutality should arouse universal alarm in view of the obvious baneful influence on children and adolescents. In each individual case it is essential to remember the motivation for the publication of such photographs.

It should be borne in mind how hard it is to overcome the contradiction between the importance and necessity of disclosing and showing the evils of human existence in order to cure them and of observing them for the sake of excitement – cheap sensationalism that is unworthy of a civilized human being. Evidently here runs the watershed between progressive journalists and those who at any moment may renounce any moral category for the sake of monetary gain or private ambition.

Leaving aside Lord Northcliffe's aggressively cynical pronouncements on the influence of sex and crime on the public, let us deal with the thesis: 'War is a bestseller'. This thesis is opposed not only by those who remember the work of Soviet photographers during

Olga Suslova

the Great Patriotic War against Nazism (1941-1945), it is also opposed by the former war photographers themselves, and by those who died in the war fighting side by side with the Soviet soldiers and officers. To this day Soviet war photography has not been given the credit it deserves in the West. One can say that the best pictures taken by such reporters as Ivan Shagin, Georgi Petrusov, Evgeni Khaldei, Anatoli Garanin, Dmitri Baltermantz, Victor Temin and a host of others can rightly be considered masterpieces of world war reporting.

What is the fundamental distinction between Soviet war photojournalism and a great many war pictures created by Western reporters, and what did it have in common with the best works of progressive photographers the world over? What all these photographers have in common is their anti-war tenor, however paradoxical this may sound. Robert Capa's photos, like those of Anatoli Garanin or Dmitri Baltermantz, are filled with humanism; they tell people about how unnatural war is for human existence, they call for banning war in general. But in order to correctly and justly evaluate the professional exploit and humanistic tendency of Soviet war photojournalism, we should recall that, unlike the majority of Western reporters, Soviet photo reporters were not only witnesses, but also participants in the war, that they defended with arms in hand the honour and dignity of their homeland. With their pictures they called on people to fight against Nazism, while retaining the highest moral and ethical concepts of universal humanism. This was shown most graphically when Soviet reporters brought back news about the liberation of other nations who were oppressed by the Nazis, when the feeling of international and humanistic traditions prevailed over the natural desire for revenge and exhilaration with the victory over ammosity. Wrath and bitterness, the joy of liberation, courage and pride in one's people combine to form the *leitmotiv* of Soviet war reportage. It goes without saying this has nothing in common with the notion of war as a bestseller, with the desire to represent a soldier as a superman, as an unsurpassed master of killing. However, that is the impression conveyed in the photographs of US soldiers taken by American reporters in Vietnam, which depict war as a 'masculine sport'.

It is difficult to establish permissible, ethical norms which separate the truthfulness of a realistic depiction of events and a naturalistic recording of concrete facts in war photography, in view of the extraordinary conditions. In such situations great importance is attached to the context. The context of all Soviet war photojour-

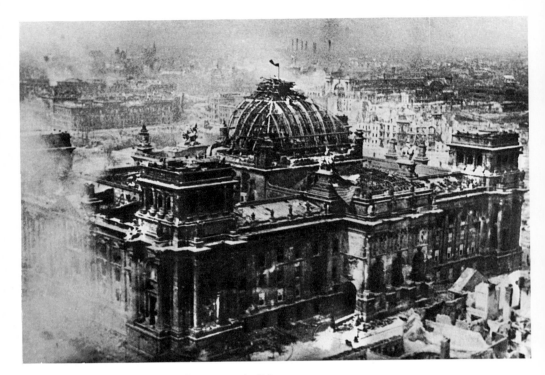

The flag on the parliamentary building, 1945.
VICTOR TEMIN, USSR

Olga Suslova

nalism was its obvious anti-war direction, the affirmation of the ideas of humanism and anti-fascism. That is, as it were, the general premise. But from the professional viewpoint it should be recalled that the specifics of journalistic photography lie in its unbreakable link with the text. This should always be obvious, but particularly in the case of pictures created in extraordinary conditions. It is the caption that gives the photograph the essential identity of meaning, even in the eyes of recipients who adhere to an opposite world outlook, and who have the most diverse social experiences and intellectual levels.

Why is this so important? The point is that those who attempt to portray the camera lens as an 'objective' recorder are absolutely in the wrong. The choice of subject, angle of photography, framing and selection of pictures for publication, lay-out on a newspaper or magazine page together with the text – all these are creative processes which reflect directly the world outlook of the author and publisher. A photo image created in a fraction of a second cannot be 'objective' and often turns out to be incapable of conveying the essence of the depicted events, facts, or the character of a person. As Fyodor Dostoyevsky justly wrote, 'At a given moment Napoleon may appear stupid in a photograph, and Bismarck benevolent'.

With the appearance of miniature cameras and highly sensitive materials photo reporters began making photo reports as they went along instead of staying with prearranged photography. This made it possible for photography to reach a new creative stage in the press, for the photo report is capable of creating an illusion of veracity. An illusion, indeed, for the photo report may contain no more truth, or falsehood, than a staged photograph, although a photo report is always preferable in photojournalism, since it corresponds better to the documentary character of the photographic image.

Probably the most difficult thing in a picture report, even if accompanied by a caption, is to express the author's attitude to the event or phenomenon, i.e. to give his own opinion. The more originally the details of events are presented, the more vivid the associations aroused by the author in connection with a concrete event, fact of phenomenon, the more expressive and synonymous with the author's position a report becomes. Tremendous importance attaches to the consecutive selection of pictures from the total taken by the reporter. In many cases the tendency of the selection and its direction become apparent precisely at this stage, though many claim that they may also manifest themselves when the picture is

taken. It is in the selection that the author's opinion of the object is commensurate with the image itself.

Photojournalism has long since learned not to restrict itself to the 'first plane of events' which is quite sufficient for information purposes. The nature of the report, like that of a photographic essay, feature and other multi-picture compositions, demands conceptualism, confliction. A reporter's professional skill helps him to solve these problems, but certain methods, especially the so-called 'hidden camera', demand highly ethical norms of behaviour, a subject which merits special attention.

The 'hidden camera' makes it possible to penetrate a person's spiritual life, to peer into depths that are inaccessible to others and are carefully guarded against any inopportune outside interference. Observing people and spying on them is by no means the same thing. In making this point, a Soviet cinema and photography theoretician said, paraphrasing a well-known Russian saying: 'Show me how you use a "hidden camera", and I'll tell you who you are . . .' Like an ordinary camera, the 'hidden camera' is a reporter's instrument, but it should be handled with the same skill and caution, the same measure of moral responsibility, as a surgeon uses his scalpel.

The contemporary photo reporter has a great variety of equipment at his disposal. It all depends on how and in the name of what it is used. For the Soviet photojournalists that problem was solved long ago. It is used in the name of the ideas of socialism, in the name of the prosperity and happy life of the people, in the name of the material and spiritual growth of the Soviet people, and in the name of the friendship and mutual understanding of the peoples of different countries.

In comparing their creative striving with progressive Western photographers, Soviet photojournalists find that they have much in common as far as their attitude to universal problems is concerned. They show great respect and understanding for the creative heritage of the US photographers mentioned above, for such names as Robert Capa or Eugene Smith, for the war reporters whose work helped stop the 'dirty war' in Vietnam and for the photographers who today work towards general disarmament and against nuclear war.

A group of photographers whose pictures dealt with acute social problems was once given the epithet 'concerned photographers'. In our day the world press needs 'concerned photographers' more than ever before. This term should be included in the annals of the world's photojournalists, thereby acquiring an even broader mean-

Olga Suslova

ing. They are the authors of socially-orientated photography, who expose the brutal exploitation of people and the bestiality of fascism, and who arouse compassion for the starving, the homeless and the unemployed. Let each one who calls himself 'concerned' be able to say that the shutter of his camera is working first of all for peace on earth. Today progressive photojournalists, irrespective of their world outlook and the narrow interests of some publications, must bear in mind the priority of universal interests. This is essential at a time when the threat of destruction of all life is looming over the planet.

Like their colleagues in the other socialist countries, Soviet photojournalists use their skill and talent to urge people to try to understand each other by appealing to the best human traits: benevolence, tolerance and philanthropy, and to come out against national discord and racial discrimination. It should be noted that photography, a means of communication that knows no language barrier, is working for peace probably better and more convincingly than any other mass media.

'A person who looks at life through the eye of a camera is always, ultimately, looking at history.' These words come from the well-known Soviet writer Konstantin Simonov. Today's global interest in retrospective photography, mentioned above, gives us food for thought: what kind of visual information about time and themselves will the people of the 20th century leave to their descendants in the next millennium? It is by no means an idle question. If photojournalism, together with other mass media, does not become a herald of peace and mutual understanding between the peoples, if it does not come out for disarmament and against the outbreak of nuclear war, then it may well be that our descendants, to our great regret, will no longer need our present-day visual information – or anything else for that matter.

L. FRITZ GRUBER

Information for a Martian

THE 'MAN FROM MARS' WHOM L. FRITZ GRUBER DIGS UP FOR US IS MORE OR LESS
PLAYED OUT IN SCIENCE FICTION LITERATURE, BUT HERE FULFILS AN EXTREMELY USE-
FUL FUNCTION THROUGH HIS SOCRATIC BEHAVIOUR AS A MAN IGNORANT OF MOST
THINGS, ESPECIALLY PHOTOJOURNALISM. PROFESSOR GRUBER (1908), WAS THE DRIV-
ING FORCE BEHIND ALMOST 300 INTERNATIONAL EXHIBITIONS OF PHOTOGRAPHS FOR
PHOTOKINA IN COLOGNE (1950-1980). HIS COLLECTION OF PHOTOGRAPHS IS AT THE
WALLRAF-RICHARTZ-MUSEUM / MUSEUM LUDWIG, THE MUSEUM OF MODERN ART IN
COLOGNE. HE IS AN OLD FRIEND OF WORLD PRESS PHOTO HOLLAND, AS IS CLEAR FROM
WHAT HE WRITES BELOW.

Let us suppose that an inhabitant of Mars would wish to visit the
planet Earth, and that the World Press Photo annuals were his only
source of information about what things are like down here.

After having read these books, he would be bewildered and be-
come reluctant to carry out his plan. He would conclude that earth-
lings are a misbred, mad creation, with exalted faces and excited
gestures, who indulge in murder, war and hatred, and whose sense
of humour surfaces only on rare occasions. Is this our world? The
old reproach that the selection of the World Press Photo contests
shows more negative than positive images still seems valid. Is it a
fair, justified criticism, which detracts from the effort that has been
made in the last 30 years? I think not.

The 'picture out of a machine', also known as photography, has
many faces and more than one name. Its applications range from
objective scientific images to the extreme, subjective visions of
camera artists. Together, in all their applications, they give a com-
plete, pictorial documentation, a record of what we live and strive
for. So where does photojournalism come in? In order to find out
and put it in the right perspective, we must scan the entire spectrum
of photography. Its scientific applications give us insight into hid-
den facts, without which our lives would be less safe. Modern medi-
cine offers abundant proof of the blessings of photography. But
there are many more applications in technology, known only to ex-

L. Fritz Gruber

perts, which broaden our knowledge and form a foundation for developments that may justly be called progress. The achievements of photography in that field, which are largely concealed from the average person, cannot be stressed strongly enough. Entire libraries filled with learned books and journals are available to the student, engineer, or researcher, and steps towards further progress are taken every day.

Let us now switch to the other extreme, to artistic photography. Everybody knows that photography can only show what is seen by the camera; it is tied to reality. When it was invented nearly 150 years ago, the praise of its protagonists concentrated on the triumph that this was 'the pencil of nature', immortalizing the visible world by engraving its picture on to light-sensitive material. The camera seemed not to need an operator. What else could he or she do but point the lens towards a subject and release the shutter? No personal interference could improve the result. Or could it? Of course it could. First of all there was the choice of what was to be fixed in the frame, and there are other ways of influencing the final image, even without manual interference. Today photographs taken by masters of the camera fill museums, collections and galleries. They vary from exalted mirrors of reality to brilliant impressions and moving expressions, some of which can be difficult to decipher.

Confronted with the results of scientific photography on the one hand and creative photography on the other, our Martian would be unable to get a proper and complete idea of what goes on on our blue planet. After all both methods require the viewer to have a special affinity, or training, in order to appreciate the results. Still clutching the World Press Photo annuals, the Martian wonders what the ecstatic and strange race of beings shown in its pages, mostly in exceptional situations, might be.

He would be able to understand the images much better, and appreciate their value, if he were able, as we are, to see their counterparts. Millions of amateurs busy themselves day and night shooting snaps of what makes their lives worth living: their families and friends, their hobbies, their holidays – a mountain of innumerable visual fixations of people, landscapes, harmless everyday occurrences. With the exception of occasional exhibitions, these pictures are not usually on show to the public. They are preserved privately in albums, wallets and frames, and exchanged among friends and relatives. They are taken at one's leisure, without risk, as evidence of private joy and aspirations. They constitute the hidden, mostly

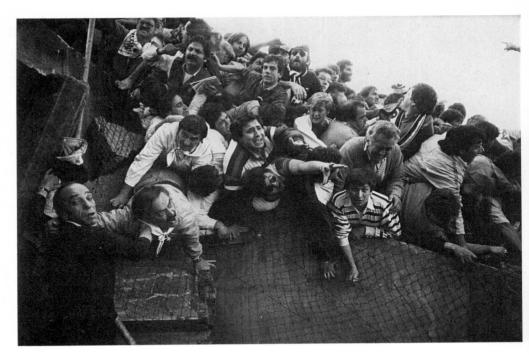

May 20, 1986: black Wednesday in Brussels' Heizel Stadium.
EAMONN MCCABE, ENGLAND (THE OBSERVER)

– high and low points of human behaviour.

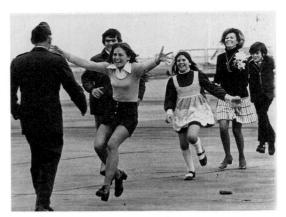

An American prisoner of war comes home from
Vietnam.
SAL VEDER, USA (AP), 1973

L. Fritz Gruber

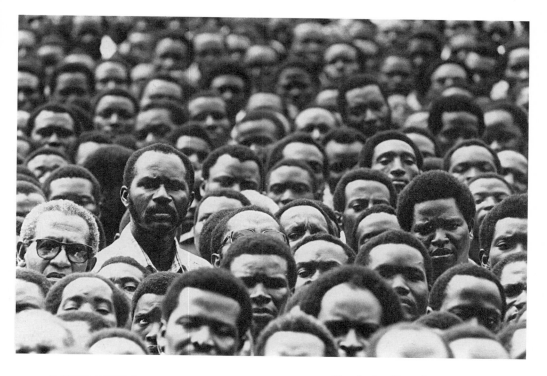

People in Uganda after
Tito Okello's coup.
SURESH KARAIDA,
ENGLAND (THE SUNDAY
TIMES), 1986

– photojournalism keeps
us awake and alert.

The parents of space
woman McAuliffe see the
Challenger explode.
JANET KNOTT, USA (THE
BOSTON GLOBE), 1986

Information for a Martian

peaceful world of our fellow citizens, a wealth of information hidden to the outside world. If only the Martian knew these private, and sometimes intimate, documents, these pictures of the ordinary, he would, like us, arrive at the proper appreciation of World Press photographs and of what photojournalists have done in the past and are still doing.

In contrast to the harmless 'sport' of amateurs, who perpetuate what they relish by taking their own photographs, the photojournalist is a professional, from whom we demand the extraordinary. He must go where the snapshooter does not. He must take risks, cope with difficulties, capture the sensational image which reveals more than any verbal description could ever do. Whereas the leisure-time photographer lives a carefree life while his film is being developed and printed, the stress-ridden professional has to obtain results that affect the editor of a newspaper or magazine, and through him the general public.

Once he knows all this, the Martian would understand that whatever the outcome of the World Press Photo contest, he sees only the highs and lows of human behavior, and the surprises of nature. He also learns that a distinct curiosity for misfortune, calamity and disaster always predominates. The amateur shows what happens often and is common, the professional presents what happens only once and stands out.

In the course of his study of back issues of World Press Photo contests, the Martian would wonder why, initially, the inhabitants of our globe appear only in black and white, while after 1981 they are presented in brilliant colours. Maybe someone could explain the problems of colour printing and console him by pointing out that the happy snapshooter has been able to capture the colours of the rainbow with his toy camera for much longer.

We would welcome a visitor from space, and would gladly show him or her the achievements of press photography. We would explain that photojournalists bring pictorial images of the most important world events into our homes. We savour the result of their endeavours daily, we owe them a debt of gratitude. The atrocities which they depict arouse in us the feeling that they should stop and that we should support all that is done towards this end. And the humorous pictures make us laugh, if only for a short respite.

As a confession to the Martian, we could tell him that these photographs are necessary to fight our complacency. That the photojournalist keeps us awake and aware. Or should we call him the press photographer? What is the difference? Typically, a press

L. Fritz Gruber

photographer is a 'one-picture man', who tries to concentrate in a single instant the gist of his visual message. It is mainly this category which the World Press Photo contest has selected and presented over three decades. In general terms, a journalist is someone writing for the day (jour is French for day), from whom a detailed written description is expected. A photojournalist on the other hand usually works for an illustrated magazine; he presents his journalistic message in a series of interconnected exposures. Even when they receive top prizes which put them in the limelight for a while, press photographers' names are soon forgotten. Among the photojournalists, however, there are some who have established international fame, to the point where their work is thought worth collecting and exhibiting in museums.

Now fully instructed about the various applications of photography, the Martian starts to evaluate and appreciate the great services which press photographers and photojournalists render to mankind. As he contemplates this merit, questions might occur to him which he wants to discuss with us. If he knows of television, he would ask: 'Does not TV make photography obsolete?' We would answer: 'Features on the small screen come and go. They are soon overtaken by new ones, and thus soon forgotten. But there always has been, and still is, a requirement for an image that remains, a valid picture that can be looked at again and again, which permits one to study it in detail and at leisure. If the man behind the camera is a master of his craft, he is able to freeze that single decisive, climactic moment, which in a way also suggests what went before and what may follow. His ability and experience enable him to pinpoint that moment. The photographs selected by the independent international jury of World Press Photo – a United Nations of editors, agencies and other experts from the five continents – displayed in exhibitions and preserved in the annuals, are all proof of the extraordinary proficiency of the photographers who took them.

We could also explain to the Martian that there is a certain magic to photography, which seems doubly active in news pictures. Life around us is in constant flow. The mere fact that someone cuts a frame out of its surroundings, fixing what is inside, accentuates the purport which is chosen, solidifying it, making it last. Philosophical findings about this phenomenon state that thus even ugly subjects are raised to a certain beauty. As we have already seen, this is particularly true for press photography, even more so in colour. Not only does colour, when concentrated in a reduced square, gain in intensity, but it is also enhanced by the printing process. Thus the

Photojournalism – both sides of life.
Prince William of England, a not-too-enthusiastic page for his uncle Prince Andrew.
BRENDAN MONKS, ENGLAND (DAILY MIRROR), 1986

L. Fritz Gruber

A courageous way of protesting against nucleair weapons in the harbour of Sidney.
ROBERT PEARCE, AUSTRALIA (JOHN FAIRFAX & SONS), 1986

result offers a dramatic overemphasis. Such a press photograph just strikes out at us, we cannot escape its message. The exaggeration reveals the true impact.

All these findings must be explained to the visitor from Mars. And of course I would add some personal recollections. I would say that, as the person who conceived and executed the cultural picture shows of the Photokina, the World Photography Fair which has been held in Cologne since 1950, I became intrigued by an event called World Press Photo as soon as it started in 1956, and that I became its adviser and collaborator, as jury member and otherwise. A decade later, in 1966, I staged an exhibition entitled *Ten Years of World Press Photo* in honour of the competition, for which I tried to reassemble the winners of the top prizes of past contests. It soon became apparent how difficult and dangerous the profession of press photographer is. Names famous for a year had disappeared, people had switched to other publications or left their jobs, some had been severely wounded, others had been killed in action. Nevertheless, we got the exhibition off the ground, and it was a brilliant and deserved tribute to World Press Photo and its contributors. Later, it went on tour through Europe, with the Balkans as its final stop.

In the following years World Press Photo kept on going splendidly. Still organized by photojournalists themselves, as it had been from the beginning, it was now supported by private and public sponsors. Thus an invaluable, hard-hitting but necessary visual record of 'human beings', or 'life on earth', was attained.

In 1978 we once more staged a selection from World Press Photo pictures at Photokina, this time under the unusual title *The 'Unknown' Press Photo*. The catalogue read: 'Press photos are documents of war and destruction, of violence, terror and suffering.' This widely held belief is a fallacy. Instead, it is a fact that most press photographs are characterized by the representation of positive phenomena of human coexistence. Photokina has made a selection of prize-winning photos taken from the yearbooks 1971-1977. In these competitions photos are invited in any of ten categories, of which only a few encourage photos with a negative message to be submitted. Thus the question arises why always those photos are selected for publication which do not, as in the majority of cases, depict a friendly, positive world, but the horrifying aspects instead. The answer might be that unpleasantness and misfortune 'sell' better than the portrayal of goodness, and that curiosity is best satisfied by negative things. Thus this is a feature of journalism which is in fact not representative. An effort is being made to correct it by

L. Fritz Gruber

means of the Photokina exhibition *The 'Unknown' Press Photo*.

The few illustrations that were shown in the catalogue did indeed prove that photojournalists portray both sides of our lives, and World Press Photo or its contributors cannot be blamed for the fact that whenever the winners are announced, newspapers, magazines and other publications only reproduce the controversial ones. Thus Photokina was glad to see the smiles on the faces of many visitors when this exhibition put matters right.

Unfortunately no visitor from Mars could be spotted at the time. Should one turn up now, then we could correct a misconception. We would draw his special attention to the sunny side of the press photographers' work, which has been unfairly overshadowed by bad news. I am sure the Martian would be deeply impressed by the overall achievements of photojournalists and World Press Photo. Maybe, if there is no such competition as World Press Photo on his planet, the example successfully set in Holland would be followed there.

Accentuated photographic commitment.
Ireland, 1979.
KOEN WESSING, THE NETHERLANDS,
COLLECTION STEDELIJK MUSEUM, AMSTERDAM

L. Fritz Gruber

ELS BARENTS

The snowball effect of documentary photography

ELS BARENTS (1949) IS THE CUSTODIAN OF THE PHOTOGRAPHY COLLECTION OF THE
STEDELIJK MUSEUM IN AMSTERDAM. HER ESSAY DESCRIBES THE DEVELOPMENT OF
DOCUMENTARY PHOTOGRAPHY IN EUROPE AND ATTEMPTS TO GIVE A DEFINITION OF
THE NOTION. BARENTS TESTS PHOTOJOURNALISM AGAINST MUSEOLOGICAL STAN-
DARDS AND CONCLUDES THAT THE CONCEPT OF A MUSEUM COLLECTION OF PHOTO-
JOURNALISM, DESPITE THE NECESSARILY SEVERE SELECTION, WILL HAVE TO BE BASED
ON THE BALANCED RANGE OF A VARIETY OF QUALITIES.

The documentation of reality is inherent to the photographic medi-
um. Like any other medium, it possesses specific characteristics
with which to communicate. Many of the nineteenth-century pho-
tographs that are now so intensively collected for their artistic and
historical value, can thus also be classed as 'documentary'. The
term 'documentary photography' did not come into use until the
nineteen thirties, following the English film producer John Grier-
son (1898-1972) who thereby gave the photographic medium an es-
sentially new role. Basing himself on his study of the relationship
between mass media and public opinion, he drew a distinction be-
tween the Hollywood productions of that time, which had great
effect and influence but were artificial, and the so-called documen-
tary or topical films which took real rather than fictitious situations
as their starting point. Grierson believed that documentary films
should have educational value and should be as successful in being
persuasive and fascinating as the Hollywood films. In order to
achieve this aim he transferred, as it were, pieces of drama to the
documentary film. He believed it was possible to do this without
violating the educational character of the film, by 'a selective
dramatization of (nothing but) the facts, at the point of their human
consequences'[1]. However, his interpretation of the documentary
film also increased the risk of over-manipulation. Giving the – in
principle 'independent' – artistic product not only an informative
but, between the lines, also a propagandist function, made it possi-
ble for the documentary film to be used as a political instrument,
as indeed it was in the period between the two world wars.

Photojournalism avant la lettre.
Dutch immigrant family at
Ellis Island, 1908.
LEWIS HINE, USA.
COLLECTION STEDELIJK MUSEUM
AMSTERDAM

Hunger winter 1944.
EMMY ANDRIESSE, THE NETHERLANDS.
COLLECTION STEDELIJK MUSEUM
AMSTERDAM

Els Barents

The master photographer of unposed political events.
Le voilà! 1931.
DR. ERICH SALOMON, GERMANY

The snowball effect of documentary photography

It was not only Grierson who, through publications and films, indirectly helped to put documentary photography on the way. Towards the end of the nineteen twenties many social, cultural and political structures were in turmoil; the changes that were taking place formed rich material for the mass media (newspapers, magazines, films) which experienced a period of rapid growth both in the United States and Europe. For photographers these developments opened up a hitherto relatively new field of activity: photographic journalism. The journalistic form of documentary photography was not in itself unknown. The strategies developed earlier (1907) by Lewis Hine (1874-1940) for the benefit of the American 'National Child Labor Committee' showed an implicitly journalistic approach to his theme, which was that of child labour. But photography was now awarded a prominent place in the media, and that had not been the case before. It had always been customary to hire photographers only for specific assignments. They worked on a freelance basis for several principals at once. More and more with the increasing demand for exclusive pictures, photographers were appointed to permanent posts and became regular members of staff. Competition was fierce in those early days. This is evident, for instance, from letters written by the German photographer Dr Erich Salomon (1886-1944) in which he extolled the unique qualities of his photographs (above those of others) to various photo press agencies and editorial departments. In order to secure a firm position for oneself in the capricious market of that time, specialization was essential: Salomon presented himself as the master-photographer of unposed political events, in which he was closely followed by his compatriot Felix H. Mann; Robert Capa was known for his war photographs, Martin Munkacsi for the style and spontaneity of his fashion pictures, Edward Steichen for his fashionable high society portaits, etc. To become a photojournalist meant in those early pioneering days to opt for an adventurous, contemporary and exceedingly expansive profession. However, we know from Dr. Erich Salomon's letters that the financial reward for his activities often was not on a par whith his much-praised photojournalistic talent.[2]

The fact that photojournalism was able to develop so quickly was partly due to the creative input of picture-editors. They had a guiding and correcting influence on the work of photographers. In an article entitled 'Das Leben in Bildern' Kurt Korff, editor in chief of several journals including the *Berliner Illustrierte Zeitung* (Ullstein Verlag) analysed the new attitudes towards the making of illustrat-

Els Barents

ed magazines. The article was published in a special jubilee volume on the occasion of Ullstein's fiftieth anniversary (1927). Korff drew a comparison between films and illustrated magazines. He stressed the point that these magazines had only become visually more trenchant because of the new brand of picture editors, who had different views about the effect of published photographs. The credit could definitely not be given to text editors, who when choosing illustration for a text, only used the subject matter as their point of reference. Korff compared their function with that of film directors, because both had to have the ability to interpret life through pictures; they both had the liberty to choose the strongest visual shots and to determine their size and sequence. Korff described his function as that of a modern art director. He placed photographers lower in the hierarchy, so that with the addition of what Korff still called the 'künstlerische Beirat' (artistic adviser) the editorial team acquired a structure of interdependence between photographers and art directors. The cooperation between Korff and Salomon was a particularly creative one. There are, however, also countless examples of situations in which the photographer felt that his artistic integrity was being violated. For instance, the numerous confrontations between the photographers Dorothea Lange, Walker Evans and Roy Stryker have produced an interesting episode in the history of photography. From 1935-1942 Stryker was the coordinator of a group of photographers working on the 'Farm Security Administration' project. His aim was clear and can be expressed in very few words: social change. His distrust of the desire of these photographers not to work as a team but individually, stemmed from his wish to protect his own objectives, which were mainly political rather than aesthetic. Stryker did not want 'art' but a factual 'document'. The tense relations between him and his contributors led to permanent discord; Stryker even went so far as to dismiss Evans. Stryker distrusted any form of individual expression, which in his opinion detracted from the subject matter. It was of little importance to him that his views conflicted with the artistic integrity of his best photographers, who had observed the life of the impoverished farmers in the American Mid West more closely than he had done himself. It must be noted here that although this chapter in the history of photography shows Stryker in a somewhat negative light, it says little or nothing about how much art directors did in fact influence the quality of an assignment. As in film, photojournalism was often team work, in which a strict selection took place before any pages were printed. This did not detract from the quality of the end product, though in later

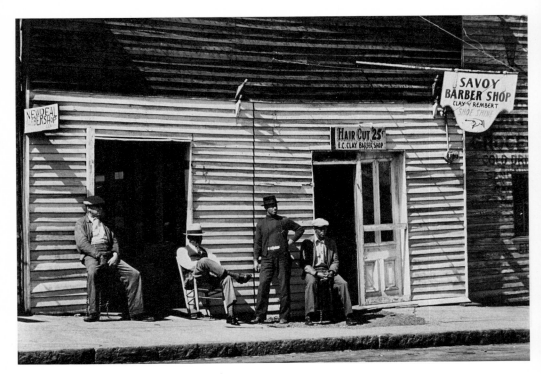

New Deal barbershop, 1936.
WALKER EVANS, USA
COLLECTION STEDELIJK MUSEUM AMSTERDAM

Els Barents

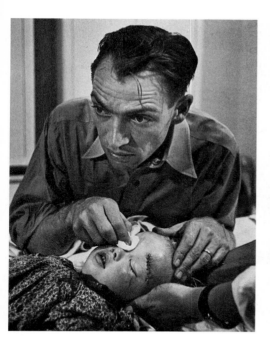

Village physician
W. EUGENE SMITH, USA

years it began to play a part in the discussion as to whether photographers should be seen as 'free' or 'committed' artists.

Photojournalism pitched the photographers from the relative isolation of their studios straight into the maelstrom of real life. Without having time to ponder whether or not producing works of art ought to have priority over politics they were literally sent all over the place. It was all in accordance with the times: historic events such as the Wall Street crash, the rise of fascism in Germany, and the Spanish Civil War all had an impact on the work both of photographers and visual artists. 'We didn't abandon our ivory towers, we were pushed out', wrote the American painter Peter Blume.[3] Political and social change had influenced Blime's work as it had done that of many other artists in the early thirties. Naturally, this applied even more strongly to photographers, many of whom especially in those days, felt the need to make their 'voice' heard in situations where Western humanitarian freedom was threatened. The American photographer Margaret Bourke White closed her advertising studio in 1934 and went to work as a photojournalist for the new *Life* magazine. The reason for this radical change was to be found in her experiences while photographing the 'Dust Bowl' (1934) on an assignment for *Life Magazine*. It was not until 1963 that she wrote about the influence these experiences had had on her personal attitude as a photographer: '...this was the beginning of my awareness of people in a human, sympathetic sense as subjects for the camera and photographed against a wider canvas than I had perceived before'.[4] Margaret Bourke White was by no means the only one to feel this way; the war turned even fashion and society photographers such as Edward Steichen, Cecil Beaton and Lee Miller into war photographers; Beaton and Steicher only for the duration of the war, but in Lee Miller's case the change turned out to be permanent.

In the Netherlands, social commitment among photographers was to be found mostly in left-wing intellectual circles. In 1931 the Vereeniging van Arbeidersfotografen ('arfots', the Society of Worker-Photographers) was founded in Amsterdam. This was a photographers' collective consisting mainly of amateurs who employed photography as a weapon in the class struggle. They felt that by using the suggestive effect which photographers can have on the masses '...the cause of the proletariat in its struggle against capitalism could be served'. (From: De Sovjet-Vriend, nr 2/3 (March 1931),

Els Barents

p. 3/ from: E. Rodrigo, 'van 1930 tot 1945', Fotografie in Nederland, The Hague 1978). During the second half of the nineteen thirties several sections of these arfots were admitted to the professional artists' organization 'De bond van Kunstenaars ter Verdediging van de Kultuur' (The Society of Artists for the Defence of Culture). Members of this Society included the photographers Carel Blazer, Eva Besnyö, Lood van Bennekom, Puck Faute, Paul Guermonprez, Emil van Moerkerken and Cas Oorthuys. Apart from participating in manifestations such as the 'Olympia under Dictatorship' (1936) and the exhibition 'Photo '37' in the Amsterdam Stedelijk Museum, members of the society also directed their activities against fascism in Spain. The work of this Society and similar organizations inspired many (left-wing intellectual) artists to go to Spain, e.g. Carel Blazer, John Fernhout, Joris Ivens and Jef Last. Last quotes Ivens' reaction to the situation in Spain: 'Do you remember how we used to talk about the role of the camera in the class war? That was mere talk. This is the first time that the camera has really been at the front itself and the first time that I felt I was shooting with my camera, the same way the others beside me were shooting with their guns. The camera trembled in my hands. I knew we had to act because the world must know the truth, the whole terrible truth'.[5] In the international journals the greatest furore was created by Robert Capa's photographs of the Spanish Civil War. Never before had artists and photographers so unanimously and so clearly taken sides in the international press: for the Loyalists and against Franco's army, which was supported by the Germans and Italians. The visual war as it was waged in the magazines was probably somewhat overdone; Capa was well aware of the fact that this Civil War would determine the success of his career as a war correspondent. In the discussions following his famous photograph of the falling soldier (Cerro Muriano, 1936) he was never able to dispel the suspicion that it might have been staged.[6] But the media were mostly interested in the symbolic implications of the war, not in the heroic death of this one (anonymous) soldier.

In this early period Dutch photographers hardly took part in international photojournalism. There is more than one explanation for this. The situation in the Netherlands was partly to blame: there was no direct economic or political need to look beyond the frontiers, as there had been, for instance, for Dr. Erich Salomon and Robert Capa. The Netherlands was a small but comparatively safe

On the way to paradise.
W. EUGENE SMITH, USA

Els Barents

D.Day 1944.
ROBERT CAPA, USA, MAGNUM

Disillusionment versus
the American Dream.
W. EUGENE SMITH, USA

The snowball effect of documentary photography

country, relatively isolated from international politics. The photojournalistic traditions that developed there in the nineteen thirties seem to have been rooted mainly in the Dutch socio-economic climate. Compared with the soaring flight of photojournalism in other countries such as the United States, France and Britain, with its resulting professional specialization, Dutch photographers were lagging behind. Before the war there had been contacts with international left-wing intellectual organizations but these had largely ceased to exist after the war. In the period of reconstruction so much was happening in the Netherlands that required attention that only a few individuals, e.g. Kryn Taconis, Joris Ivens and John Fernhout, adhered to their pre-war position and continued to follow international developments. In Amsterdam a number of photographers organized themselves in the 'Gebonden Kunstenaars Federatie' (Federation of Committed Artists) which was founded shortly after the war. The nucleus of this group consisted of Cas Oorthuys, Emmy Andriesse, Carel Blazer, Eva Besnyö, Maria Austria, Aart Klein, Henk Jonker, Paul Huf and Ad Windig. Their work was characterized by quality and versatility. They worked both by assignment and on their own initiative. To them, being a photographer meant to exercise a 'free' profession, to advocate a mentality and to produce work of a high standard. Unfortunately it turned out that in the Netherlands the opportunities for publication remained relatively limited. Nevertheless, these Dutch photographers developed their own traditions separate from but similar to the traditions of international photojournalism. This tradition was grafted upon the individuality of the photographer, had a sometimes lyrical, almost poetic quality and was especially expressive of the small details of domestic life. At the time, the work of these photographers was known only to a limited circle. It is significant that some of them have managed to make an international reputation for themselves, despite the fact that for quite some time they were isolated from the international publication channels. In the period following the war, Kryn Taconis was the only Dutch photographer who sought contact with international photojournalism. Armed with his junior memebership card of Magnum Photos, the cooperative of photojournalists founded in Paris in 1947 by Robert Capa, Henri Cartier-Bresson, David Seymour and William Vandivert, Taconis left the Netherlands and went to work first in Brussels, then in Paris. Partly through his intervention, Ed van der Elsken obtained a job not long afterwards as a printer in the photographic laboratory of Cliché-Labot. Ater working in Paris for about

Els Barents

four years, van der Elsken eventually opted for an independent career in the Netherlands. His successful first book, 'Een liefdesgeschiedenis op Saint Germain dès Prés' (A love story at St Germain dès Prés) was followed by several others. Although he had been offered junior membership of Magnum Photos in Paris, he found it difficult to work under commission and declined the offer. The golden years of Magnum's photojournalistic activities now seem to have paled; even Cartier-Bresson has ceased to photograph. He and his colleagues were succeeded by a younger generation of photographers, including Josef Koudelka and David Douglas Duncan. Photojournalism has not declined in quality, but there seems to have been a certain measure of 'levelling'. This was a levelling in the positive sense – a levelling of professionalism. Two things have made the going difficult for illustrated magazines: the fact that people have become increasingly inured to shocking pictures, and fast changing attitudes to society in the sixties. *Life Magazine* and *Look* have disappeared, and with them the great visual adventure. Margaret Bourke White was no longer alive when in 1975 her co-author Erskine Caldwell wrote his introduction to the new edition of their popular photo-book 'You have seen their faces' (1937). In disillusionment he wrote: 'The tortured face of poverty was not an appealing sight in the Deep South in the 1930s when 'You have seen their faces' was first published. Now, forty years later in the 1970s, whether in full view or in profile, the shriveled visage has not been improved by the passing of time. And this was during a period when numerous social and economic benefits were being freely bestowed elsewhere in American life'. It was the American photographers in particular who had been inspired by the belief that documentary photography was an effective method of bringing about social change through its influence on public opinion.

Eugene Smith was the most notable example of this idealism, which had a somewhat naïve aspect to it. In 1977, at the age of 59, he summed up the results of his work. To him, photography was art; he added that by means of photographs he had been able to destroy a concentration camp and build a clinic for a midwife, and that his work had made a contribution in the fight against racism and air pollution. Not without modesty he concluded with these words: 'I don't feel all that dedicated. I just feel like the normal guy. Too any people insist upon my being a legend, but I feel humble and lways on the threshold of knowing how to do my work'.[7] Disillusionment versus the American Dream; Smiths's idealism was

unable to withstand the 1970s, when it seemed for a time as if the grandeur of postwar photojournalism had gone forever.

Magnum Photos still exists but it is doubtful whether the work of people like Henri Cartier-Bresson can still be regarded as photojournalism. His photographs have as it were outlived their topicality and on their own strengh have found their way into many museum collections where they are stored, counted, inventoried and exhibited. Just as picture editors did in the past, curators now distinguish between one photograph and another on the basis of: the visual and technical quality, the power of expression, the complex, somtimes hidden layers of meaning, and with regards to the photographer's position in the as yet (partly) unwritten history of photography. Those photographs that in the past were of a sufficiently high quality to catch the attention and be published, are now regarded as important items of our cultural heritage, with a specific and individual expressiveness which is grafted upon a collective past. In photojournalism, history has once again overtaken the facts. Henri Cartier-Bresson's work found its way effortlessly into the museums. But this was not the case with the work of many other photojournalists; to them it proved more difficult to cross the boundary between art and photography.

This contrast between photography and art became topical again in the sixties. In the Netherlands it was the younger generation of photographers (with the exception of Ed van der Elsken and Cor Jaring) including Hans van den Bogaard, Willem Diepraam, Han Singels and Koen Wessing who gave a pictorial account of the student protests in Amsterdam (1968). The emotion and vehemence of the confrontations, the atmosphere of the happenings, in brief, the whole vitality of that period had shaped and sharpened their commitment as photographers. The *elan* of their photographs and their critical attitude towards society were infectious; they were readily accepted by the anti-establishment media. The developments in the visual arts (succesively Pop Art, New Realism and conceptual art) resulted in considerable changes in attitude towards the photographic medium. Those artists who made use of photography were, however, not interested in everyday topicality, nor in aesthetic photographs; they handled the camera with a more abstract aim. In particular, their treatment of both medium and themes was different, reflecting the abstract, contemplative manner of observation traditional to the visual arts. They did not see the news as such, but

Els Barents

constructed their own commentary on media clichés. Their concern was not the visual harmony of the moment, but the artist's attitude towards reality. What mattered to them was not, in the first instance, representation, but imagination.

As to the future of the relative positions of the visual arts and photography, at first sight so irreconcilable, there can be no simple prediction. The controversy is strongly influenced by the traditionally firm social position of the visual arts. There is great reluctance on the part of artists to accept the restrictions on their freedom implicit in the photographic process. A photographer is considered to have less status than an artist, and artists object to the documentary duties which the photographer has accepted without demur. Supporters and opponents have regularly crossed swords. For the time being a compromise solution seems to have been found in the distincion between, on the one hand, artists who use the photographic medium experimentally and conceptually, and on the other hand photojournalists and/or documentary photographers. The critic Siegried Kracauer has warned that this kind of attitude could draw attention away from the true character of the medium. To his question: 'Why should the term art be limited to the free compositions of these experimental photographers, which in a sense lie outside the actual terrain of photography', he gave the following answer: 'Perhaps it would be more fruitful to use the term "art" in a looser way so that it covers, however inadequately, achievements in a truly photographic spirit – pictures, that is, which are neither works of art in the traditional sense nor aesthetically indifferent products. Because of the sensibility that goes into them and the beauty they may breathe, there is something to be said in favor of such an extended usage'.[8]

Kracauer's art-theoretical observations are valuable to museum collectors inasmuch as they outline a general situation within which the journalistic qualities of photography may well become relevant. This does not mean that the entire field of photojournalism has suddenly become part of the visual arts. That heritage is too diffuse and diverse in quality to warrant such an assertion. It does mean, however, that it is an area well worth studying, because there is a great deal going on which is of interest and because much of it may well prove to have greater permanence than every day events. Just as a photographic archive cannot with impunity be transformed into a museum collection merely on grounds of its size and versatility, so museums cannot in all reason content themselves with buying photographs at random, without a preconceived plan. Over the

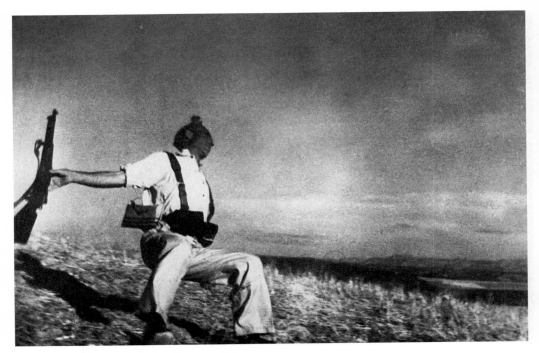

The symbolic implication of the war.
Cerro Muriano, 1936.
ROBERT CAPA, USA
COLLECTION STEDELIIJK MUSEUM AMSTERDAM

Els Barents

Spanish Civil War, Madrid, November 1936.
ROBERT CAPA, USA, MAGNUM

years a collection derives its strength from the balanced range of a variety of qualities – the concept of a collection is irrevocably based on the making of choices.

Els Barents

References

1. F. Hardy: *Grierson on documentary*. New York 1947, introduction p. 4.
2. Cat. Stedelijk Museum, Amsterdam, 'Dr. Erich Salomon, from the life of a photographer', 1981, e.g. letter dated 12.11.1937.
3. Elizabeth Mc Causland, 'Artists thrown into the world of reality present their cases', Springfield Democrat and Republican, 3.1.1936 / quoted from: Anne Wilkes Tucker, 'Photographic facts', in: 'Observations, Essays on documentary photography', The Friends of Photography 1984.
4. T.M. Brown, C. Mydans / introduction, 'The Photographs of Margaret Bourke White', New York 1972, p. 13.
5. Jef C.F. Last, 'Madrid strijdt verder' (Madrid fights on), Amsterdam (1936), p. 33.
6. Richard Whelan, 'Robert Capa, a biography', New York 1985, p. 96/7.
7. W.E. Smith, in: 'Photography within the humanities', New Hampshire 1977, p. 109.
8. Siegfried Kracauer, 'Theory of film, the redemption of physical reality', New York 1960, p. 23.

GIANFRANCO JOSTI

Sports photos bring legends to life

GIANFRANCO JOSTI (1941) IS A SPORTS WRITER FOR THE DAILY PAPER *CORRIÈRE DELLA SERA* IN MILAN. HE ALWAYS SEASONS HIS SPORTS COLUMNS WITH A DASH OF HIS SLIGHTLY MELANCHOLIC PHILOSOPHY OF LIFE. IT IS THIS SPECIAL OUTLOOK ON LIFE WHICH MAKES HIM SUSCEPTIBLE TO THE DEEPER MEANING OF BOTH THE HISTORICAL AND THE TOPICAL SPORTS PHOTOGRAPH.

'Photojournalist' is a term that brings to mind the explorers – almost mythical personages – who investigated the most remote corners of the globe at the turn of the century. But explorers are a part of the history of yesteryear, in contrast to present-day photojournalists who are still a living part of the stream of daily information. It goes without saying that the advent of television has changed the traditional image of the photojournalist. It used to be that you had to know little more than how to handle a camera, you had to have some spirit of adventure, and that was that: pictures of a new and unfamiliar world – different from the mundane one – filled magazines the world over. Now that television brings all manner of things into every living room – everything from natural wonders to bloody events, from illustrious personages to the star of the show – the photojournalist is asked to present the image of joy or sorrow, enthusiasm or despondency, in short, what in jargon is called: 'the meaningful photograph'. We live in a world that is rapidly developing, that is always looking to the future and simply has no time to turn around in order to get to the bottom of particular themes, to discover the why and what for of facts which have come into being. In this world, sports have undoubtedly experienced the least transformation.

It is evident that former training methods and modern ones cannot be compared. The modern ones are so rational that they can be entrusted to computers. Athletes themselves are now at a level of development where they can perform feats unthinkable at the beginning of this century. Certain sports have become so commonplace that they are more like a part of daily life rather than a part of the true world of sports. Being a professional has changed the way of being an athlete. However, the spectacle of sports and the

Gianfranco Josti

enthusiastic public – and here I do not mean the 'supporters' who, through their excesses, have made history all over the world in atrocious ways – are still in line with times gone by, with tradition. It is perhaps for this reason that sports photographers exhibit more similarities to their 'forefathers' than those whom we would describe as 'traditional'.

Sports lend themselves well to, among other things, the effects of an image, and certain photographs are an essential part of history. Who wouldn't remember Dorando Pietri, the short Italian athlete who, a few yards away from the finishing line of the London Marathon of 1908, was so exhausted that he couldn't move another inch? A sympathetic stuward helped him to end the murderous ordeal. The photographs of the courageous Italian athelete – knees buckling, stuward holding him up by his arms in order to take the last steps – flashed around the world, even though there was no television at that time. The now yellowed, faded copies of these photographs are still to be found in all sports archives.

A large-scale press campaign was mounted on Dorando Pietri's behalf by people who felt that the Olympic victory should not have been denied him, particularly since the stuward's assistance had really been what made him lose. But the inflexible judges did not change their mind. This story demonstrates how a fact, fortunately documented, can be transformed into a legend, in that day and age as well as this. This is why photojournalism is actual even now in the age of television and video.

More so than the few remaining film clips, the image of Jesse Owens, the American 'black arrow', and hero of the 1936 Olympic Games in Berlin, still hovers in the memories of those who are interested in sports. The gripping photograph is the one of Owens at the starting blocks: his thin face, his gaze on infinity, his whiter-than-white eyes contrasting with the dark skin. Jesse Owens, the man who made Hitler's blood boil; Hitler the Nazi dictator, who preached the superiority of the Arian race, who demanded that the 1936 Olympic Games be held in Berlin so that the Third Reich's glorious deeds could be celebrated. Jesse Owens is, perhaps, the first truly legendary athlete in the long history of the Games, because he took four gold medals: for the hundred and two hundred meter dashes, for the running broad jump and for relay racing.

Owens is legendary on account of his achievements: because he can be seen as the forerunner of the social liberation of black people through sports and because until today he is still a point of orientation for athletes worldwide: nobody, not even the great Carl Lewis,

has been able to match him. The hunt on his extraordinary record is as wide-open as ever.

Nevertheless, we must take the following into account: Olympic Games, soccer/football matches, baseball and American football games, tennis tournaments, (roller) skating competitions, are all sporting events that viewers can see 'live'. Some of the particulars might be missed, but on the whole everything is seen as if one was present at the event. The same is obviously true of indoor sports, starting with boxing – transformed into a 'business' by American managers/organizers – to basketball, volleyball and hockey.

The television camera succeeds in bringing home every phase of a motorcycle racing event for those who are priviliged enough to be able to sit at home in an easy chair and take in the swerves of Formula-I machines or the acrobatics of motorcyclists. The viewing is different than from the side of the racetrack, because from there the leading figures are seen only for an instant.

Skiing is a sport that has witnessed a revival over the past ten years, not only in the Western world, but in Asian countries as well – and attempts are being made to introduce the sport in Africa, too. Thanks to television, skiing has also become a sport that can be followed at each stage, from start to finish. Sports technicians now use videotaping as a special source of study, to adjust their formula, correct their form, and achieve perfection. It is evident that motor and winter sports have television to thank for their enormous popularity.

In contrast there is another sport, one of the oldest, which is still an enormous crowd puller for the opposite reason: it is not possible to follow it entirely with the cameras. I am refering here to cycling, the sport that has involved more legendary figures than any other. No one has yet been successful in following a cycling classic or just a leg of a national tour; even with the most modern methods, even now that helicopters and mobile cameras have come into play. There always seems to be something that escapes the commentator or the camera-eye, as it is simply impossible to cover an event that is spread out over 120 or 150 miles. According to tradition cycling is a sport that moves ahead, it cannot be limited to a marked off track (except in the case of the world championships), because then the true character of the sport might be violated. It is for this reason that the photographic commentator has such an important task: he is the one who has to capture the special images which only he can discover, while following the cyclists in blazing sun or rain or even in driving snowstorms.

Originally a means of diversion, later a means of transportation,

Gianfranco Josti

the bicycle is still of interest in the age of motorized transport. This interest, moreover, has continued to grow, also in the United States, where nowadays taking care of the body is a cult and where doctors have determined that bicycling is the healthiest exercise along with jogging. It is logical that cycling also attracts younger people. The sport is rapidly becoming very popular on the other side of the Atlantic.

Still, cycling's greatest glory was known in Europe, the Europe of days gone by and also of today, despite the fact that other sports have gained a firmer foothold by undermining the position cycling had between the world wars when it reigned supreme. Naturally, Europe also produced the three greatest cycling champions, each of whom characterized specific periods of time. Firstly Alfredo Binda, the Italian who won the world championship three years in a row, and who marks the period between the pioneering days of cycling and modern-day cycling. Secondly, Fausto Coppi, another Italian who represented the top, and whose endeavors helped not only his own country, but also France, Belgium and Spain, to wipe out the horrific memories of the Second World War. Lastly, the Belgian, Eddy Merckx, today's super champion, the super athlete who participated in all the important competitions: the legendary conquest-chaser, so hungry for succes that he earned the nickname 'the cannibal'; the man who acquainted the US and Japan with cycling.

Three legendary champions, three easily distinguished periods of time, three ways of entering sports history.

Alfredo Binda was born August 11, 1902 in Cittiglio, a small village in the hills of Varese. With his brothers, he moved to Nice on the Azure Coast, where he worked at odd-jobs for a living. He devoted his Sundays to cycling, and he competed with compatriots who had likewise found work outside Italy. He was the kind of man who made crucial decisions without any hesitation – a characteristic way of dealing with things that he used later on as well, when he was chosen to be the technical commissioner of the Italian team for the Tour de France and the world championships. When, at the age of twenty, he discovered that he could earn enough to live on with cycling, he became a professional. He began his career in France, but became the 'great champion' in Italy where he engaged in valiant duels with Costante Giradengo and later with Learco Guerra.

Until he entered the picture, cycling was seen only as a proof of strength and endurance. Alfredo Binda was the first one who understood how important both aerodynamic position and cycling

Fausto Coppi, completely absorbed in ascending the Dolomites pass, the Pordoi.
It is without doubt a true sports shot, picturing the most legendary champion, but
it is also a valuable historical document. After the war, some mountain passes still
had something of a paved surface, but all of them were littered with boulders and
pitted with potholes. The days of asphalt came only years later, and with its ad-
vent, a lot of the old appeal of cycling waned.

PHOTO TERRENI

Gianfranco Josti

This is one of the shots that triggered one of Italy's most strident controversies concerning the two cyclists Fausto Coppi and Gino Bartali, splitting the penninsula in two. During the tour of '52, the two 'enemies' shared a flask during a leg that would end in Alpe d'Huez: who had given it to whom? It took several years before the mystery was unveiled: they had done it to humour Carlo Martini, the well-known sports photographer for the 'Gazzetta dello Sport', who was present at the Tour.

style were. He put his ideas into practice so well that at one point he had no more rivals, at least not in Italy. This lasted until the day the organizers of the Giro d'Italia asked him not to participate in the Giro d'Italia of 1930. By that time he had won it four times running – including the one in 1929 when he managed to win eight stages in a row. Binda, an excellent cyclist, but not a bad businessman either, accepted the proposal on the condition that Legnano, the company sponsoring him, would present him with a sum of money equivalent to what he would have won in prizes: 22,500 lire, which in 1930 was enough for anybody to be very comfortable... as comfortable as an oil sheik!

He was the first professional bearing the title of world champion, a title established at the Nurnburgring, Germany, in 1927. He won yet two more world titles, and he was successful in every Italian cycling classic. When it came to the Tour de France, however, he could not sustain the successes he had enjoyed in Italy. In the course of the race his fighting spirit was such that a now world-famous photograph, taken during the Tour of Lombardy, shows him as he is ripping the tire off a wheel with his teeth, because he couldn't manage with his hands. In 1936, a nasty spill during the Milan-San Remo race – he broke his thigh bone and had to stay in hospital for a very long time – marked the end of his career.

Binda, however, remained involved with cycling, even though he had earned enough to lead a life of leisure for the rest of his days. He had proved his mettle as a champion cyclist and now also proved to be an excellent strategist. Making use of a following car, he guided Fausto Coppi to success in 1949 and 1952. Fate brought these two legendary men together. It is easy to link the names Fausto Coppi and Alfredo Binda, maybe because the old champion saw the young one as an ideal link between two essentially different periods.

All this contributed to Fausto Coppi's success with the public – in Italy and France he was idolized. This was because cycling, as opposed to other sports, is truly universal and is not subjected ot chauvinistic fanaticism in the way soccer is, for example. Although it is a national sport, it often happens that younger people and those a little older discover they are fans of a particular cyclist, regardless of his nationality. Fausto Coppi is the first case in point.

On account of his slight, almost frail build, he seemed born to be a cyclist. Even as a boy, cycling was his way of making a living. For quite some time, he zipped through the streets of Castellania in Alexandria, where he was born (Septmber 15, 1919), to make

Gianfranco Josti

deliveries. It was Biagio Cavanna, the blind masseur, who spurred him on to start a cycling career. His entrée into a world that was practically unknown to him can certainly be called impressive. He started alongside the talkative Tuscan Gino Bartali, who later became his bitterest enemy.

When Coppi was twenty he produced a stunning surprise by winning his first Giro d'Italia himself, at the expense of the one who should have been his leader. These circumstances caused a rift that divided Italy for fifteen years and all that time other champions hardly ever had a chance to try and wedge their way into the duel. The great legend that formed around Coppi was also nurtured by an impressive series of accidents that intensified his bitterness. Each time he fell, he incurred some fracture, ensuring long periods of absence from cycling competitions. On returning, he would book new successes and obtain even more incredible results. It was after he took a spill in the Motovelodrome in Turin, during the national championship pursuit races, that the idea of challenging the world endurance record, then in the hands of the Frenchman Archambaud, cropped up. But then the Second World War started. Italian fascism had aligned itself with German Nazism, and Hitler had begun taking over Europe.

Coppi was supposed to serve in the armed forces as well, but if he could perform some worthwhile feat in the field of sports, he could avoid being sent to the front. Taking this to heart, he went out on a grey Saturday in November of 1942, the seventh to be exact, and made his bid on the world endurance record on the Vigorelli track during several air-raid alerts. He was poorly prepared, he certainly did not have one of those modern supersonic racing bicycles and on top of that he was wearing a wool sweater that wasn't aerodynamic in the least. But in 1942 these were all unknown considerations. Through superhuman effort, Fausto Copi managed, in the presence of a few spectators, the judges and the timers, to set a new world endurance record by adding 31 metres to Archambaud's 45,848 kilometer (27,508.8 mile) record. His remained the standing record for fourteen years. Coppi himself could have broken it, but he was not interested any more: ironically enough, he was sent to the Tunisian front only a few days after setting the record, in spite of his gruelling achievement. In Tunisia he ended up a prisoner of the English forces under the command of Montgomery.

The end of the war and life's return to normalcy after all the brutal killing, gave cycling a new impetus, and the Coppi legend as well. People needed an escape from reality, they had to have an idol

This photograph outlines Alfredo Binda's character better than a long discourse on this 'great champion' cyclist. During a stage of the 1928 Giro d'Italia he got a flat tire. In order to remove the 'palmer' off the wooden rim, he tore at it with his teeth.
PHOTOGRAPHER UNKNOWN

Gianfranco Josti

Total desperation for a young cyclist in the classic Boucle de la Seine 1971.
PHOTO JACQUES MARIE, FRANCE

Sports photos bring legends to life

to latch on to. Italy especially looked to sports to be able to show the world another image than that of a fascist dictatorship. Fausto Coppi and Gino Bartali interpreted the role of ambassadors of peace in the best way, by generating enthusiasm, by scoring one win after another and by setting up heroic duels on the roadways of the Giro d'Italia and the Tour de France. The Italian press began making up new superlatives to describe Coppi and his deeds, because he alone had succeeded in winning both the Giro d'Italia and the Tour in the same season.

The Coppi myth also withstood the ravages of time. During the final years of his career, the proud bird that flew over the Alps and the Pyrenees, capturing the champion's shirt both on the track and the road, felt his wings grow heavy. He was having serious marital and family problems, his name could be seen more and more frequently in the gossip column and less and less in the sports column. And finally his tragic death – he died of malaria (not diagnosed by any of the specialists who rushed to his bedside) contracted in Africa while on a hunting expedition – undoubtedly helped shape his legend. Today Fausto Coppi is still the man most-often recalled in Italian opinion polls of all the champions of sports.

Eddy Merckx is a sportsman who can be considered as the prototype superman of the year 2000, even though his career extended from 1969 to 1977. Fausto Coppi was the man of great escapes; Eddy Merckx is the cyclist who won the most in the most ways, in the final sprint and solo, on the flat stretches, in time trials, on the track and in the mountains – even though he was not build to be a climber. There is not one single big race – be it a stage race or a tour – in which his name doesn't appear at least once on the 'golden lists'. His insatiable appetite for fame caused his career, which might have lasted longer, to burn out prematurely. But he was Merckx, the man who had to come in first, in a continual battle against the clock, almost a crazy man in his ways. It was not in him to take a gradual decline, like other cycling greats. He just collapsed one day and plummeted straight down. However, all this certainly did not make the Belgian less great!

Alfredo Binda was the champion of prehistory; Fausto Coppi the one of the romantic period of cycling; Eddy Merckx was the champ of modern times – more concrete, more scientific, more linked to our own day.

These three exceptional people were caught by the lenses of hundreds of photographers. It is inevitable that the three time periods they represent should be compared, whereby Binda certainly

Gianfranco Josti

loses out to Coppi, and this 'champ of champs' in turn loses out to Merckx. These matters should always, however, be observed in their proper proportions. Besides, the three of them were equally great in one important aspect: they all brought luck to photojournalism. And today certain photographs showing the champions' expressions of extreme joy or dejection are still actual, still 'alive', even though we are living in the computer age with its penchant for making everything impersonal.

PETR TAUSK

150 Years press photography: the changing opinions of public and press

PETR TAUSK (PRAGUE, 1927) STUDIED CHEMISTRY AT THE UNIVERSITY OF TECHNOLOGY IN PRAGUE, BEFORE EMBARKING ON A MANY-SIDED CAREER: PHOTOGRAPHER, THEORETICIAN, HISTORIAN AND PUBLICIST. IN 1977, HIS 'DIE GESCHICHTE DER FOTOGRAFIE IM 20.JAHRHUNDERT, VON DER KUNSTFOTOGRAFIE BIS ZUM BILDJOURNALISMUS', WAS PUBLISHED BY DUMONT IN COLOGNE (GERMANY). BESIDES MANY MAGAZINE ARTICLES, HE ALSO WROTE *A CONCISE HISTORY OF PHOTOJOURNALISM*, A PUBLICATION OF THE INTERNATIONAL ORGANISATION OF JOURNALISTS IN PRAGUE, WHICH WAS PUBLISHED VERY RECENTLY. IN HIS CONTRIBUTION HE SKETCHES THE CHANGING IMAGE OF PHOTOJOURNALISM IN CONNECTION WITH THE CHANGING OPINIONS OF CRITICS AND PUBLIC, DURING ALMOST 150 YEARS OF PHOTOJOURNALISM.

When we look at the evolution of mankind, we see that it did not proceed by leaps, but more by gradual transitions. After all, major innovations and breakthroughs always had less conspicuous changes prepare the way for them. More or less the same can be said for people's lives, traditions and customs.

Journalism and, subsequently, photojournalism developed in a similar fashion. In fact, journalism already existed before anything was ever published. Evidence of this can be found in Egon Erwin Kirsch's brilliant anthology *Klassischer Journalismus*, published originally in 1923[1]. It includes one of the first reportages ever, by Plinius, on the eruption of Mt. Vesuvius. Similarly, the discussion about photographs, which could be seen as the 'prehistory' of photographic communication, also has quite a long history. Books such as those by Josef Muller-Brockman[2] and William M. Ivins[3] bear witness to this. No wonder that the historiography of opinion regarding press photography has been built on several important thoughts, which originate from a time when photography was still to be discovered. The young Johann Wolfgang Goethe, for example, after he had travelled from Leipzig to Dresden in order to visit a famous collection of paintings, noted in his diary that 'the aim of the artist is to teach people how to see'. Later, Max J. Friedländer[4]

Petr Tausk

explained the difference between mere visual perception and seeing as the ability to recognize the significance of the objects which one perceives, an idea which was more or less a complement of Goethe's. And in the course of time it became commonly accepted that photographers are the best teachers of 'seeing', especially the photographers working with the press.

Another fundamental contribution to the intellectual background of press photography can be found in the treatise on *Aesthetics* by Georg Wilhelm Friedrich Hegel[5]. In this book, Hegel states that the most important approach to art has always been to find interesting situations, i.e. situations which reflect the profound and essential interests and preoccupations of the mind. This notion, generally valid for every kind of art – possibly particularly so for literature – could with regard to photography be interpreted in such a way that the word 'situation' does not only apply to an event created by living beings, but also to an arrangement of still objects which, because of the conditions (such as lighting, season, weather) governing it, cannot be repeated in the same way on another day.

In the early days of photography, when several minutes were needed to expose a film, the possibility of registering a latent image on a sensitive layer in a relatively short time opened new opportunities. With improved technology and techniques, the photographer's chances of being able to react to situations improved as well, both from the aesthetic and the narrative point of view. This became especially important when the photographic image found its way to magazines and in particular to newspapers.

However in the early days after the invention of photography most attention was paid to the accuracy of the image, which was measured by its informational content. The significance of this typical property of the photograph was explained in a historical speech by Dominique François Arago to the French Chamber of Deputies on July 3rd, 1839. In his magnificent explanation, which was designed to convince the deputies that they should acquire the new invention for the state, he used, among others, the following argument[6]: 'While these pictures are being shown to you, every one of you will realize that extraordinary advantages could have been derived from so exact and rapid a means of reproduction during the expedition to Egypt; everybody will realize that, had we had photography in 1798, we would today possess faithful pictorial records of that of which the greed of the Arabs and the vandalism of certain travellers has deprived the learned world of forever. It would require decades and legions of draughtsmen to copy the millions of

Attention for the new and unusual
at the end of the 19th century.
Edison's phonograph pavilion in
Prague, 1891.
RUDOLF BRUNER
DVÓRÁK, CZECHOSLOVAKIA

Attention for everyday, ordinary
things after the difficult war years.
Street scene, Budapest, 1945.
JINDRICH MARCO. CZECHOSLOVAKIA

Petr Tausk

hieroglyphics which cover the exterior of the great monuments of Thebes, Memphis, Karnak and others. If daguerreotypes are used one person will suffice to successfully accomplish this immense work'.

Arago's words were certainly a valid prophecy. From the first phases of the evolution of photography, there have always been authors who recognized the positive significance of a documentary approach towards it. In 1859, the early use of the photographic image as a basis for the engraver, who produced a graphic reproduction on the printed page, indicated that photography would play an important part in the development of the modern mass media. Léon de Labrode[7] even mentioned photography in connection with his thoughts on the revolution of reproduction.

Of the photographers who were active in investigating the properties of pictures which could be significant for future use by the press, those who were aware of the unique documentary value of such images occupied the key positions. In a letter to William Agnew from the Crimea, written in May 1855, Roger Fenton[8] said: 'I send you herewith a few portraits which are worth engraving and will serve to keep up the attention of the public until my return. I make slow progress, though as far as lies in my power no time is lost. I am very anxious to return home, as my interests are suffering in my absence, but I cannot make up my mind to leave until I have secured pictures and subjects likely to be historically interesting'.

Relatively soon, even though photographs still had to be reworked by the engraver, it became apparent that they could also be important for personal purposes. In 1860 Mathew Brady's portrait of Abraham Lincoln was used by newspapers for their wood engravings, and Currier and Ives made a few lithographs based on it. Lincoln admitted later: 'Brady and the Cooper Institute made me president.'[9] This statement gave what was perhaps the first hint of the picture's power to influence people – more than words – and also emphasized the significance of a good portrait for use by the press.

Important contributions to the historical documentation of photography, later to be used by editorial offices, were the opinions of authors who took pictures during their travels in distant countries. Some photographers even confessed that it was their endeavour to depict the world which allowed them to discover the significant qualities of the landscape, so that they could interpret it for their countrymen at home. Thus Samuel Bourne described his feelings about an expedtion to the Himalayas in 1863 as follows[10]: 'For my

own part, I may say that before I commenced photography I did not see half the beauties of nature I do now, and the glory and power of a precious landscape has often passed before me and left but a feeble impression on my untutored mind; but it will never be so again'. Taken out of context such a thought complements Goethe's opinion about 'the duty of the figurative artist to teach people to see', since without any doubt the artist must first of all learn himself what there is to discover through the use of his own eyes. The correct evaluation of the significant qualities of reality later became one of the first requirements for photographers who wanted to collaborate with the press.

The concept which describes photographers as being the best eyewitnesses was clearly defined by John Thomson[11] in his recollections of China in 1873: 'With this intention I made the camera the constant companion of my wanderings, and I am indebted to it for the faithful reproduction of the scenes I visited, and the different races with which I came into contact.' Once back home, Thomson put his ideas about the nature of photography into practice in the lovely book *Street-Life in London*[12] which he made jointly with journalist Adolphe Smith in 1876. In the preface to this publication they stated: 'And now we have also sought to portray these harder phases of life, bringing to bear the precision of photography in the illustration of our subject. The unquestionable accuracy of this testimony will enable us to present true types of the London poor and shield us from the accusation of either underrating or exaggerating individual pecularities of appearance.' This emphasized the significance of the truthfulness of the photographic image, a truthfulness which would enable it to support the word of the writing reporter in cases where the audience might have doubts. A few decades later, the harmonious cooperation of photographer and author came to be one of the characteristic properties of photojournalism.

The halftone reproduction of photographs opened new ways for the use of pictures by the press. As demonstrated by Dail Buckland[13], the first step was taken by New York's *Daily Graphic* on December 2, 1873, when a picture of Steinay Hall appeared on the last page. The editors called the reader's attention to this fact by this notice: 'The photo is worth a thorough inspection since it is the first picture ever printed in a newspaper directly from a photograph. There has been no intervention by artist or engraver; the picture was transferred directly from a negative by means of our patented process of "granulated photography".' The real triumph of the

Petr Tausk

direct reproduction of photographs in the press, however, would have to wait some 20 years, until the great innovations made by Georg Meisenach and Karel Klic were implemented.

In the meantime, great progress was made in the evaluation of the moment a photograph should exposed. In *Naturalistic Photography*, which appeared in 1889, Henry Emerson[14] wrote: '...In fact, we feel sure a first principle of all artistic work in photography is quick exposure.' The way the right exposure can contribute to the emotional appeal a photograph has for the spectator was still more profoundly formulated by Alfred Stieglitz[15] in his essay *The Hand Camera – Its Present Importance*, published in 1897; especially important was this observation: 'In order to obtain pictures by means of the hand camera, it is well to choose your subject, regardless of figures, and carefully study the framing and lighting. Having determined upon these, watch the passing figures and await the moment in which everything is in balance; that is to say, is satisfactory in your eyes. This often means hours of patient waiting'. Although Stieglitz did not use the phrase 'aesthetics of a situation', he interpreted very well Hegel's requirement with regard to the nature of photography.

Stieglitz, of course, was not a press photographer, even though his ideas later were fully confirmed by the demands of modern photojournalism. At the time his opinions were published they were exceptional rather than generally accepted. An understanding of the evolution of photography was extremely rare and even learned people did not recognize photography's growing potential and importance. The well-known Czech aesthetician Otakar Hostinsky[16], for example, wrote in his essay *Photography and Painting*, published in 1905: 'It is evident that with regard to depicting events from everyday life the art of painting is quite safe from any competition on the part of photography.'

Books about the 19th century and its progress point to the breakthroughs in newspaper and magazines production. Thus Jan Klecanda[17] informs us that in 1900 a newspaper of 16 pages was printed on a rotary machine at a rate of 100,000 copies an hour; to arrive at the same output on the hand press used in 1800 would have taken 6,400 hours. This productivity growth at the printer's helped editors, who benefitted from the relatively new methods of photoreproduction, to develop new concepts. It has to be said, however, notwithstanding the respect for the direct use of photographic images in the press, that the pictures published at the turn of century reveal a certain amount of confusion. S. Stefan[18], for

example, wrote in his book on the 19th century: 'The draftsmen and illustrators were slowly pushed back by the snapshot photographers, some of whom thought they were entitled to register everyting they found before their lenses without any attempt at an aesthetic arrangement or at capturing the right moment of a vivid scene . . .' Thus it became obvious that the mecanical process needed people's taste and discernment to direct it. If one trusted the lens and photographic plate, the result on the printed page could only be something to satisfy curiosity and sensationalism, and not something which could fulfill aesthetic requirements.

At the beginning of the 20th century it was not yet clear what kind of photographers should collaborate with the press. Most of the professionals ran studios and therefore dedicated themselves mainly to the portrait. Great press photography personalities, such as Louis Held[19] in Germany and Paul Martin[20] in England, were still very rare. Nevertheless the editors began to have more grasp on the situation and it slowly dawned on them that of all the pictures the ones we call 'live-photographs' today were the ones most suited to the demands of the press. The confusion about how to use photographs for press purposes is aptly described in the following paragraph from an article published by Willy Frerk[21] in 1906: 'Nearly every newspaper offers his readers an illustrated supplement, which summarizes the events of the past week in pictures. Then there is a second group of publications, which endeavours to use images of high artistic quality; finally, there is a third category: the press, which is focused on sensational photography'.

With the exception of the second category, the editors use mostly picture material prepared by authors without any apprenticeship or training in photography; quite often, these images are taken by amateurs, who witnessed interesting events by chance, or by writing journalists, for whom taking pictures is only a sideline.'

Opinion on the aims of the illustrated journals crystallized slowly. Approximately three years before the outbreak of the First world War it was, among others, Carl Conte Scapinelli[22] who came to the conclusion that 'the immense growth in the number of periodic publications using pictures was the logical consequence of the natural wish to visually absorb information which could take much more time and effort to acquire in the form of the printed word. Simultaneously, this evolution was facilitated greatly by the enormous progress in the field of photography in the last decades, and by the new and less expensive methods of picture reproduction, which allowed faster printing than ever before !' In the same essay

Petr Tausk

Scapinelli pointed out that 'no other brand of photography requires as much knowledge and skill as picture reporting'.

The exchange of opinions on press photography slowed down slightly because of the First World War. On the other hand the war offered photojournalists the unique opportunity to broaden their experience by capturing battlefield scenes and life in the homeland under unusual conditions. Of course society as a whole was also changed by the war and thus the time was ripe to go for a more realistic expression in the sphere of artistic photography and abandon the type of pictures that belong in photo albums and scrapbooks. In the 1920s some people began to realize that the difference between the approach of press photographers and of photographers attempting to create works of art, had become quite small.

The involuntary four-years interval allowed time for a certain ripening of the ideas that had been developed. Approximately two years after the war the well-known Czech painter, writer and editor Josef Capek[23] published the lovely book *The Most Modest Art*, in which he went into the significance of images on the printed page. He emphasized that 'photography and film are by their nature documents and the results of the art of the spectacle. Above all this is true for press photographs of the kind which are used in the modern illustrated journals'. Of no less importance was Capek's observation that 'just like film the photographic illustration wants to be a joy to the eye. The quality and method of depiction should be determined by the taste and concept of the photographer; the press photograph needs the effect and the art of direction. Significant results are not an impersonal merit, since they are reached by means of the deliberate participation of the author's emotion and spirit.'

A quite complex collection of opinions was offered by John Everard[24] in his book *Photographs for the Papers*. One important observation stands out from all the others: 'The news photograph must tell a story'. Everard distinguished between the demands of various kinds of publications. On the subject of the daily newspapers he observed: 'The lives of news pictures may frequently be expressed in hours, and during that period they are golden. But often they are worthless a day or two after they were taken'. As to weekly publications he wrote: 'Thus a very wide scope of opportunities is open to the diligent pressman. He is untrammelled by the insistent requirement for immediate interest. He can go about his work carefully and, unlike the news photographer, he need not expose himself either to the inclemencies of the weather or the righteous indigna-

Attention for the extraordinary in relaxed, 'fun' times.
'Ludic' summer walk, Cerveny Hradek, 1982.
MIROSLAV HUCEK, CZECHOSLOVAKIA

Petr Tausk

tion of people who have been snapped against their wills. Provided always that he infuses into his work the necessary story element, he will experience little difficulty in disposing of his pictures.'

The most important progress in press photography took place in the context of weekly publications in the period between the two World Wars. The requirement that the image should maintain its story-telling effect for several weeks enabled talented photographers to explore more deeply the powers of expression of their photographs. The improved opportunities for photo-reporters, doubled with better handling of the images, contributed to significant changes in the magazines. One of the most successful editors of the 1920s, Kurt Korff[25], explained his opinions as follows: 'The changing approach of the audience towards life itself nurtured the evolution of the illustrated weeklies. The journals of the past decades used mostly comprehensive texts which were only illustrated by a few pictures. Sometimes the opposite was the case: a caption was written to accompany an available image. Particularly in our time, when the visual perception of life started to play a more significant role, the demand for images has grown so much that it has become possible to use picture as the main source of information. This required an entirely new approach towards the image. It was no coincidence that the evolution of the cinema and of the *Berliner Illustrierte Zeitung* (i.e. the weekly edited by Korff) ran more or less parallel...' The audience became more and more used to a pictorial perception of world events that was stronger than when they read articles about them. Information about world affairs without images had become unacceptable and often even unbelievable; it was the picture that made the strongest impression.

A number of German weeklies developed an innovative character during the 1920. At the same time a number of journals in the USSR also reached an admirable level; it was not surprising, therefore, that important opinions on press photography were published in that country. A leading personality in Soviet cultural matters, Anatolij Vasiljevic Lunacarskij[26] wrote in 1926: 'Photography has invaded illustrated journals and even newspapers, and its reproduction enriches the human eye, enabling it to become the observer of life all over the world.'

The new emphasis on photographs in illustrated journals led to the fact that the presence of an additional expert on the editorial staff became more and more important: the picture editor. In his book *Das Bild als Nachricht*, published in 1933, Willy Stiewe[27] vented his views on the duties connected with the new position: 'The differ-

Attention for artistic detail — at all times.
Cannes, 1980.
VLADIMIR BIRGUS, CZECHOSLOVAKIA

Petr Tausk

ence between the picture editor and his colleague working with words lies exclusively in the necessity to see the world and its events in terms of pictures... As to the technique, he should know enough about the photograpic process to be able to function as photoreporter in case of urgent need. However, first of all he must have an eye for the effect of a picture, for the significance of details, and for the choice of the right trim in order to present the image well in its final shape. Furthermore he should be able to judge whether the photograph can be reproduced in the press satisfactorily. In addition to all that, a talent for the typography of lay-out should also be expected... From the journalistic standpoint he needs to be able to determine where the boundary lies between publicistic effectiveness and mere sensation'.

In addition to the above requirements the experienced Soviet journalist L. Mezericer[28] expected the picture editor to use photographs in such a way that they mobilized the people to have new ideas and that they became a tool to educate the masses with. He also wrote in the 1930s that the profession of picture editor should become an important specialization in higher journalistic education in the Soviet Union.

The picture editor could thus determine both the face and the concept of the illustrated weekly to a considerable extent. Moreover, since he had the final say the picture editor was able, albeit in an indirect way, to teach the press photgrapher which aspects of reality should be registered. How great his personal responsibility was, is illustrated by the words Stefan Lorant[29] uttered in an interview while reminiscing about the days of his employment by the *Münchener Illustrierte Presse*: 'In the 1920s nobody came to tell me what to do – not the publisher, not the person who finances the paper, nobody – I had absolute power regarding what went into the magazine. I could use my own imagination. In those days magazines were so much more personal than they are today. If one looked at the pages of an illustrated weekly in the 1920s, one instantly recognized the editor's style; one immediately knew that the story was from the *Berliner Illustrierte Zeitung* or the *Münchener* or the *Kölner* – one recognized the editor's hand.'

In his history of illustrated weeklies, published towards the end of the 1920s, Tium N. Gidal[30] pinpointed the victory of the carefully composed photo-reportage forming an autonomous whole as a significant contribution to the evolution of press photography. According to Gidal, this was how modern photojournalism started.

The evolution of press photography and the opinion about it

were, next to the audience's requirements, the editorial choice and the author's personal taste, quite strongly influenced by the latest developments of new cameras such as Ermanox, Leica, Rolleiflex and by faster lenses. The image taken by Erich Salomon[31] in particular represented a breakthrough in the development of modern live photography. He endeavoured to give his pictures a voice by capturing the expression on the human face at the right time. He was convinced that 'the inner life of civilized Europe took place in closed rooms, where it was difficult to use a normal camera. The position of the photo reporter wanting to take authentic pictures in such circumstances was similar to that of a hunter waiting for a lucky chance'.

In the 1930s Henri Cartier-Bresson[32] started to investigate the significance of a ready reaction to aesthetic real-life situations. Much later, when he dealt with the nature of the medium in the introduction to his book *The Decisive Moment* he said: 'Of all means of expression, photography is the only one that fixes forever the precise and transistory instant. We photographers deal in things which are continually vanishing, and when they have vanished, there is no contrivance on earth which can make them come back again. We cannot develop and print a memory. The writer has time to reflect . . . But for photographers, what has gone, has gone forever. From that fact stem the anxieties and strength of our profession. We cannot do our story over again once we've got back to the hotel. Our task is to perceive reality, almost simultaneously recording it in the sketchbook which is our camera. We must neither try to manipulate reality while we are shooting, nor must we manipulate the results in a darkroom. These tricks are patently discernible to those who have eyes to see'.

Cartier-Bresson analysed the ability of photography to depict what might vanish to be a result of the changing needs of modern society. In doing so, he echoed the point made by Arago in connection with Egyptology in 1839. Similarly, he lumped together all previous observations on the significance of the unrepeatability of situations recorded in a manner and at a moment that made them a suitable basis for contemporary photojournalism.

The evolution of press photography was furthered by contributions from photographers interested in collaborating with journals, newspapers and picture agencies. For the personal growth of these authors not only talent and the right mentality were important factors, but also the opportunity to use their images and get suitable assignments. Therefore each innovation in the concept of newly-

Petr Tausk

Photography and psychology meet in a journalistic portrait.
Cornell Capa reminisces about his brother Robert, New York, 1983.
PETR TAUSK, CZECHOSLOVAKIA

founded illustrated publications was a positive contribution to the progess of photojournalism.

The second half of the 1930s marked the first appearance of the weekly *Life*. The magazine subsequently became a magnificent tribute to both live photography and the inventive production of eloquent picture stories. All important contributions to photojournalism, including a wide range of expressions on the human face and events recorded at precisely the right moment, were summarized in its pages just before the outbreak of the Second World War. *Life's* visual effectiveness was ensured through the choice of material and the final composition of photo stories, responsibilities of picture editor (and later executive editor) Wilson Hicks. When he gave up his editorial responsibilities in 1952, he recorded his opinions and experiences regarding press photography and its use in the excellent book *Word and Pictures*[33]. In it he said: 'The coming together of the verbal and the visual medium of communication is, in a word, photojournalism. Used in combination, its elements do not produce a third and new medium. Instead, they form a complex whole in which each of the components retains its fundamental character, since words are distinctly one kind of medium, pictures another.' Of no less importance was the fact that Hicks carefully analysed the apparent objectivity of the medium in comparison with the subjective approach of the photographer, in the choosing of subjects, in the pictorial interpretation of his aesthetic and journalistic style, and even in the photographic expression of persons; points of view related to the requirements of the press.

The many attempts at clarifying the nature of photojournalism resulted in the publication of a wealth of opinion on press photography which dealt with the problems in detail. After the Second World War the popularity of the illustrated journals increased due to a better understanding of society's demands. The unusual number of images published in periodicals, and, on the other hand, their frequency almost led to some misunderstandings in the evaluation. Karl Pawek, for instance, was of the opinion that the process of creating a 'live photograph' was not finished until the result was printed on a page. Although the audience usually saw live pictures reprinted in magazines, these images did not loose their right to occupy important positions among photographic originals presented as autonomous works of contemporary art. On the contrary, creative photography in general owes quite a lot to the talented people who depict life while on journalistic assignments. In this connection it is possible to quote Lubomír Linhart[35], who wrote the following

Petr Tausk

words in his introduction to the catalogue of the *International Exhibition of Photography* in 1959: 'The whole character of live photography tends to serve the discovery of the specific properties of the medium, as well as the departure from the last remaining efforts to resemble painting in any way.'

The best press photographers always had, and still have, close contacts with other colleagues who are looking for ways to express themselves. Their mutual influence enriches both parties. For instance, surrealistic images gave photojournalists a taste for the depiction of situations of a dream-like character. On the other hand, those who tried to find their own way by instantly reacting to the aesthetic appeal of reality and by making use of the specific documentary possibilities of the medium, benefitted a lot from the technique of press photography. Similarly, photographers inclined to interpret the personality of the depicted person from a psychological standpoint sometimes used a more or less modified version of the methods applied for journalistic portraits, when the moment of exposure is selected while conversing.

The possibility of making use of the experiences with aesthetic effectiveness of other branches of photography became especially important in the light of the constant increase of interest in television, which is able to bring the latest news much sooner. Just like photography released painters from the duty to show people what there was to see in the world, television is helping press photographers get rid of the merely routine registering of news events. This has brought us a step closer to fulfilling Heinze Frotscher's[36] wish that the profession of the photojournalist should not be that of a photographic robot, but of a thinking reporter who feels a responsability towards society. In the introduction to his volume *The Best of Photojournalism 2* American television expert Harry Reasoner[37] said: 'There is something special about a big, clear, black-and-white still. It does something that motion pictures can never do; it preserves a moment for eternity in a kind of halftone amber'.

Last but not least, one may assume that having contact, however long, with a press photograph published in a magazine enables the spectator to perceive better the aesthetic values of the image, which helps to educate his taste – and this indirectly contributes to society's visual culture. The unlimited time of observation also helps to understand better the nature of the reality depicted. Thus, the above mentioned points help to fulfil the artist's duty as described by Goethe: 'To teach the people how to see.'

References:

1. *Klassischer Journalismus.* Gesammelt und herausgegeben von Egon Erwich KISCH; originallypublished in 1923, reprinted Aufbau-Verlag, Berlin, 1982
2. MÜLLER-BROCKMANN, Josef: *A History of Visual Communication*; Niggli Verlag, Teufen, 1971
3. IVINS, WILLIAM M., JR: *Prints and Visual Communication*; The M.I.T. Press, Cambridge, Massachusetts 1969
4. FRIEDLÄNDER, Max J.: *Von Kunst und Kennerschaft*; Cassirer Verlag, Zürich 1946
5. HEGEL, Georg Wilhelm Friedrich: *Ästhetik*; originally published in arrangement byH.G. Hotho in 1835, reprinted Aufbau-Verlag, Berlin 1955
6. ARAGO, Dominique François: *Report of the Commission of the Chamber of Deputies*; reprinted in: TRACHTENBERG, Alan: *Classic Essays on Photography*; Leete's Island Books, New Haven 1980
7. LABORDE, Léon de: *Die Revolution der Reproduktionsmittel*; originally published in 1859, reprinted in: KEMP, WOLFGANG: *Theorie der Fotogra + e I*; Schirmer/Mosel Verlag, München 1980
8. FENTON, Roger: *Letter to William Agnew* of May 18th, 1855; reprinted in GERSHEIM, Helmut en Alison: *Roger Fenton, Photographer of the Crimea War* – His Photographs and his Letters from The Crimea; Secker and Warburg, Londen 1954
9. HORAN, James D.: *Mathew Brady* – Historian with a camera; Bonanza Books, New York 1955
10. BOURNE, Samuel: *Ten Weeks with the Camera in the Himalayas; The British Journal of Photography*, 1864, No. February 15th, reprinted in: SCHARF, Aaron: *Pioneers of Photography*; British Broadcasting Corporation, Londen 1975
11. THOMSON, John: *Introduction to Illustrations of China and Its People*; originally published in 1873, reprinted in the anthology *Photography in Print*, edited by GOLDBERG, Vicki; Simon and Schuster, New York 1981
12. THOMSON, John en SMITH, Adolphe: *Street-life in London*; originally published in 1876, reprinted Harenberg Verlag, Dortmund 1981
13. BUCKLAND, Gail: *First Photographs*; Robert Hale Limited, Londen 1980
14. EMERSON, Peter Henry: *Naturalistic Photography for the Students of the Art*; E. en P. Spon, New York 2nd edition 1890, reprinted Amphoto, New York 1972
15. STIEGLITZ, Alfred: *The Hand Camera* – Its Present Importance; The American Annual of Photography, 1897, reprinted in the anthology *Photographers on Photography*, edited by LYONS, Nathan; Prentice-Hall Inc., Englewood Cliffss 1966
16. HOSTINSKÝ, Otakar: *Fotogra + e a malirstvi (Photography and Painting) Pražská lidova revue (Prague's Popular Review)*, Vol. 1, (1905), No. 10, p. 257-260
17. KIECANDA, Jan: *Uměni polygra + cká (The Art of Printing)*, a part of the teamwork-book *XIX stoleti slovem i obrazem (19th Century in Words and Pictures)*, Jos. R. Vilimek, Prague 1900
18. STEFAN, S.: *Hundert Jahre in Wort und Bild* – *Eine Kulturgeschichte des XIX. Jahrhunderts*; Verlagsantstalt Pallas, Berlin 1899
19. RENNO, Renate en Eberhard, MÜLLER – KRUMBACH, Renate en SCHROTER, Wolfgang, G.: *Louis Held, Hofphotograph in Weimar* – *Reporter der Jahrhundertwende*; VEB Fotokinoverlag, Leipzig 1985
20. JAY, Bill: *Victorian Candid Camera, Paul Martin 1864-1944*; David and Charles Ltd, Newton Abbot 1973
21. FRERK, Willi Jr.: *Berichterstattung und Amateurphotographie; Photographische Rundschau*, Vol. 20, (1906), p. 262-263

Petr Tausk

22. SCAPINELLI, Carl Conte: *Über Photographie zu Illustrationszwecken; Photographische Rundschau*, Vol. 25, (1911), p. 128-131

23. ČAPEK, Josef: *Nejskromnši uměhe Most Modest Art)*; Aventinum, Prague 1920

24. EVERARD, John: *Photographs for the Papers*; A. and C. Black Ltd, Londen 1923

25. KOR ½, Kurt: *Die Illustrierte Zeitschrift*; originally published in *Fünfzig Jahre Ullstein*, Berlin 1927, reprinted in the anthology *Die Wahrheit der Photographie* edited by WIEGAND, Wilfried; S. Fischer Verlag, Frankfurt am Main 1981

26. LUNAČARSKIJ, Anatolij Vasiljevič: *Fotogra +ja i iskusstvo (Photography and Art); Fotograf*, 1926, No. 1-2, reprinted in the anthology A.V. LUNAČARSKIJ: *Stati o umění (Texts on Art)*; Odeon, Prague 1975

27. STIEWE, Willy: *Das Bild als Nachricht*; Carl Duncker Verlag, Berlin 1933

28. MEŽERIČER, L.: *O postanovke fotoobrazovanija (About Education in Photography); Sovetskoe foto*, 1935, No. 11, p. 3-4

29. LORANT, Stefan, MAK, Felix H. en NEWHALL, Beaumont: *Photojournalism in the 1920s (A Conversation)*; reprinted in the anthology *Photography Essays and Images,* edited by NEWHALL, Beaumont; Museum of Modern Art, New York 1980

30. GIDAL, Tim M.: *Deutschland – Beginn des modernen Photojournalismus*; Bucher Verlag, Luzern 1972

31. SALOMON, Erich: *Berühmte Zeitgenossen in unbewachten Augenblicken*; originally published in 1931, reprinted Schirmer/Mosel Verlag, München 1978

32. CARTIER-BRESSON, Henri: *The Decisive Moment*; Simon and Schuster, New York 1952

33. HICKS, Wilson: *Words and Pictures*; Harper and Brothers Publishers, New York 1952, reprinted Arno Press, New York 1973

34. PAWEK, Karl: *Das Bild aus der Machine*; Walter-Verlag, Olten 1968

35. LINHART, Lubomir: Introduction in the catalogue *Mezinárodní výstava fotogra +e (International Exhibition of Photography)*, Prague 1959

36. FROTSCHER, Heinz: *Reportagefotogra +e*; VEB Fotokinoverlag, Leipzig 1983

37. REASONER, Harry: Introduction to the volume: *The best of Photojournalism 2*; Kesweek Books, New York 1977

RAYMOND DEMOULIN

Photojournalism & tomorrow's technology

AMERICAN RAYMOND DEMOULIN IS VICE-PRESIDENT AND GENERAL MANAGER OF THE PROFESSIONAL PHOTOGRAPHY DEPARTMENT AT EASTMAN KODAK COMPANY IN ROCHESTER, N.Y. (USA). IN HIS CONTRIBUTION HE DISCUSSES THE INFLUENCE OF TECHNOLOGY ON PHOTOJOURNALISM. TO WHAT DEGREE HAS THE DEVELOPMENT OF PHOTOJOURNALISM BEEN DETERMINED BY THE DEVELOPMENT OF TECHNOLOGY? IS NEW TECHNOLOGY A RESPONSE TO THE NEEDS OF THE PHOTOJOURNALIST, DOES HE EAGERLY ACCEPT THE NEW POSSIBILITIES OF THE PERFECTED MATERIAL? OR HAVE TECHNOLOGY AND PHOTOJOURNALISM DEVELOPED SEPARATELY?

On the day of John F. Kennedy's funeral the White House drive was filled with quiet, reflective reporters waiting to cover the departure of the Kennedy casket. The press photographers, like their print and broadcast colleagues, were standing together in small groups. As always, they were switching lenses, camera bodies and loading film, and down the line one could hear them whispering to one another, 'five hundred at five-six,' the correct exposure for the TRI-X film in many of their cameras on that overcast day.

Apocryphal or not, this is a story that could be told about almost any occasion in the history of photojournalism. Photojournalism has always been charged with a tricky technical task. Whatever the event or conditions the camera must work perfectly. The picture, to use a common but accurate expression, must come out. In this respect, the photojournalist of the future will surely resemble the photojournalist of the past. He will increasingly load fast, accurate black-and-white and colour films in conventional cameras and he may also carry an electronic camera, but his assignment will be the same: to return to the office with a good picture. Henri Cartier-Bresson, as usual, was right. 'Photography since its origins has not changed,' he once wrote, 'except in its technical aspects.'

Of course, by the early 1960s the technical aspects of picture taking had become extremely sophisticated. Automated cameras with electronic intelligence were still some years away, but all the same, the tools these photographers carry were very reliable. Most photojournalists had at least two cameras ready: one loaded with black

Raymond Demoulin

and white film, the other with colour. In many cases, by late afternoon the black-and-white film would have been developed, transmitted, edited and appeared on the front page of newspapers all over the world.

Not, however, if each of the photojournalists that morning had not woven their technical expertise together with the instincts of a good reporter and the practical eye of an accomplished visual artist. Since the beginning of photojournalism the art of the job has been to fuse these three tasks together and produce a seamless piece of reportage. That's the tradition. As we leaf through the whole history of the profession, the pictures that stop us are technically expert, historically profound and visually striking.

The problem is, of course, that unlike, say, easel-sized oil painting, the tools of the trade have changed enormously in what really amounts to a very short time. In 1550 Giorgio Vasai could write a technical handbook on the plastic arts with the assurance that nobody in the near future would come up with some sort of miraculous new automatic brush or computer-generated stone cutting tool. There were, to be sure, always changes in art technology; Michelangelo had it better than the Parthenon sculptors. But compare, for instance, Matthew Brady's camera and film with that of contemporary photographers such as Susan Meiselas or Don McCullin.

So the technology matters. But that's not a particularly startling observation. What is interesting about all this, and what is sometimes overlooked, is the quirky, non-linear progress of the history of the technology. Particularly that of photojournalism. The history of the genre is compelling and economical; photojournalism throws away very little as it proceeds and certainly its accomplishments are remarkable. Sometimes it startles with its technical expertise, often it is content to let its tools disappear, but it never lets the viewer forget what an amazing thing the medium is.

Look at the work of Matthew Brady. Along with Crimean War photographers Roger Fenton, James Robertson and Felice Beato, Brady is usually thought of as one of the inventors of photojournalism. Actually, by training and inclination Brady was not a journalist at all. Apparently apolitical, he drifted from schoolboy painting to Daguerreotype to the photo business with a lack of intensity that is remarkable for one who would in many ways revolutionize the way the public viewed current history.

But Brady never lacked the ability to understand photography's mesmerizing appeal to the public. After he wound up in Washing-

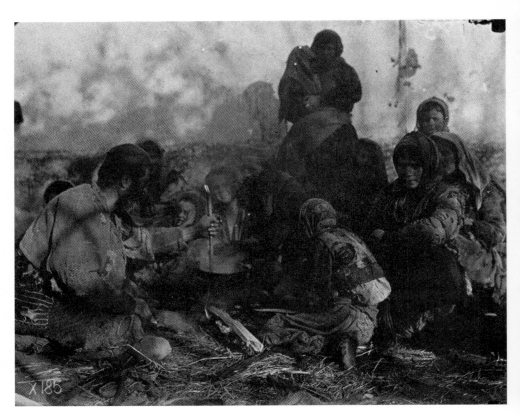

Serbian refugees come home.
LEWIS HINE, USA, 1918

Raymond Demoulin

Blind man.
JACOB RIIS, USA, 1888

ton he opened a gallery and began selling celebrity portraits. For studio work, he bought a special carved oak chair, sometimes called the Lincoln chair. In photo after photo there is the chair; and sitting in it, or standing stiffly next to it, is another famous figure. Lincoln once remarked that two events had elected him: the widely reported Cooper Union speech and a photograph of him taken by Brady.

Brady understood the implication of this remarkable statement immediately. The public loved pictures. Photographic pictures fixed, as never before, powerful, memorable images in the mind of the public. Once the Civil War began Brady somewhat brilliantly took this phenomenon one step further. When he crossed The Long Bridge heading out of Washington the morning of the first Battle of Bull Run he initiated a brand new tradition in American reporting. He sounds a lot like any contemporary photojournalist. 'I felt I had to go,' he said later; 'a spirit in my feet said go and I went.'

There are a lot of jokes about that day and they too anticipate the tradition. One observer bitterly blamed Brady for the Union defeat. The runaways, it was said, mistook Brady's 'mysterious and formidable looking instrument' for a 'great steam gun discharging 500 balls a minute, and immediately took to their heels when they got within its focus.' This would not be the last time that the technology used to record an event was blamed, like the Greek messenger, for the content of the message.

The truth was that technology wasn't even close to that powerful. It was creaky, cumbersome and slow going. Brady had discovered the wet plate collodian method of photography and that was a great improvement, but the technology had definite limits. Brady's wagon of equipment, called the 'Whatsit,' was about as speedy as his camera. Each time he stopped, the slow speed of his photographic outfit required that compositions be pre-frozen in two or three minute sections.

Thus the double nature of Brady's pictures, which are either posed shots, with all the posturing associated with such compositions, or photographs of dead people. Someone once said of Brady's Civil War work that before his camera the dead grew deader. This was meant critically, as a comment upon the incompetent and youthful nature of the technology. But look at a celebrated and much later picture: Don McCullin's horrifying shot of a murdered Congolese citizen. McCullin has written that 'it was as if the corpse were made out of flat bronze,' and indeed, like the best Civil War pictures, the corpse does seem mysteriously more dead when its image is fixed on film.

180 Raymond Demoulin

So in many ways, though the technology has changed, the tradition hasn't. A great deal is made of Brady's working methods. Since it was impossible to capture action accurately on film, Brady would wait until the battle was over and then drive his mobile darkroom around the fields like a travelling mortician. Roll ahead a hundred years of technological time, the assumption goes, and Brady would have produced action shots typical of the contemporary photojournalist.

It's not that simple. In the decades intervening between the American Civil War and the First World War the technological achievements of photography were astonishing. Gelatin bromide dry plates replaced collodian wet plates. Then came the much simpler rolled film. It took George Eastman a while to perfect this invention, but by 1888 he was able to market the first Kodak camera, which, complete with shoulder strap, carrying case and film, sold for twenty-five dollars.

Around the same time the half-tone process was also introduced. Photographs could for the first time be widely and accurately reproduced. In 1873, the New York *Daily Graphic* published what is usually considered the first piece of photojournalism, Stephan Horgan's shot of New York City's Shantytown.

Photographic historians usually combine these two momentous changes under the rubric 'popular interest in photography'. With a Folding Pocket Kodak Camera even an amateur could take a picture. Picture taking was thoroughly democratized and images seemed all the more epistomologically sound by virtue of that fact. By 1900 the whole operation was so simple that even a child could pull it off.

The problem with all of this is that photos of the twentieth century's first great news events are in many ways very disappointing. Many photographers worked the war and the best of them was a British journalist turned military photographer named William Rider. Just the right man for the job. But even taking account of the fact that his 4 x 5 glass plates were clumsily developed (like Brady's, in a field darkroom), Rider's best work cannot be considered to be aesthetically and historically very different from all those war pictures which had preceded it.

The much reproduced Rider photo captioned 'Fate of German machine gunner' is typical. Aesthetically the photo is not much better, in fact maybe of a lesser quality, than Alexanders Gardner's photo of a dead rebel sharpshooter propped up against a Gettysburg stone wall. Here the German soldier has crumpled head first

into a foxhole, his gun still on the lip of the hole, his belt of bullets trailing down towards his body. It is a good picture, make no mistake about that, but there is little to distinguish its information from that of the earlier photo.

How could that be? True, fast film and high quality hand held cameras were not yet available. And World War I was a new sort of engagement, a war of attrition in which battles were measured by years and the sheer numbers killed on each side. It was a hard war to photograph. A few years earlier another British press photographer named Herbert F. Baldwin had been sent to cover the Balkan War. He came up with a few rules for the photojournalist. A bicycle, he said, was more efficient than a horse and it was always better to be on the losing side. The best pictures, he said, can be taken of a good retreat, and besides, an attack is liable to leave one stranded in no man's land.

Most of this advice was unusable in trench warfare. But the question remains: why is there no single set of photos that seems to make sense of World War I? Millions waited months in slimy, rat-infested trenches only to slip over the top and be killed. The wholesale destruction caused by this war sent a whole generation into shock. But World War I photojournalism, unlike much writing of the period, is practically mute about these facts.

The answer may well be that World War I photographers simply didn't know how to use what they had. The technological history of photojournalism is not always as simple as it seems. A perfectly good piece of machinery, like a camera, must be linked to an up-to-date, creative set of sensibilities. Tim Gidal, who was one of that great group of photojournalists working in Germany in the 1920s has given one particularly clear example of this principle. When the brand new Leica and Ermanox cameras were introduced, he says, it took about five years for photographers to accept them and even then it was mostly a younger generation that saw the possibilities of the new equipment. Sometimes technology is ahead of its own time.

This is a reasonable explanation; but there is another, I think, which reflects equally well the ongoing tradition of photojournalism. And that is that the photographic technician, no matter how good the equipment, cannot produce a great picture without the other two parts of his working persona. He cannot report a historical event taht he does not fully comprehend and he cannot aesthetically document a scene which the tradition has not prepared him to see.

Raymond Demoulin

A husband and wife evicted from their house.
WEEGEE, USA, 1945

Photojournalism & tomorrow's technology

What was missing, then, was a reliable intellectual tradition, a tradition which was invented, all the textbooks tell us, by two very different men. The first, a police reporter and social reformer named Jacob Riis, apparently had little interest in photography. Primarily a writer, his major responsibility, as he saw it, was to raise public consciousness in regard to the terrible conditions among the urban poor of New York City.

This Dickensian task was not beyond the power of the written word, but Riis made an imaginative leap that would initiate a long tradition. He took pictures. If the public did not completely believe his words, well, there was the proof. When he lectured he showed slides, and his first book, the influential: *How the Other Half Live: Studies Among the Tenaments of New York*, included direct half-tone reproductions of the photos he had taken in the alleys and over-crowded slums of New York.

Even more remarkably, these were good pictures. Most photographic historians are quick to call Riis lucky, and perhaps he was. His methods were hardly painstaking. The story is that Riis would suddenly appear in a tenement room, usually at night, quickly set up his camera, light the flash, open the shutter and be gone; not an unheard-of technique, but also not one which suggested a fussy artistic sensibility.

That these photos turned out to be wonderfully symbolic, punctuated by menacing shadows and dark threatening forms, is only half the point. Picture taking, after all, was meant to be easy. That was one of its advantages. Photographs were miracullous, a technological tour de force, and the machine could be trusted simply by virtue of its intellectual and aesthetic neutrality. Those who read Riis's work could be sure that the accompanying pictures were indubitably true, a product, as one advertisement said, of 'the camera's merciless and unfailing eye.'

The other great documentarian of the early twentieth century was a university sociologist named Lewis Hine. Unlike Riis, Hine cared about the aesthetic power of his work. 'The picture is a symbol,' he once said, 'that brings one immediately into close touch with reality.' This idea was a huge leap in another direction. Riis provided photojournalism with two thirds of its working personality; he was a reporter with a camera. Hine added the final piece of the triad; he was a reporter with a camera who believed in the aesthetic power of his work.

This aesthetic control made all the difference. Some of Hine's work appears posed, and to that extent it lacks the spot new im-

Raymond Demoulin

mediacy of Riis's lethargic and often dreary scenes. But the photos make up for that slight deficiency by their overwhelming symbolic import. In one shot a young girl sits by her father's bed. Her hands are together in her lap; her back is straight; and her sad, stoic face is turned quietly toward the hopeless-looking man wrapped in dirty sheets on the bed. A third or more of the scene is taken up by the wall above the father's bed and just slipping into the frame is a picture of a horse standing in a pasture. Everything in the picture works towards the same goal: powerful, informative, symbolic immediacy.

It's fair to say, then, that shortly after the turn of the century the photographic technology was some distance ahead of its common use. Certainly there were huge advances in equipment yet to take place. The flash pan was awkward, the film slow and the camera cumbersome; but none of these were photojournalism's biggest problems. Despite the power of Riis's work and the elegance of Hine's, a common tradition had not yet been universally articulated.

World War I went by pretty much as if Riis and Hine had not existed. The photojournalistic story at this time was one of missed opportunities and blind alleys. To be sure, by the 1920s photojournalism had become a bona fide profession. Newspapers hired staff photographers and there was a hunger for new photos, sometimes the more sensational, the better.

The famous sneak shot of murderess Ruth Snyder at the moment of execution, which ran under the headline 'DEAD!' in a 1928 edition of the *New York Daily News* is perhaps the most lurid example of this trend. It was also during this period that photojournalists began to be known as people who were always mixing chemicals, lugging equipment and setting off flash powder explosions. Almost all of them had extensive darkroom experience. Photojournalism was a physically demanding and technically tricky job and the image of these men as part reporter – part technician has not changed since the days of slippery glass plates and the rows of half-filled chemical bottles.

There were, though, few great news photographers of the twenties. Photojournalism seemed to be waiting for new social, artistic and technical developments to spur it on, and these came during the eventful 1930s. Flexible gelatin film, which had been used in home cameras for many years, replaced the glass plates common to most press cameras. The 4 x 5 Speed Graphic took the place of the old 5 x 7 Graflex and, even more important, the 35 mm camera could now be sometimes employed for special available light assignments.

The Associated Press and United Press companies introduced wire transmission of photos in the middle of the thirties. Now pictures could be transmitted coast to coast for quick reproduction. In printing, dry plate engraving replaced the wet plate process. And in 1936 *Life Magazine*, the greatest on the growing list of picture magazines, first hit the newstands.

These are huge technological accomplishments, revolutionary really, and the changes they brought about in the field of photojournalism were equally astonishing. From the late 1930s on through the war years of the 1940s photojournalism came into its own. Many of the great masters of photojournalism either began or continued their careers during this time. Photojournalists were everywhere, for the first time almost as mobile as their print collegues.

For the next 25 years the Speed Graphic camera, loaded with light sensitive gelatin film, was the news photographer's chief tool. In movies of the time the news photographer is identified by his rumpled look, aggressive behavior and the blinding flash of the bulb that he digs up out of his pockets. The papers wanted pictures and no one provided so many graphic shots as a freelance street photographer called Arthur Fellig, nicknamed Weegee for his uncanny Ouija-board ability to predict the time and location of the latest atrocity.

Weegee specialized in murder, or to put it more accurately, the victims of murder. Much has been made of the fact that throughout his career Weegee took over 5,000 body shots, many of them depicting a victim lying face down in a spreading circle of blood. But in these, as in many of Weegee's other street scenes, shocking images share pictorial importance with a simple technological effect. Weegee worked at night and his subjects are caught in an ugly pool of light that bleeds off melodramatically as it heads toward the edges of the frame.

The mobile camera, relatively fast film and the unadjusted flash are used here powerfully and intrusively. Riis's flash pan had created startling effects, but this was something new. Photojournalism would never be the same. Thirty years later Harry Benson's award-winning shot of the wounded Bobby Kennedy floating on his back in a swamp of light only updated the tradition. The flash, like a television cameraman's spotlight, adjusts our vision. It allows us to see clearly through the gloom. It could be called the Weegee factor.

Much of the great photojournalism produced during this period, however, took a significantly different direction. The most influential picture of the period, and perhaps the most famous war photo-

graph of all time, is Robert Capa's 'Death of a Loyalist Soldier', published in the French magazine *Vu* in October 1936. Again the subject, as it has often been in photojournalism, is death.

Not death in its Brady, Rider, Weegee form – stiff, mortuary and heavy; but death as a process. Capa's great achievement was to capture on film the exact second during which the anonymous Loyalist soldier changed from a charging rifleman to a statistic in the history books. All this would be a fine example of the wonders of the new technology were it not for the legend which has grown up around this picture. One of Capa's friends, a war correspondent named O.D. Gallagher, swears that not only was the shot faked, but that Capa told him that the best way to make such a picture was to have the camera slightly out of focus and to move it slowly just at the second of exposure.

Elsewhere Capa himself is quoted as telling still another version. John Hersey, in a review titled 'The Man Who Invented Himself', recounts Capa's story this way: 'During one battle, he (Capa) was in a trench with a company of Republican soldiers ... finally as they charged the photographer timidly raised this camera over the top of the parapet and, without looking, at the instant of the first machine gun burst, pressed the button. He sent the film to Paris undeveloped. Two months later he was notified that he was now in truth a famous photographer, talented and nearly rich, for the random snap turned out to be a clear picture of a brave man in the act of falling dead as he ran and that it had been published all over the world, accompanied by his name.'

The third version told, of course, is that with this single picture Capa practically invented the photojournalistic idea known as the decisive moment. Whatever the truth, this photo does anticipate a whole new world of photojournalism. From here on, the ability of ever faster films to frame and fix a critical and definitive microsecond became the single most powerful metaphor of modern photojournalism.

Henri Cartier-Bresson articulated this idea best. 'Photography,' he said, 'is at one and the same time the recognition of a fact in a fraction of a second and the rigorous arrangement of the forms visually perceived which give that fact expression and significance.' The problem with the Capa picture in these terms is obvious. If it was fake, there goes its empirical premise, and if it was an accident, then man and machine part artistic company.

A better and more economical way to solve this problem is to say that all of these possibilities were latent in the meeting of the new

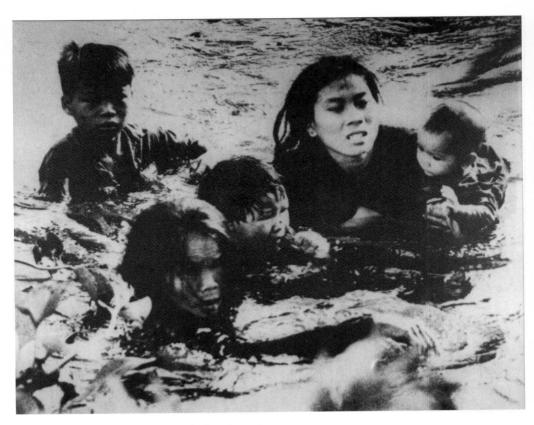

Mother and children fleeing from the war.
KYOICHI SAWADA, JAPAN (UPI). VIETNAM 1965

Raymond Demoulin

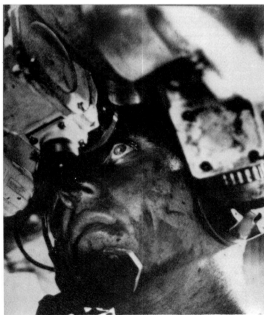

American Marine during
the battle at Con Thien.
JOHN SCHNEIDER,
USA (AP), VIETNAM 1967

Tank commander.
CO RENTMEESTER, THE
NETHERLANDS (LIFE).
VIETNAM 1967

189

technology and the old tradition. Was Brady's posed Company 'B' shot historically accurate? Of course. Was Riis a lucky photographer? Again, yes. And did Hine's artfully composed photos of slum life reflect the basic truth? Few would argue with that.

So the great new technology, and it was revolutionary, make no mistake, gathered and rearticulated the whole tradition. *Life* magazine's promise 'to see life, to see the world, to witness great events' was not an empty boast. That had, in one way or another, been the task of photojournalism since its inception. Even today, leafing through a few of the earliest issues of the magazine, one is stunned by the technical brilliance of the magazine's photographers and editors.

George Eastman's democratic art form reached fruition in the pages of *Life*. The great documentary tradition of Riis and Hine had been worked over by that band of very talented Farm Security Administration photographers and finally flowered into the amazing form known as the *Life* photo essay. On the spot news side there was World War II. Pictures of men and battles thousands of miles away both assured and horrified viewers. If not exactly a 'living room war', as the later Vietnam conflict was described, World War II will always remain photographically etched in many people's minds.

The years following this much praised high point in photojournalism could only improve the discipline it seemed. Though the 35 mm camera had been introduced in Germany in the 1920s, by the late 1950s this marvelously efficient little machine became the photojournalist's camera of choice. In 1954 Kodak began marketing the perfect film for this camera. Rolled 35 mm Tri-X was much faster than other films and besides, it was not excessively grainy. From that time until the present, advances in silver halide chemistry continued and by the 1960s few photojournalists went anywhere without two cameras, one loaded with Tri-X black and white, the other with high speed Ektachrome film.

By the 1960s photojournalists were free to move quickly, could click off an unprecedented number of exposures and could count on the equipment to be reliable. Robert Capa's well known admonition, 'if your pictures aren't good enough you're not close enough,' was gospel in the photojournalistic world. Now that the photographer's technical chain was not much longer than the neckstrap of his camera, it seemed that this problem could easily be solved. Anyone with a good camera, the right film, and guts enough to get close could come up with a brilliant piece of photojournalism.

Raymond Demoulin

While that promise overstates the matter a bit, the new technology did produce an interesting twist of the tradition. If one compares, for instance, the work of two Vietnam war photojournalists, each of different generations, this change is clear. David Douglas Duncan, the older, more experienced photographer, was a veteran of both the Pacific front in World War II and of the Korean War. His great Vietnam work drew upon both of these previous assignments.

But if one arranges Duncan shots from each of these wars side by side it is difficult to distinguish one war from the other. All of the photos are beautifully composed, dramatic and informative. Duncan's vision, like much of the older *Life Magazine* tradition, is panoramic and historical in scope. Each photograph is a nicely punctuated sentence that is ready to be placed in the paragraph form of an equally well composed photo essay.

The new generation of photojournalists, however, worked differently. *Life* magazine's Larry Burrows is often called the greatest of all war photographers. Burrows obviously loved old master paintings and the larger part of his work is also an intense, colour-modulated masterpiece. His most famous photo was shot inside a helicopter in the midst of battle. A young machine gunner is frantically shouting for help. At his feet the body of a badly wounded crewman is being pulled away from the open door. Desperation and fear are palpable.

The shot is as decisive a moment as could be, and is beautifully composed. It is also in colour, a fact made possible by fast reliable new colour stock. But what separates this picture from the thousands of others in the 150 year old archives of war photography is the unmistakable feeling that the camera itself is almost preternaturally alive. It is not quite the sense that the machine has disappeared. There is still a mechanical thread connecting Burrows and his subject. What one senses is that somehow Burrows has recorded on film the inaudible gasp and skip of his own heart.

Of course, the truth is that Burrows' camera was not yet cybernetic. The photographer can never escape the camera – it is his palette, brush and canvas. Don McCullin, arguably the greatest living photojournalist, claims to have no technical interest in photography. In fact, he once failed an Air Force photography exam – they failed him he says. But he never, no matter what the conditions, takes a single shot without a light meter reading. Why bother if it won't come out, he says.

Certainly for most contemporary photojournalists the technical

aspects of picture taking have been hugely simplified. In Burrows's case the camera and film were very user friendly; but they were definitely not user neutral. Certainly he knew how to work the machine, but he was also well aware of the tradition. The two are inextricably linked. Without Brady's decision to turn his camera upon the dead, Hine's insistence upon well composed symbolic shots, Weegee's glimpse into the darkness and Capa's decisive moment, Burrows' beautifully expert picture would be an inexplicable anomaly.

Over the next few years Burrows came to typify the photojournalist in his most knowledgable, compassionate and artistically astute form. Movies celebrated this new heroic status of the profession. In Oliver Stone's *Salvador* and in other recent films, the photojournalist is a hero, brave enough to put himself in the midst of the most dangerous situations, honest enough to always be looking for the truth.

It may be a mistake to make too much of movie mythology, but look at the obviously 'photographic' colour tone of a film like *Salvador*. What we see is not just scene painting. Not too many years ago photojournalists were wary of colour. But a film like *Salvador* celebrates the press photographers' immersion in the lush language of colour. Neither the film maker, nor the photographer he portrays, is afraid to provoke deeper levels of meaning.

In fact, photojournalistic assignments increasingly specify colour. Some of the best of the new photojournalism is thus dramatic and visually complicated. The great Central American pictures of Susan Meiselas, Harry Mattison and others come immediately to mind as does the colour work of Harry Gruyaert in Belgium, Rio Branco in Brazil and David Burnet in the United States. It has been just over 50 years since Kodak Kodachrome 35 mm colour transparency film was introduced, but that's not an excessively long lag time in the tradition as we have seen it. Over that period film speeds increased to ISO 1000 and higher, lenses and shutters have become faster. Technology had continually refined all aspects of exposure control, while motor drives and dozens of other improvements make today's best 35 mm cameras mimiature marvels of intricate precision.

The photojournalist of the future, it seems, will be even freer to pursue the truth. Though electronic cameras are for the most part still in the formative stages of development few doubt that they will eventually become standard tools. Technical progress in just the area of sensors alone has been astonishing. Kodak Research Labs

Raymond Demoulin

recently announced a 1.4 million pixel sensor which displays 1035 x 1320 resolution lines.

As a quick transmitter of visual information the video still camera may turn out to be enormously useful. But for most purposes, digitally recorded photographs are not yet as good as those produced by the ever more sophisticated silver halide chemistry. The best sensors currently available in still videa cameras are 50-80 times below the information storage capacity of a single frame of 35 mm film.

The two systems of picture taking seem destined to coexist. Acrylic paint did not replace oil based colours; photography did not kill representational art; and television did not take the place of the movies. And it's hard to imagine electronic photography, even as it comes down in price and goes up in quality, becoming a substitute for conventional photography. Electronic photography will probably never be the refrigerator to photography's icebox. A more reasonable way of imagining the photojournalist of the future is to see him carrying three cameras: one with black-and-white film, one for colour shots, and one that electronically captures and transmits the news for immediate use.

Photography in general and photojournalism in particular are a technology with a tradition. Certainly the art of picture-taking has improved immeasurably. The distance between Brady's wet collodion plates and the latest thin remarkably sensitive T-Grain silver halide technology is enourmous. In the future the progress of electronic photography may be equally amazing.

But the tradition created over these last 150 or so years remains marvellously compact and economical. In the movies the press photographer risks his life to take one last picture. He has already shot may rolls of film, and any one of these pictures would probably serve the purposes of his publication. But he wants a great picture, a photo to match the best of Robert Capa's work. He wants a picture that will tell the whole story reliably, accurately and beautifully. And so, of course, did Capa, and Hine, and Brady and all the rest of the photojournalists in the photographic tradition.

Acknowledgement

The World Press Photo Holland Foundation wishes to express its appreciation and gratitude to all the photographers, agents, press agencies and museums who were kind enough to lend their assistance to this book.

Every effort has been made to obtain and give the right information on all the photographs shown here. If, despite our efforts to avoid errors or omissions, these do occur, we offer our sincere apologies.

The World Press Photo Holland Foundation, Weesperzijde 87, 1091 EK Amsterdam, will welcome any information which will help it to correct any errors and to locate parties entitled to anonymous photographs.